Salad

illustrated
by Joana Avillez

for

**A Cookbook
Inspired by Artists**
Julia Sherman

Abrams
New York

President

To my husband, Adam, who has spent
countless hours analyzing every
salad in this book, and who desperately
deserves a pizza.

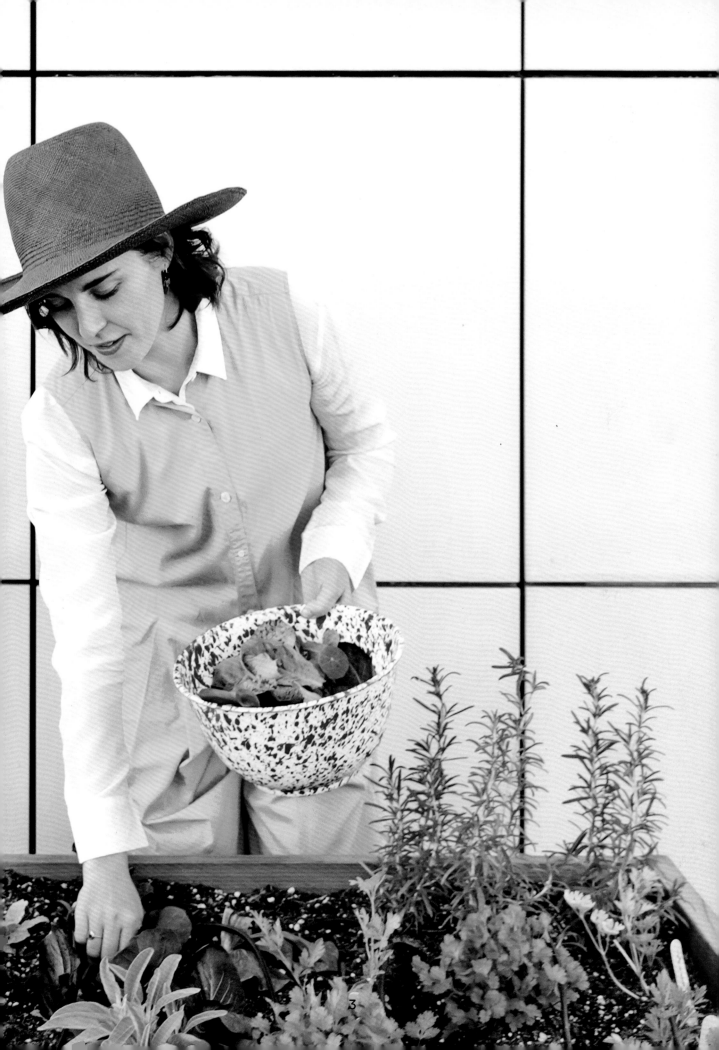

3

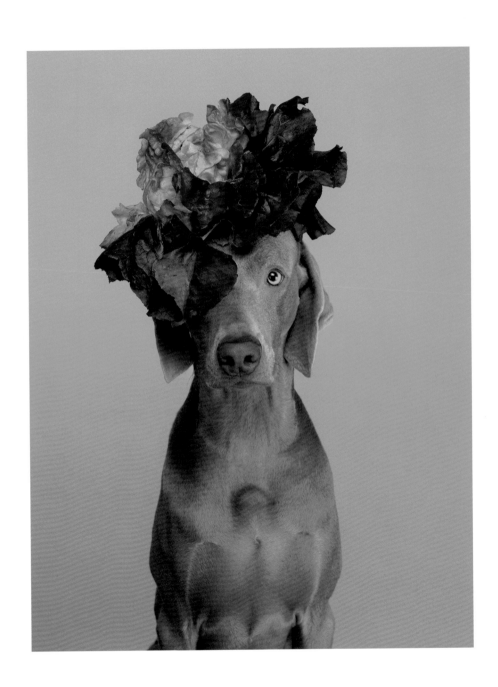

Table of Contents

Foreword Part I; Christine Muhlke

Christine Muhlke is the editor at large at Bon Appétit.

MoMA PS1 was closed, but I wasn't there to see the art. I was there to eat it. Julia Sherman had invited me to a lunch made from the garden she built on the roof. It was August, and even though she had hosted a summer of edible events with food gathered from the raised beds, the plants were still abundant and getting a little wild, bolting against the Manhattan skyline.

Only ten minutes from Midtown, I was being fed just-blitzed gazpacho and salads bearing elements from every bed. There was cornbread sprinkled with herb salt she'd blended and poured into amulet-like vials; and herbal agua frescas to drink. It was delicious, of course, and how cool to be able to eat and talk on a rooftop above an empty museum while everyone else I knew was staring at their phones while waiting in line for salads trapped in plastic domes. More importantly, it popped open a door in my imagination: How cool to have a simple, radical idea—I want to build a garden on the roof of a museum and ask artists to come make salads—and then bring it so fully to life. What would she pull off next?

Making and serving food is not a new art form. From Gordon Matta-Clark's 1970s restaurant, FOOD, to Rirkrit Tiravanija's gallery curries of the '90s (and, now, upstate restaurant, Unclebrother, with gallerist Gavin Brown), the public has consumed the work. But for Julia, the work also involves curating experiences and discussions, bringing food and artists together as she invites them to share their processes and discuss how it relates to their own art, then sharing it through her blog, *Salad for President*.

It was Madeleine Fitzpatrick who taught me five years ago that making a salad could be a form of artistic expression. The otherworldly painter led me into her anarchic garden in Marin County, big metal bowl in hand, and began gathering wild-seeded leaves, fruit, flowers, shoots, sprouts, seeds, and probably grasses. When the bowl hit the dinner table, guests, including some of the Bay Area's greatest chefs, were firmly instructed to eat it with their fingers. They did as told, eyes closed, then opened wide in surprise as they came across some beautiful element they'd never experienced before. That salad—if you could call it that—brought us together. It was a creation, a performance, never to be repeated.

Madeleine is here on page 79, sharing her wild wisdom. You'll find artists like Laurie Anderson, William Wegman, and Tauba Auerbach, too. There are recipes, of course, but you don't have to follow them to the letter. *Salad for President* is about inspiration, about making and sharing something bright and beautiful that has been gathered from whatever moves you.

Foreword Part II; Robert Irwin

Robert Irwin is a conceptual artist and seminal member of the Light and Space Movement that emerged from Southern California in the 1960s. In 1997, he created the Central Garden at the Getty Center, an evolving work of art that continues to draw millions of visitors to this day.

This is an excerpt from a conversation between *Salad for President* and artist Robert Irwin, November 2015.

Julia Sherman: You are not a gardener or a landscape designer, but some of your best-known works take the form of gardens or architectural spaces. Are there any limits to what you can do as an 'artist'?

Robert Irwin: I decided a long time ago that being an artist had something to do with how we exist in the world, and that it shouldn't be limited to painting, sculpture, or the studio. So I got rid of the studio years ago and spent a little while just wandering around. I developed the idea of Conditional Art: You give me a set of conditions and I will respond to them. With this idea of an artist, I could plan a city, I could plant a garden, I could be the architect at Dia: Beacon. The artist can essentially operate anywhere in the world with the right setting and an understanding.

JS: But the moment you gave up your studio, did you feel relieved or were you terrified? You make it sound so easy.

RI: Who said it was going to be easy? I felt both. I was nervous, but as long as I remained in the studio, I would keep making studio art. So, my options were: stay in the studio or leave.

JS: So, what does an artist do?

RI: An artist is an aesthetician. We understand the world through feeling, and an artist makes us aware of our feelings in a more interesting and demanding way. It's not about creating paintings and making things.

Introduction

I was born into a family of artists.

My grandmothers met in a sculpture class at New York City's National Academy School before setting my parents up on a blind date. I grew up in my mother's SoHo studio, where encaustic was an everyday art supply and my first clay sculptures of cats and dogs were cast in bronze. In 2007, in my early twenties, I moved to Los Angeles, where I finally had my first real studio, a storefront in East L.A. that my now-husband and I turned into a not-for-profit gallery called Workspace. After each art show, I carried the excitement from the gallery to our nearby home, where, with ingredients reaped from my vegetable garden, I cooked elaborate meals and served salad to whomever showed up.

Simultaneously, I was trying to define my own work in the privacy of my studio. I raised silkworms and spun their cocoons into thread. I experimented with ceramics, sculpture, film, and photography. When I think back on the time period now, the work I made in my studio exists in a kind of hazy shroud. What I remember clearly, however, is the energy at Workspace and the meals that extended our early evening happenings late into the night. My little side project attested to our collective vision of an art world that was messy and complicated and—importantly—shaped by its participating artists, not by commerce or institutions.

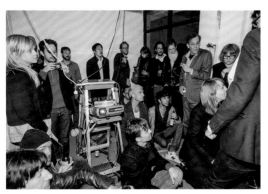

The audience at a Workspace performance in 2008.

I moved back to New York to pursue an MFA. There, I began to use my own art practice as a way to to gain firsthand insight into the way other people approach their art. Why do we make the things we make? I worked alongside a wigmaker in Cusco, Peru; a third-generation cobbler in Burbank, California; a trailblazing drag queen on New York's Upper East Side; and a goddess-worshipping weaver. Instead of reinforcing the

New York bastion of high culture, I wanted to explore art making as a common denominator that brought unlikely people together, not set them apart.

When it came time to complete my graduate thesis, I found myself living in Connecticut with a community of Benedictine nuns. The brilliant women of the Abbey of Regina Laudis wear denim habits in solidarity with American blue-collar workers. Their mantra is *ora et labora* (prayer and work). They raise heritage-breed livestock, produce their own musicals, and build their own coffins. They are famous for their cheese, handmade by Sister Nöella, who studied with master cheese makers in France after pursuing a PhD in microbiology. True, I wanted to taste Sister Nöella's cheese. But what I really wanted was to hear the nuns chant, deep in trancelike prayer, as I'd heard them rumored to be when they milk the cows. I wanted to pay homage to the rituals of someone else's daily practice.

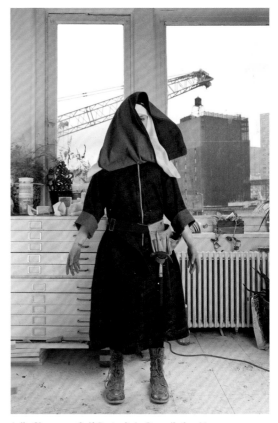

Julia Sherman, *Self-Portrait As Benedictine Nun*, C-print, 42" x 63" x 8", 2011.

I spent the days riding around in their pick-up trucks, tending to their livestock, and working the land. I saw the tremendous freedom they enjoy: They live their lives exactly as they please,

Introduction

unencumbered by the pressures of conventional "success" as we know it. These women had already had their taste of all that in former lives as lawyers, environmental-rights activists, and Hollywood actresses. At the Abbey, they found pleasure in life's simple things: the food they cook, the people they host, the land they tend, and the art (and cheese) they make.

Taken by their radical thinking, I began to suspect that being an artist is an intention more than a profession. An artist is not defined by the limits of her studio, but by the way she shapes the world around her. Making things is part of it, yes. But an artist's curiosity, engagement, sensitivity, and community are more important than the objects they produce.

And, assuming this was true, then I ought to consider the food I made, and the environments I created, part of my practice. Maybe, *this* was my work. Cooking and gardening were the last things I thought about when I went to sleep and the first things I did when I woke up. The experiences I manufactured in the studio were happening naturally in my kitchen, where I was a facilitator and a producer, where I brought people together and instigated conversation.

Artists Love Salad

I started the *Salad for President* blog in 2012 as an online sketchbook in which to chronicle my culinary experiments. I was learning the finer points of food photography by trial and error, writing and posting a new salad recipe each day (my fiber intake was off the charts). I was a woman possessed. I blabbed about *Salad for President* with contagious excitement, and, in response, artists flipped the script, wanting to share their salads with me. I started cooking with painters, musicians, architects, and designers whose practices I admired, photographing them in their kitchens, studios, and eventually in the public salad gardens I would go on to build. Turns out, I'm not the only artist who has a thing for food. Artists LOVE salad, and that's no coincidence.

By spring 2014, the blog was my primary focus. In May, the staff of MoMA PS1, the Museum of Modern Art's contemporary art museum in Queens, New York, invited me to make a proposal for their rooftop, a rare patch of unused New York real estate with a captive audience—artists, tourists, students, and locals alike. Before long, I was planting the MoMA PS1 Salad Garden, taking my

project from the private homes and studios of artists and into the public sphere. This green space, accessible to museum visitors and staff, was the ideal backdrop for my collaborative meals and conversations, and soon became the venue for my own dinner parties, potlucks, and outdoor performances.

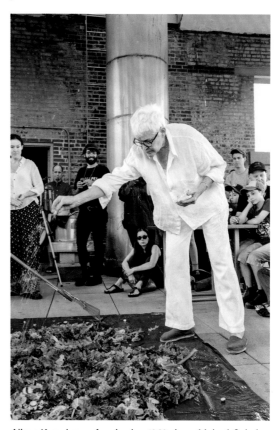

Alison Knowles performing her 1962 piece, *Make A Salad*, in Sherman's Salad Garden at MoMA PS1 in 2014.

Along with urban farmer Camilla Hammer, I planted more than fifty varieties of heirloom herbs and vegetables on the roof of the museum, highlighting what can be eaten straight from the planter, salad-style. There were crops that I had never encountered before—*spilanthes* (a mouth-numbing yellow flower akin to Sichuan pepper), pineapple sage (a sugary but delicate fuchsia edible flower), and the Reverend Taylor butter bean (a shelling bean that ranges in color from celadon green to lilac to blood red), whose seeds I had recently brought back from a family trip to Tennessee. I transformed previously neglected museum real estate into the best kind of green market—the free kind. People were making lunch in the open air and taking bushels of Thai, lemon, and Persian basil home for dinner. Unsuspecting museumgoers came to tour the galleries, and found themselves elbow deep in soil.

Introduction

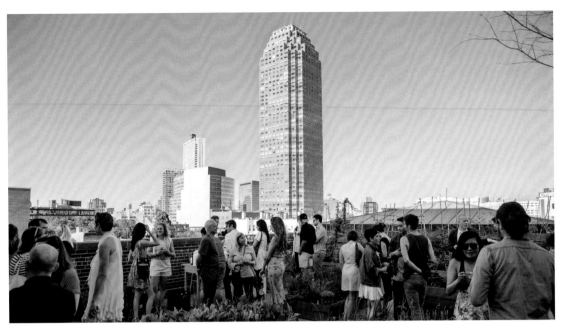

Opening party for The MoMA PS1 Salad Garden project, 2014.

I no longer took meetings in my studio; instead, colleagues met me on the roof of the museum for happy hour (typically a glass of crisp rosé and an herbaceous salad made à la minute). People wondered why an artist was growing a vegetable garden at the museum. What were my credentials? Was I a farmer? My answer: "I don't have any credentials."

This project, as innocuous as it might seem, asks critical questions of museum visitors, the artists who show their work there, and the staff who collectively keep the museum afloat. How are we *supposed* to use this space, and to whom does it belong? How might a museum maintain its authorial position while learning from, and also empowering, its public? How can an artist activate the imagination of museum visitors through the environment they create?

Following the project at MoMA PS1, I was invited to bring my Salad Garden to the J. Paul Getty Museum in Los Angeles. The Getty was known for its artist-designed Central Garden, a monumental project by California Light and Space artist Robert Irwin that served as an important precedent for my work. Irwin had famously "never planted a plant" before taking on this ambitious public project twenty years ago. Now, more than one million people visit the Getty each year, many of them making pilgrimages through the winding paths of his Central Garden to picnic and enjoy views of Los Angeles from the main lawn. With the museum grounds perched high

above the city, this is likely the only spot in Los Angeles where people might appreciate the glittering freeway traffic.

Working with landscape architect David Godshall, I devised a plan to make a garden that would transition between the main building's austere architecture (designed by Richard Meier) and Irwin's whimsical garden. Next to the bright white building, with its gridded tile surface, we planted a cluster of raised beds in a Tetris formation, implying that the geometry of the building was coming undone, giving way to overflowing flowering herbs and monster red-mustard plants. Taking inspiration from the illuminated manuscripts and historical documents of the Getty's collection, we planted rare herbs and greens: valerian root, wormwood, angelica. This being Los Angeles, where people take their gardens very seriously, the public came by to talk shop— to find out what kind of soil mix we were using, where we'd purchased the seeds, why salad? Why at a museum?

The Getty Salad Garden was a hub of activity: a place where artists came to prepare a meal against the backdrop of some of the best sunsets I have ever seen. It was here that I met with Irwin himself, who had *me* make a salad for *him*; artist Samara Golden, who created a tiny sculptural work out of the greens, herbs, and flowers; Michael Parker, who put to use his own fifty-pound ceramic bowl and handmade citrus squeezers; and Marcia Reed, chief curator of

Introduction

Artist Larry Bell "dressing" his salad in Ed Ruscha's 1971 film, *Premium*.

the Getty Research Institute, who took a historical approach, referencing a cookbook that was 431 years old. Artists Larry Bell and Ed Ruscha screened one of only two films made by Ruscha over his career, *Premium*, featuring one of the greatest salad appearances in contemporary art history.

Think Like an Artist, Cook Like an Artist

Although I don't consider my Salad Garden an artwork, it operates like good art should: It makes the everyday seem at once familiar and strange. The garden incites curiosity and conversation from the experienced gardener and the novice alike. At its best, the garden inspires creative thinking. The Salad Garden mirrors what I see as the ideal museum-going experience: an open-ended engagement that leads eventually, circuitously, to knowledge—the kind of knowledge that can only be attained by an engaged audience.

An artist reinvents the things you already know. They reframe the details of life, and prod us to pay closer attention. Home cooks are no different. They are free to experiment and start from the beginning every single day. Making salad is about juxtaposition; it's about mixing and matching, contextualization and comparison. It's about

constant rediscovery and remaining open to the unexpected. To really get down with salad—or art, for that matter—you have to know when to let go of your ego and serve a beautiful avocado with nothing but lime and salt. But unlike the experience of making art, the best part of cooking happens at the end, when you have the satisfaction of watching your guests devour the product of your funny little hands (I speak for myself here). With any luck, they shower you with gratitude, rub their bellies, and go home. I assure you, the transaction is never this straightforward in the gallery.

Now I cook food for museum dinners and host events with guests who have studied food for far longer than I have. I have made a career out of *Salad for President*, but cooking for friends at home is still what I do best. Surrounded by a crazy cast of characters, I spill, splatter, squeal, and stain my clothes; I experiment with otherworldly produce and trash the house in the process. Somehow, from within this cloud of chaos, some of my best recipes have emerged, and some of my closest friendships have formed.

Salad is what I crave at every meal, late-night snacks and breakfast included. But salad also complements my ever-shifting role as host. The way I make it, salad is edible confetti: pretty but not precious; scalable, affordable, and unbelievably good looking on a family-style platter. Beyond pragmatics, if I love you enough to make you dinner (and yes, I've got a lot of love to give), then I want my food to taste good and make you live forever.

We are all creative. You don't need to study art history or *Mastering the Art of French Cooking* to express yourself. But I encourage you to cook and think like an artist: to steal ideas, break rules, and find something spectacular in the everyday.

Not that much has changed since I began my career as an artist in LA. I still ask the same questions: Why do we make what we make? What are the trappings of an artistic life? Only now, together, we make salad.

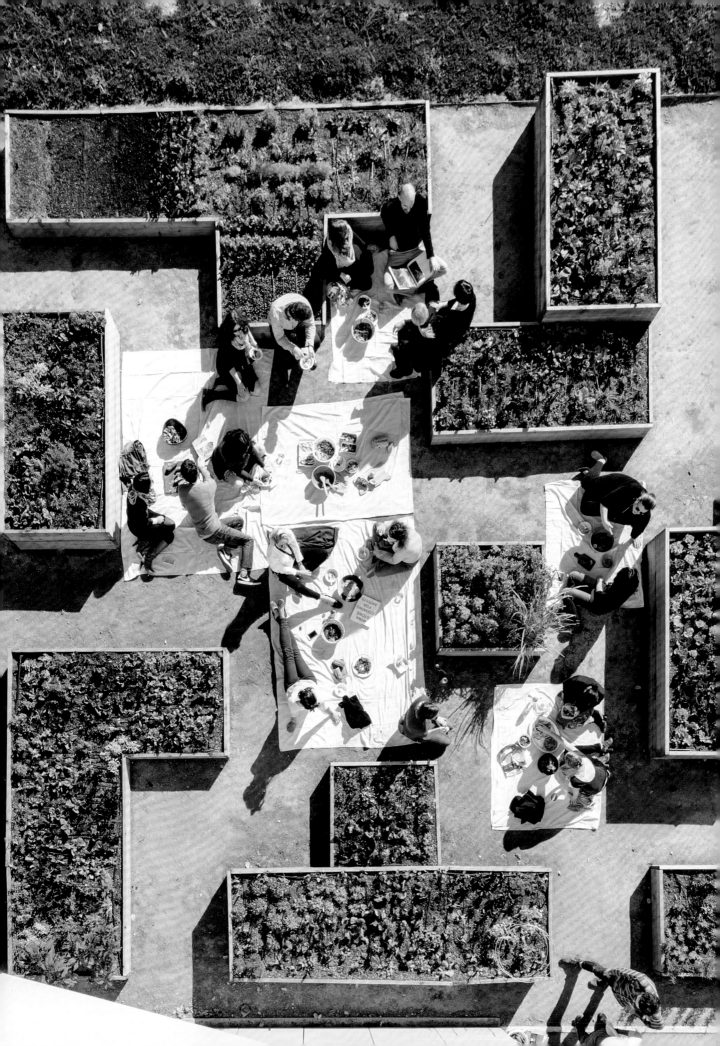

Salad Best Practices

If you are purchasing greens from the farmers' market, then you will want to store them in a way that will preserve their fleeting freshness. You seek it out, you pay for it—it would be stupid not to treasure it. This is salad best-practice 101.

First, fill the salad spinner (strainer inside) with ice-cold water; I even add a couple of ice cubes. If working with a head of lettuce, separate the leaves. Plunge the greens into the ice bath, gently swishing them around with your hands. If your greens are looking a little limp, let them sit for 5 minutes; the cold water will perk them right up. Drain and spin. If you do not have a salad spinner (tsk tsk), plunge and drain them in a fine-mesh sieve set into a larger bowl of cold water. Drain and spread the greens out on a kitchen towel laid on a flat surface (I sometimes do this in addition to spinning to ensure maximum dryness). Let the greens air dry briefly, then gently pat them dry.

To store the greens, wrap them in a loose bundle with a damp paper towel or a thin cotton kitchen towel, place in a large freezer bag, seal and refrigerate them in the crisper drawer. If the crisper drawer is full and you have no choice but to store the greens on the refrigerator shelf, keep them as far away from the walls of the interior as possible (the walls are extra cold and contact with them will freeze the greens, aka sudden death). For more delicate greens, store them in loose layers in a large plastic container, arranging them with a sheet of lightly moistened paper towel in between. Top the heap with one last paper towel and seal.

Aerial view of Getty staff and visitors picnicking in Sherman's Getty Salad Garden.

Chapter One

F*%k Brunch

Things you want to
eat bright and early

Most pair well with eggs
or include eggs

Salad-y alternatives to the
classic brunch menu

This chapter is a rejection of the American tradition of waiting in line for the meal that is the easiest and most rewarding to prepare at home. When I say "F*%k brunch," I am not suggesting you skip a meal. To the contrary, if we are going to roll two meals into one, I propose we make it count. I am looking for redemption on Sunday morning; I am not trying to make matters worse.

With this in mind, I began sharing my Sunday morning kitchen experiments on Instagram with the tag #FuckBrunch. Viewers echoed my sentiments and applauded my creative efforts, and I realized this was cause for foment. Inspired by my weekend homemade meals, I started a F*%k Brunch pop-up restaurant in Red Hook, Brooklyn, collaborating with chef friends to brighten even the most beleaguered morning-after faces. So, let's trade pancakes and bottomless mimosas for piles of veggies, eggs, and herbaceous cocktails leagues beyond the bottom shelf.

This is the food that gets me out of bed in the morning: brunch seen through salad-colored glasses.

This salsa is inspired by a recipe I tasted first in cook/musician Niki Nakazawa's Mexico City home. Her version calls for rare *chilhuacle* chiles, moderately hot with strong notes of cocoa, tobacco, and dried fruit. They are difficult to find domestically, but if you have a hook-up, sub them in for the pasilla chiles used here.

Dried shrimp are easy to find at Asian and Mexican grocers, but if you can find Louisiana dried shrimp, they tend to be higher quality. The texture of the dressing should be chunky and spoonable, with an oily base. Niki says, "Toasting chiles is a good way to clear the sinuses and rid your home of the bad juju." So there is that added benefit, too.

Soft Eggs, Avocado, Radish, and Peanut-Pasilla Salsa

1. Slice the radishes lengthwise, very thinly, using a mandoline or vegetable peeler. Toss them in a container filled with cold water and refrigerate. They should curl in on themselves, taking on the shape of a Frito (but much healthier).

2. Make the salsa: Wipe the chiles down with a damp cloth to remove any dust or dirt. Heat a large skillet over medium-low heat. Reduce the heat to low and toast the chiles, dried shrimp, and the garlic in the pan, stirring once a minute to make sure they toast evenly and do not burn. After about 1 minute, add the peanuts and stir until the nuts are lightly browned.

3. Peel the toasted garlic clove and put it in a food processor along with the chiles, shrimp, peanuts, and salt. Process until smooth, adding the oil in a thin stream through the hole in the lid. At the very end, add the tomato and blend thoroughly.

4. For serving: Bring ½ inch (12 mm) water to a boil in a medium saucepan over medium-high heat. Carefully place

3 breakfast radishes or another long, skinny variety like Bartender or Flamboyant

For the salsa

3 dried pasilla chiles (about 1 ounce/28 g), seeds and stems removed

1 tablespoon medium-size dried peeled Louisiana shrimp, or other headless, medium dried shrimp

1 small clove garlic, skin on

¼ cup (40 g) dry-roasted peanuts or cashews

1 teaspoon kosher salt

½ cup (120 ml) olive oil

½ small tomato

For serving

4 to 6 large eggs (one per person)

2 ripe Fuerte or Hass avocados

2 teaspoons fresh lemon juice

Ricotta salata (optional)

Sea salt

1 tablespoon fresh micro cilantro or torn conventional cilantro

Sourdough toast or warm corn tortillas

Coriander berries for garnish (optional)

the eggs in the boiling water so they are about halfway submerged. Cover with a tight-fitting lid and cook the eggs for 6½ minutes, so they are soft-boiled. Drain, then rinse the eggs under cold running water for 30 seconds. Peel and set aside.

5. Remove the radishes from the fridge; drain and pat them dry.

6. Peel and slice the avocados and drizzle them with the lemon juice to prevent oxidation. Arrange the avocados on a platter, layering them with the radishes to achieve some volume. Cut the eggs in half lengthwise and place them within the salad.

7. Use a vegetable peeler to shave paper-thin strips of the ricotta salata, if using, on top of the salad.

8. Spoon the salsa over the whole mess, mixing in 1 teaspoon of water if it is too thick to distribute evenly. Sprinkle with sea salt, garnish with the cilantro, and serve alongside toast or tortillas.

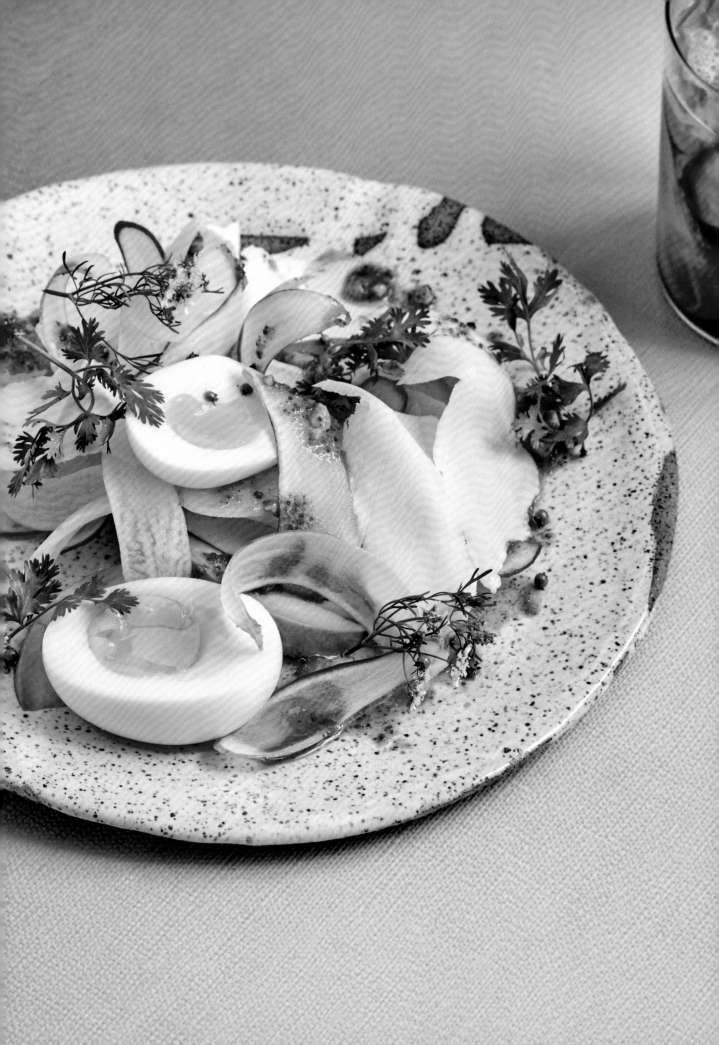

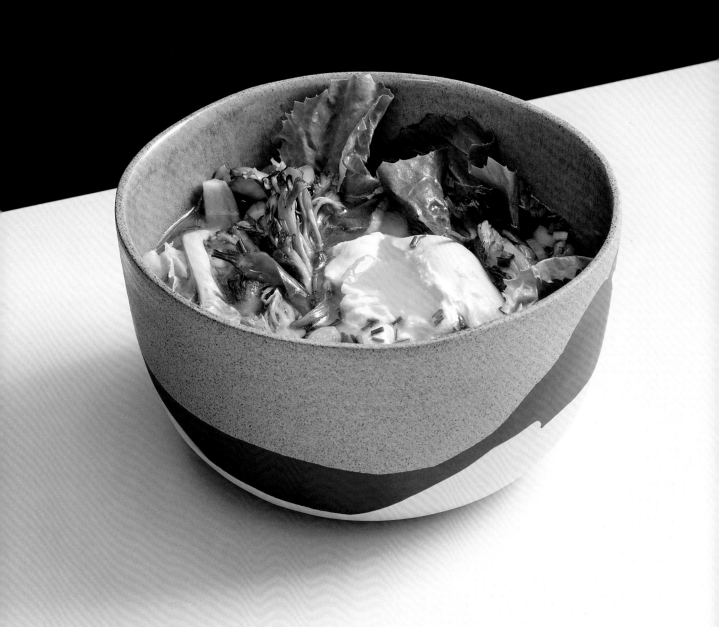

In the cold winter months, nothing gets me out of bed like an egg poached in warm stock. It is a breakfast that keeps me satisfied (at least until lunch). I love to use the heart of escarole for salad, but that leaves half of the head unused. The sturdier outer leaves are perfect for this soup—a big pile of them placed in the bowl and drowned in flavorful broth. If you don't have escarole on hand, make efficient use of any dark leafy greens that might be only *just* past their stand-alone salad prime—beet greens, Swiss chard, lacinato kale, or spinach.

If you have the stock premade, this does not take any longer than eggs on toast. If you do not have homemade stock on hand, try to buy some from the butcher or an upscale grocer. If you must, use the shelf-stable stock, but be sure to look for low sodium or unsalted, or you will have to reduce the amount of miso in the recipe so it does not turn out too salty.

Brothy Breakfast Soup with Maitake, Escarole, and a Poached Egg

1. Heat the oil in a medium saucepan over medium heat. Add the leek and salt and cook, reducing the heat to medium-low, stirring constantly, for 3 minutes. Grate the garlic into the pan, add the chile, and cook for 2 minutes.

2. Add the stock and miso paste, raise the heat to medium, and bring it to a low boil, then reduce the heat to a simmer. Make sure the miso is fully dissolved in the broth.

3. Add the mushrooms and simmer for 1 to 2 minutes. Using a slotted spoon, transfer the cooked maitake to a soup bowl with a slotted spoon.

1 tablespoon olive oil

¼ small leek, top and bottom trimmed, thinly sliced

¼ teaspoon kosher salt

1 small clove garlic

¼ to ½ Thai bird chile, seeded (depending on your spice tolerance)

2 cups (480 ml) unsalted homemade Chicken Stock (page 253) or vegetable stock

1 tablespoon white miso paste

2 ounces (55 g) fresh maitake (hen of the woods) or oyster mushrooms, torn into bite-size pieces

1 large egg

1 cup (40 g) escarole, torn into bite-size pieces

Minced fresh chives

Thick, crusty toast

4. Gently crack the egg into the soup, lower the heat, cover, and simmer for 3 minutes, until the whites solidify and the egg is soft-poached.

5. Place the escarole in the soup bowl and pour the soup on top. Garnish with chives and serve with toast.

Styrian black pumpkin seed oil has been part of the Austrian pantry since the eighteenth century, and now I know why. The first time I served it, I thought a riot would break out. An Austrian friend brought back one bottle from her trip back home, and with a loaf of bread on the table, there was no way 16 ounces (480 ml) would meet the demand. The entire bottle of oil was tapped within the hour; we begged for more, blindsided by the deep green color and the viscous pumpkin seed essence.

Don't bother looking for this at the store, just go ahead and buy it online. And trust me, it's worth the $20. It is toasty and nutty, sweet and rich. Topped with a light herb salad, this is the best accompaniment to a poached egg. Look for tender young parsley for the salad, as the leaves will be less toothsome and milder in flavor. I also love black or chocolate mint in this salad, but conventional peppermint works well too. And if you are looking for an easy dessert, drizzle a tablespoon of the oil over a scoop of vanilla ice cream and don't look back.

Toast with Styrian Black Pumpkin Seed Oil and Parsley Mint Salad

1. Wash the parsley and mint and spin or pat them dry.

2. In a medium bowl, whisk together the vinegar and oil until the oil is emulsified. Toss the herbs with the dressing and season with salt and pepper.

2 cups (100 g) young flat-leaf parsley leaves

1 tablespoon young black mint leaves or torn peppermint

1 teaspoon sherry vinegar

1 tablespoon olive oil

Sea salt and freshly ground black pepper

1 loaf miche or other crusty bread, cut into slices 2 inches (5 cm) thick, lightly toasted or grilled

Styrian black pumpkin seed oil

3. Arrange the toast on a platter or large cutting board and drizzle it generously with the pumpkin seed oil. Top with the herb salad and serve.

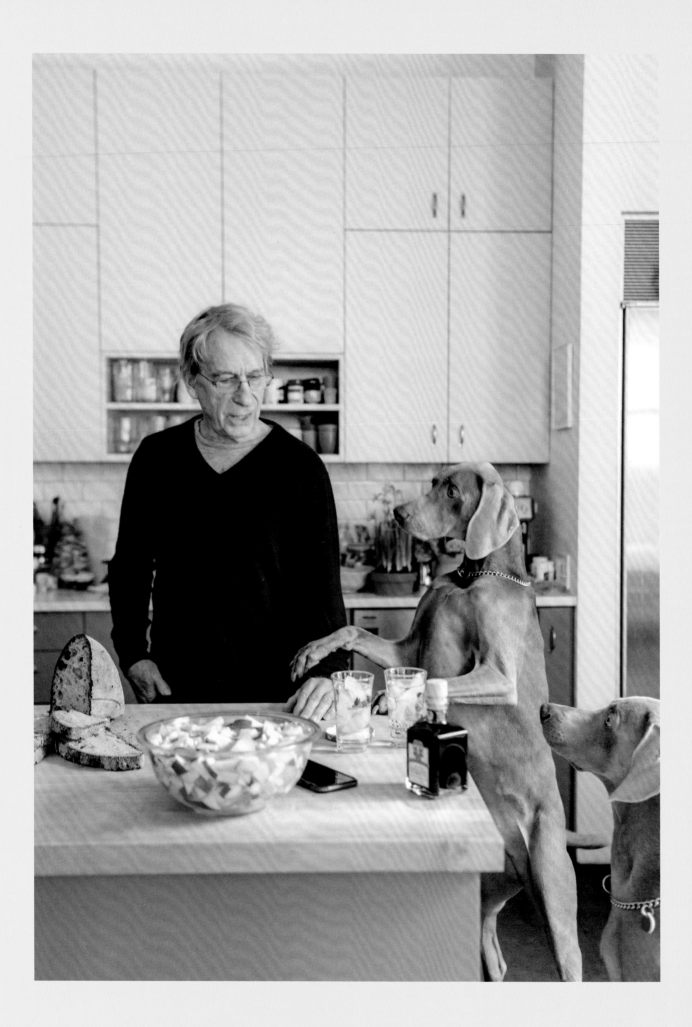

William Wegman

Occupation: Mixed-media artist
Location: New York City
Salad: Charoset: Toast with Minced Apple, Concord Grape Juice Poached Figs, Pecans, and Balsamic Drizzle (page 28)

If you are not a dog person, you might want to skip the following interview. For the animal lovers in the crowd, William Wegman requires no introduction. Wegman has made a forty year career of collaboration with his famed Weimaraners—from seminal video art to coffee table books, museum exhibitions, and fashion ads. When I was a child, Wegman captured my imagination when his dogs appeared on Sesame Street, their stoic faces popping out of human costumes, their proportions and movements uncanny as they performed domestic tasks such as baking bread and preparing a meal. Of course, the kindergarten me would not have put it in these terms, but watching those episodes now, I see the world presented as a stage with all of us actors playing our assigned roles to the best of our abilities—and with varying degrees of success. When dogs behave like humans, our own social conventions suddenly appear absurd.

As an adult, I discovered that Wegman had not only created my favorite childhood books and TV segments, but he also made some of my favorite experimental video art. Similar to the Sesame Street videos, the dogs were his subjects, only without the elaborate sets and costumes. In one early video, he and his first dog, Man Ray, share a desk. Wegman addresses Man Ray as he would a pupil or a son, correcting his answers on a spelling test and explaining the concept of the homonym. Where Man Ray falls short on language, his laser beam gaze and connection with Wegman is far more palpable than that of any human I've met. Wegman's pared-down experiments on camera seem to say more about the limitations of the human condition than they do about the capacity of his particular pets (who are remarkably adept at their jobs).

Wegman and his wife, Christine Burgin, a brilliant independent publisher and curator, now live with Man Ray's cousins Flo and Topper. The two Weimaraners continue to inspire and appear in Wegman's work.

What impresses me most about Wegman is the breadth of his career and his lasting ability to do exactly what he loves while speaking to such varied audiences. You will be happy to know that his success with the dogs has not curtailed his creative freedom. He is grateful to have made a sustainable career as a photographer, but these days you can find him in his painting studio. He has returned to the medium that first piqued his interest in the arts as a child. When Wegman is not painting, he is playing hockey or biking along the West Side Highway with Flo and Topper. Wegman is working on increasing his daily intake of leafy greens (he is not a huge fan of leafy greens, hence the nut-and-fruit-based recipe we made here), but other than that, this guy has it all figured out.

Wegman's dogs Flo and Topper in their costume and prop closet.

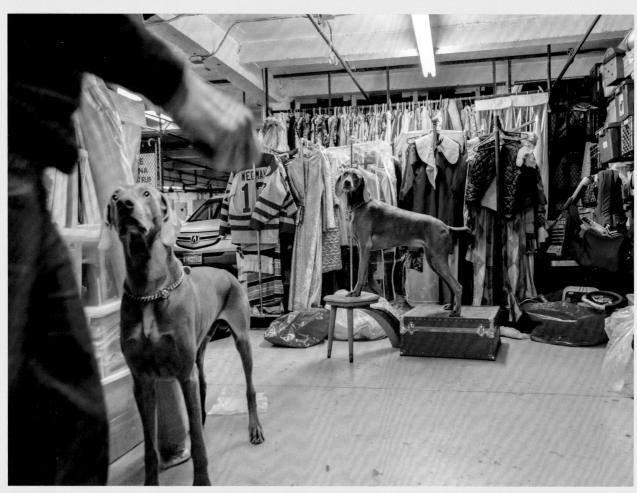

Julia Sherman: Oh my god. The dogs are up on the counter!

William Wegman: Oh yes, Flo will help.

Christine Burgin: Be careful, you might slip in the most enormous puddle of drool.

WW: Yeah, lots of drool.

JS: Oh really?

CB: Yeah, the more food we make, the more the drool piles up, and then at some point you just go, "Wh-o-o-o-ps!"

JS: The dogs are very different than I expected; I thought they would be so well behaved, but they are unruly! I'm wondering if there are other things that people don't understand about your process, or if there is something that you wish they knew?

WW: Well, I've had ten dogs since 1970, and although they were all Weimaraners, they were all very different in wonderful ways. I try to exploit their individual characteristics, but not abuse them. If one of the dogs doesn't want to do something, I never force him. The dogs have real particularities, and that's a big part of the work.

JS: Oh yeah? Such as?

WW: Fay was really odd, so I worked with her quirks, not against them. She hated to be close to metal objects. If I wanted her to look like she had an aversion to something, I would just put her near something metal. She was also very sensitive to noise. Walking her down the gauntlet from our house to the Polaroid studio was torture for her—she would start foaming, and spitting, thrashing like a helicopter that had just been shot down. Then once we got there and went inside, she was magnificent. She had this fragility, but she was one of the strongest dogs ever. In contrast, Batty was a very drapable dog; I could fold her right over any object as if she were a blanket.

JS: So, it's a material practice in some ways?

WW: Yeah, when I'm in the studio, I pick these dogs up like clay, like I'm molding them in certain ways, but the clay has specific characteristics and different formulas that I cannot change.

JS: I have always found that a fruitful collaboration can only happen when everyone is equally invested. I didn't realize how much the dogs want to pose and perform until we went into your costume closet. They begged for it.

WW: Yeah, if I had to force them, I wouldn't have been able to do this for forty-five years, or however long I've been doing it.

JS: Was there one "aha" moment when you started working with the dogs, a moment when you knew this subject would sustain you for a lifetime?

WW: One day I took the dogs to the studio to take their picture. The camera was oriented vertically, so I brought Fay Ray up to the level of the lens by placing her on a little table. I threw some fabric over her shoulders, and Andrea, my assistant, went to steady her. It looked like Fay had Andrea's arms, and that's what gave me the idea of portraying the dogs as sort of mythical hybrid characters.

JS: Your art videos, and the Sesame Street videos for that matter, say more about human relationships than they do about the dogs.

WW: When I cast the dogs in human roles, I'm saying something about all of us. It's hard to explain, but when stand-ins for humans do human activities, the actions resonate in a whole different way. The work is about something bigger than any one individual.

JS: Have you ever taken pictures of humans, or have you only ever worked with dogs?

WW: I've photographed people now and then— poor Steve Martin a couple of times and Mick Jagger. I'm not good at it, but it's kind of interesting. I have no problem talking to the dogs and asking them to do things, but I'm hesitant to direct another person. When I photographed Mick Jagger, I tried to portray him as the opposite of his normal persona. I asked him to put on a cardigan sweater, and he said, "I'm not going do that."

JS: [Laughs.]

WW: I wouldn't have had any problems getting Fay to put on that cardigan sweater, and I wouldn't have felt bad about it either.

JS: People are far more judgmental than dogs!

25

I am wondering what it is about your work that allows it to transition so well from one context to another. It's really rare to see an artist's work used commercially without any compromise.

WW: Well, when I do editorial or so-called commercial work, I *don't* compromise. The client doesn't even expect me to behave. Unlike a lot of visual artists, I actually like getting suggestions from the audience, similar to a stand-up comic—it's good to get outside of myself sometimes.

JS: Do you think you will ever make more children's books?

WW: I got tired of being a children's book author. I will make more books eventually, but I'm glad I'm not making them right now. You have to go to conferences and book signings, share the stage with other authors, and all of that. It's all great, but I don't identify as a "dog person," or a "children's book author." I love dogs, I love children's books, but I'm not comfortable subscribing to these categories.

JS: Is "artist" one of the categories to which you easily subscribe?

WW: I'm happy being an artist. You know, I would have loved to be a hockey player. It's pretty rare to be a pro hockey player, but it's even more unusual these days to be an artist that anyone has heard of. I'm quite lucky to have found an audience; it's amazing.

Wegman in his painting studio in his Chelsea home.

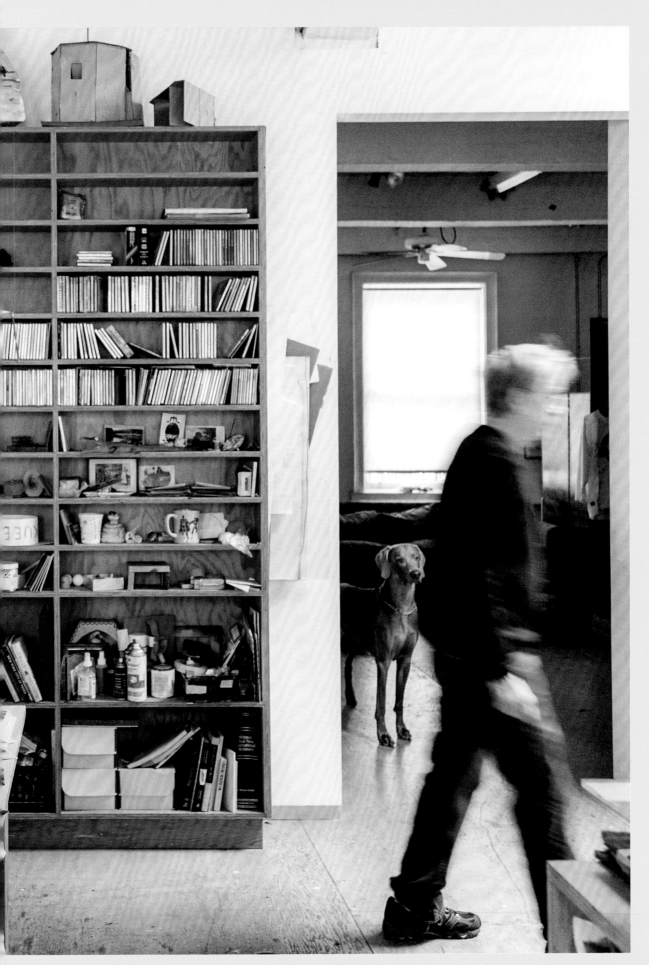

Charoset (pronounced "ha-row-set") is by far the best part of the Passover Seder plate, and not just because the other options include a lamb shank bone and curly parsley. This sweet and nutty topping for matzoh is, like most things involved in this holiday, interpreted differently in every home. But the best part for me is always the sweetness of the apple and nut mixture, contrasted with the nasal spice of fresh horseradish root. And because I encourage you to eat this year-round, we are serving it on a big piece of toasted bread. It gets a little messy, so serve this with a fork, and guests can scoop fallen charoset back onto their toast.

The best way to incorporate fresh ginger and horseradish into a dish is to grate them on a Microplane. Make sure you go against the grain to achieve a fine pulp instead of fibrous chunks (both horseradish and ginger grain run lengthwise, so you should grate in the direction perpendicular to the way the fibers are arranged).

William Wegman's Charoset: Toast with Minced Apple, Concord Grape Juice Poached Figs, Pecans, and Balsamic Drizzle

1. Preheat the oven to 350°F (175°C). Spread the pecans on a baking sheet and toss with 1 teaspoon of the oil and a pinch of salt. Toast in the oven for 8 to 10 minutes, until fragrant and toasty. Leave the oven on.

2. While the pecans are toasting, put the lemon juice into a large bowl and add the ginger and half of the tangerine zest. Add the apple and toss with the remaining 1 tablespoon plus 1 teaspoon oil.

3. Add the pecans to the bowl and stir to combine.

4. Crush the cardamom seeds with a mortar and pestle into a coarse dust. In a small saucepan, combine the figs, dates, grape juice, and cardamom and cook over medium heat until the fruit has absorbed most of the liquid, 5 to 7 minutes. Add to the apples and stir to combine.

1¼ cups (125 g) pecan halves, finely chopped

2 teaspoons plus 1 tablespoon olive oil, plus more for drizzling

Sea salt

Juice of ½ lemon

2 teaspoons grated fresh ginger

Grated zest of 1 tangerine

1 crisp sweet apple such as Fuji or Gala, cored and minced

Seeds from 3 green cardamom pods

4 dried Calimyrna figs, coarsely chopped

2 Medjool dates, coarsely chopped

6 tablespoons (90 ml) unsweetened Concord grape juice (not from concentrate), or Beaujolais wine

1 loaf miche (French sourdough) or your favorite bakery bread

Ground cinnamon

Fresh horseradish root, peeled and thinly shaved with a vegetable peeler

Extra-fancy balsamic vinegar

Freshly ground black pepper

5. Cut the bread into slices about ½ inch (12 mm) thick. Arrange on the baking sheet, drizzle with oil, and put them in the oven until lightly toasted, about 5 minutes.

6. Arrange the toast on a serving platter. Spoon the charoset onto each piece and sprinkle with cinnamon, salt, and the remaining tangerine zest, and shave horseradish over the top. Drizzle generously with vinegar, season lightly with pepper, and serve with forks.

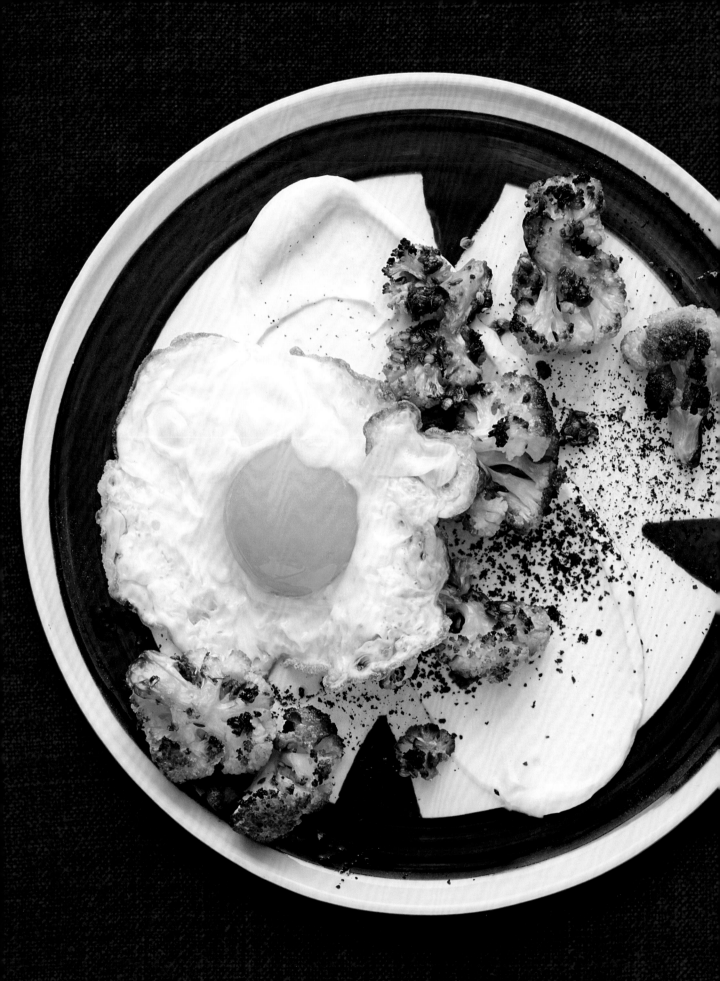

Serves
4

Prep Time
35 minutes
active

4 hours
passive

Here is the trick for evenly browned, golden roasted cauliflower: Marinate it in spices and a generous amount of olive oil for at least four hours prior to cooking. This allows the oil to be absorbed, instead of resting on top of the uneven surface of the florets. Marinate the cauliflower the night before your brunch, and all you will have to do when you wake up is fire up the oven and toss it in.

Labneh is a thick Middle Eastern strained yogurt cheese that is tangy and mega-creamy. You can buy it, or make your own the night before, while you are prepping the cauliflower and flexing your planning skills. Line a fine-mesh sieve with two layers of cheesecloth, dump 1 cup (240 ml) plain cow's, sheep's, or goat's milk yogurt inside. Cover the yogurt with plastic wrap, and set the strainer over a small bowl in the fridge. The excess whey will seep out overnight, and you will wake up to a delightfully thick, concentrated labneh in the morning.

Golden Coriander Cauliflower with Labneh and a Fried Egg

1. Do ahead: Separate the cauliflower into florets and toss them into a large re-sealable plastic bag or a mixing bowl.

2. In a small, dry skillet over low heat, toast the coriander and cumin seeds until fragrant, about 3 minutes. Transfer them to a mortar and pestle and pound until entirely crushed. Add the garlic, salt, lemon zest, thyme, and red pepper flakes and continue crushing until combined. Add the olive oil and whisk to combine. Pour the spice-and-oil mixture over the cauliflower in the plastic bag, stir to distribute the oil and seasoning evenly, seal, and refrigerate for 4 to 24 hours.

3. Place a rimmed baking sheet in the oven and preheat it to 450°F (230°C).

4. Spread the cauliflower on the baking sheet in a single layer and roast it for about 25 minutes, until golden brown.

1 large head cauliflower, leaves and stalk trimmed

1¾ teaspoons coriander seeds

1 teaspoon cumin seeds

2 cloves garlic, chopped

1 teaspoon kosher salt, plus more for the eggs

Grated zest of 1 lemon

1 teaspoon fresh thyme leaves

¾ teaspoon red pepper flakes

¼ cup plus 1 tablespoon (75 ml) high-quality extra-virgin olive oil

¼ cup (60 ml) labneh or full-fat Greek yogurt

Ground sumac

1 to 2 teaspoons grapeseed oil

4 large eggs

Freshly ground black pepper

5. While the cauliflower is roasting, put 1 tablespoon of the labneh on each plate, shmearing it across the surface of the plate with the back of a soup spoon. Sprinkle each plate with a generous pinch of sumac (it will look pretty dusting the labneh and the plate itself). When the cauliflower is nicely browned and crispy on the edges, remove it from the oven and spoon some onto each plate.

6. Heat a 12-inch (30.5-cm) cast-iron skillet over medium heat and add the grapeseed oil. Swirl to evenly coat the surface. Crack two eggs into the pan and cook without moving them for 1 minute, then cover the pan and cook for an additional 2 to 3 minutes, or until the whites are solid but the yolks remain bright yellow and glossy. Transfer the fried eggs to the plates and season with salt and pepper. Repeat with the remaining two eggs, adding more oil if needed. Serve hot.

When I first tried the beloved late-night party dish *okonomiyaki* in Osaka, I couldn't help but want to make it more salad-y. I know, leave it to me to pervert Japan's favorite junk food. Traditionally cooked on a *teppanyaki* (flat-top griddle), the cabbage is cooked in the pancake, which is then topped with bonito flakes (yum), Japanese mayo, and a saccharine-sweet BBQ sauce (less yum). In my version, we keep the cabbage fresh, tossed in a spicy mayo dressing, and pile it on top of the pancake, skipping the BBQ sauce altogether. Okay, so the result is nothing like *okonomiyaki*, but now you know the provenance of your breakfast.

Japanese Green Onion Pancake with Spicy Cabbage Slaw

1. Make the pancake batter: In a medium bowl, combine the flours and salt, then add the dashi, tamari, and eggs and whisk until all the lumps disappear. It should be the consistency of thin, smooth yogurt; whisk in a little more rice flour if needed. Add the scallions and set the batter aside.

2. Make the cabbage slaw: In a salad bowl, combine the mayonnaise, Sriracha, lime juice, oil, and garlic and whisk to combine completely. Add the cabbage to the bowl and toss to coat. Season with sea salt.

3. Preheat the oven to 200°F (90°C).

For the pancakes

½ cup (65 g) all-purpose flour

½ cup (60 g) rice flour, or more if needed

¼ teaspoon kosher salt

¾ cup (180 ml) dashi or low-sodium chicken stock

4 teaspoons tamari, plus more for dipping

2 large eggs, beaten

1 cup (55 g) sliced scallions (¼-inch/6-mm slices)

Grapeseed or coconut oil

1 teaspoon tiny freeze-dried shrimp (optional)

¼ cup (5 g) bonito flakes

For the cabbage slaw

1 tablespoon mayonnaise or full-fat Greek yogurt for the mayo-averse

2 teaspoons Sriracha sauce

1 tablespoon fresh lime juice

1 tablespoon extra-virgin olive oil

¼ teaspoon minced garlic

¼ green cabbage (about 250 g), cored and thinly sliced on a mandoline

½ teaspoon sea salt

4. Heat a medium sauté pan or cast-iron skillet over medium heat with 1 teaspoon grapeseed oil until it is shimmering. Stir the pancake batter and pour one ladleful into the pan. If using freeze-dried shrimp, sprinkle a few of them onto the pancake while it is still runny. Cook on the first side until golden brown, about 5 minutes. Flip the pancake and cook on the second side for 3 to 5 minutes, until golden brown. Transfer the cooked pancake to a baking sheet and pop it into the oven to keep warm while you prepare the remaining pancakes, adding ½ teaspoon oil to the pan each time.

5. When all the pancakes are finished, remove them from the oven to individual plates. Top each with a generous pinch of bonito flakes, and serve each one with cabbage slaw piled on top and extra tamari on the side for dipping.

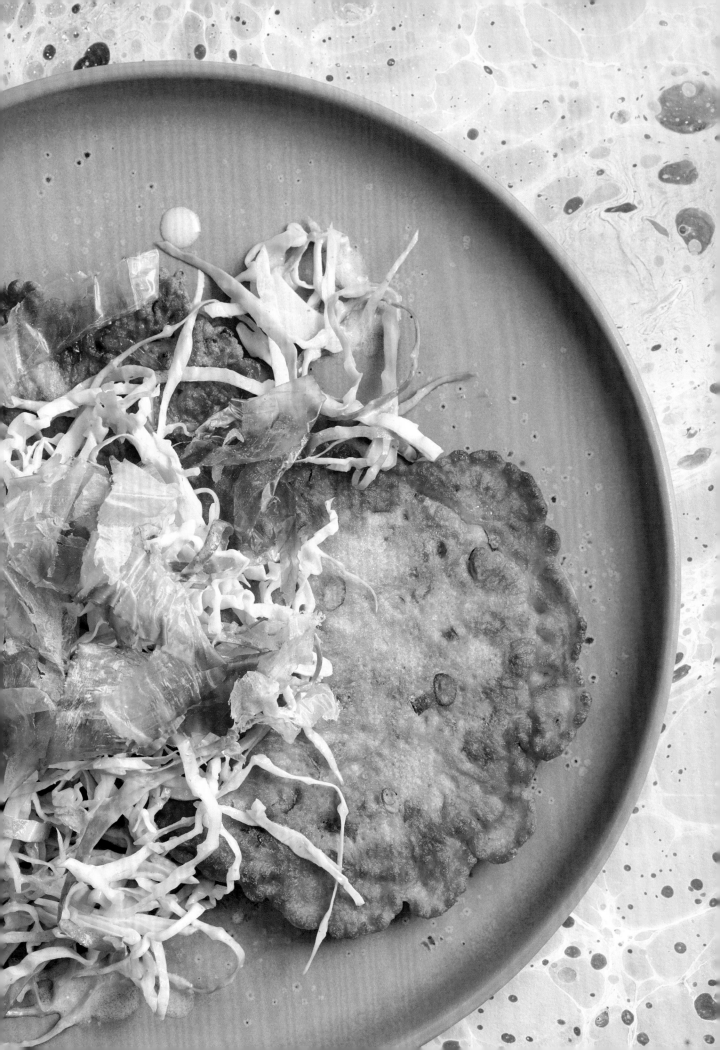

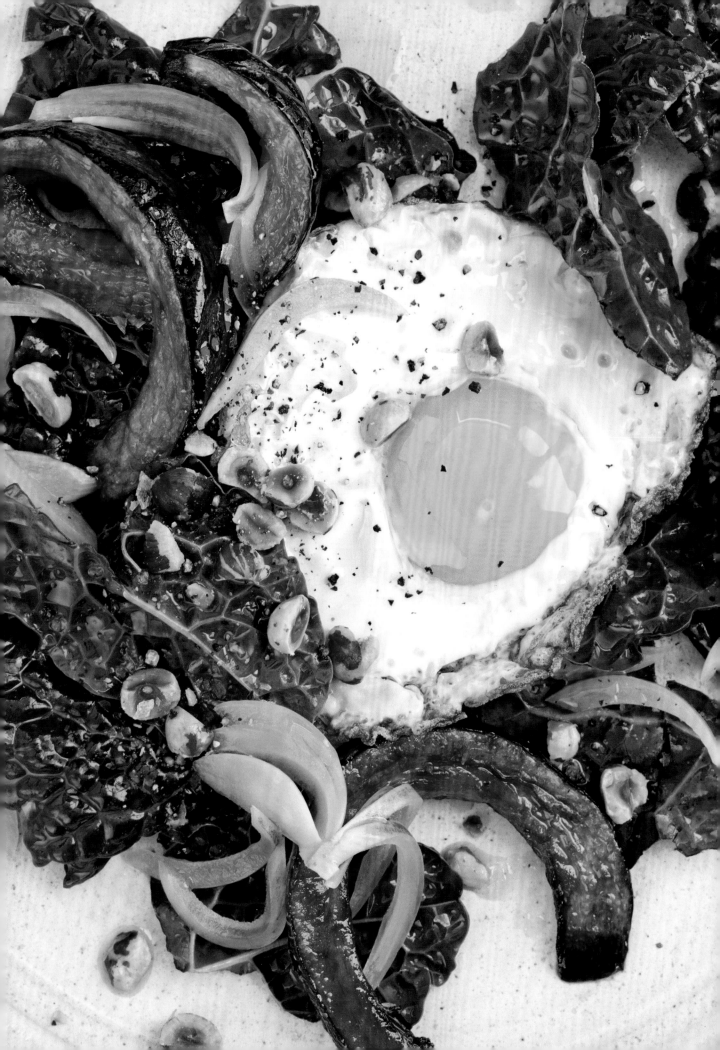

Serves
4

Prep Time
45 minutes

This salad, shared with me by actress Hayley Magnus and bookstore owner/creative director David Kramer, fares well for lunch, dinner, or brunch, but topped with a fried egg, it's a meal that can carry you through the day. If you are of the vegan persuasion, jettison the ghee, the feta, and the egg and you will still have yourself a rich main-course salad.

Kuri squash might be less common in your local market, but it's a great one to try if it is mid-winter and you have had your fill of run-of-the-mill squash. It is not as sweet as its brethren, so if you are playing it safe and subbing in the classic butternut here, cut the maple syrup down to 1 tablespoon (or even less).

Lacinato Kale, Roasted Kuri Squash, Hazelnuts, and Marjoram Salad

1. Preheat the oven to 400°F (205°C). Position a rack in the top third of the oven.

2. In a medium bowl, whisk together 2 tablespoons of the olive oil, the ghee, maple syrup, and lemon juice. Add the squash and toss to evenly coat. Season with salt and pepper and sprinkle with 1 teaspoon of the marjoram. Spread the squash on a baking sheet and roast for 20 minutes. Flip the squash slices over and roast until they are soft and golden brown, about 15 minutes longer. Set aside.

3. Put the hazelnuts in a small ovenproof pan and drizzle with 1 teaspoon of the olive oil. Place in the oven on the lower rack. Toast until light brown and fragrant, about 10 minutes. Let cool and roughly chop.

4. While the squash and nuts are in the oven, remove and discard the center ribs and stems from the kale. Tear the kale leaves into bite-size pieces and massage the leaves with the remaining 1 tablespoon

3 tablespoons plus 1 teaspoon olive oil

1 teaspoon ghee, melted

1 to 2 tablespoons maple syrup

1 tablespoon fresh lemon juice

1 red kuri or other winter squash, halved, seeded, and cut into ¾-inch (2-cm) slices (no need to peel if using kuri)

Sea salt and cracked black pepper

2 teaspoons fresh marjoram leaves

½ cup (70 g) peeled hazelnuts

2 bunches (approximately 10 ounces, 280 grams) lacinato kale

1 teaspoon salt, plus more to taste

1 tablespoon sherry vinegar

¼ cup (40 g) crumbled feta cheese (optional)

1 tablespoon Pickled Red Onions (page 255)

1 to 2 teaspoons grapeseed oil

4 large organic eggs

olive oil, 1 teaspoon salt, and the sherry vinegar. Add the cheese, if using, and toss to thoroughly distribute.

5. Arrange a large handful of kale on each serving plate and top each with squash, hazelnuts, and a few slices of pickled onion.

6. Heat a 12-inch (30.5-cm) cast-iron skillet over medium heat and add 1 teaspoon of the grapeseed oil. Swirl to evenly coat the surface. Crack two eggs into the pan and cook without moving them for 1 minute, then cover the skillet and cook for an additional 2 to 3 minutes, or until the whites are solid but the yolks remain bright yellow and glossy. Transfer each egg to a salad. Repeat with the remaining two eggs, adding more oil to the skillet if needed.

7. Season the salads with cracked black pepper and a pinch of salt. Scatter the remaining 1 teaspoon marjoram over the top and serve.

This recipe pairs well with eggs and toast, and it adds an unexpected shock of color to the brunch table. Pea tendrils and sunflower shoots are the first signs of spring in the farmers' market. If you can't find sunflower shoots, use more readily available pea shoots alone. The horseradish adds a kick, but make sure you use the fresh root as opposed to bottled, prepared horseradish. Horseradish from a jar is packed in vinegar and salt and will bulldoze the light crème fraîche here; the fine shavings recommended are spicy but not sharp.

Your guests will spoon up the dressing from underneath the salad as they serve themselves. This is a great way to pair a rich dressing with delicate greens, while avoiding wilting and sogginess, a trick that can be applied to other recipes as well.

Watermelon Radishes and Spring Shoots on a Crème Fraîche Puddle

1. Make the dressing: In a large, shallow serving bowl, whisk together all the ingredients for the dressing, season with salt and pepper, and tilt the bowl in a circular motion to completely coat the sides with dressing.

2. Make the salad: Wash the sunflower shoots and pea tendrils and spin them dry, then gently toss with the oil and sprinkle with salt and pepper.

For the dressing

3 tablespoons extra-virgin olive oil

3 tablespoons crème fraîche

1 tablespoon sherry vinegar

Juice of ½ lemon

1 small shallot, minced

½ teaspoon honey

1 teaspoon Dijon mustard

Salt and freshly ground
black pepper

For the salad

3 to 4 cups (3½ ounces/100 g)
mixed sunflower shoots
and pea tendrils

1 teaspoon olive oil

Sea salt and freshly ground
black pepper

1 to 2 small watermelon radishes,
trimmed, peeled, thinly sliced

1 tablespoon chopped fresh dill

1 teaspoon Pickled Mustard Seeds
(page 259)

1 teaspoon finely grated fresh
horseradish

3. Assemble the shoots and tendrils and the radish slices on top of the dressing puddle; scatter the dill and pickled mustard seeds over the salad. Grate the horseradish on top and serve.

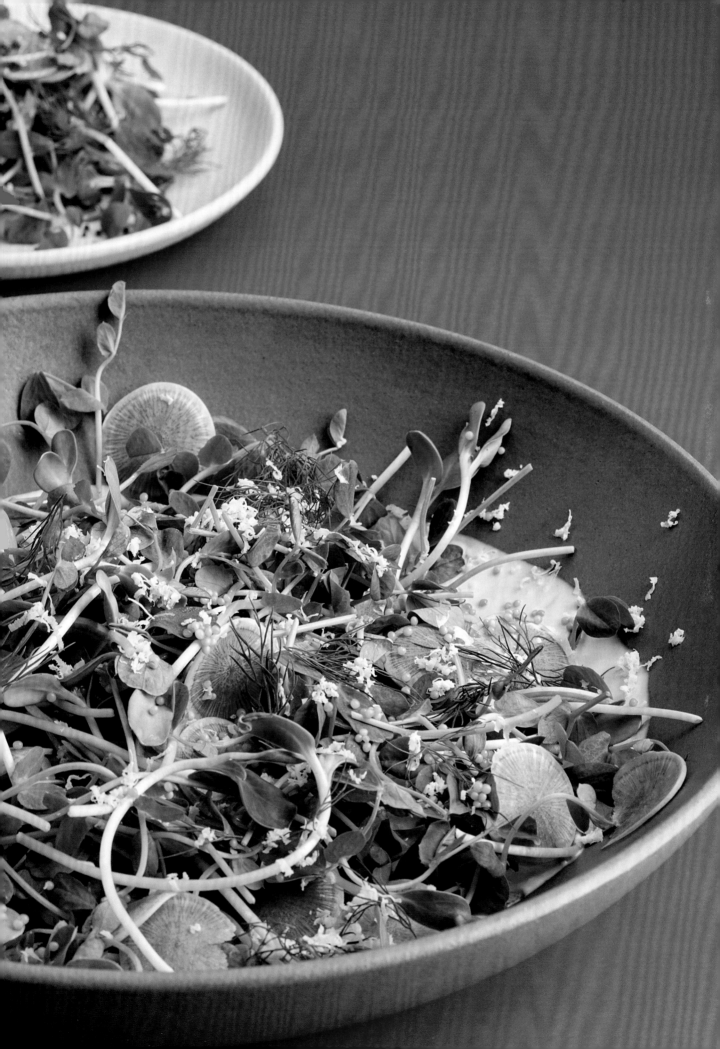

Salad in Sweatpants: Casual Meals for People Who Already Love You

Keeps well in the fridge; makes great leftovers

Comfort food

Makes use of pantry staples; not dependent on items from specialty market

The moment I return home, I drop my pants. Don't worry, I put on another pair. For better or worse, that anointed pair are drop-crotch sweatpants. They are stylish but well-worn, vaguely Japanese, and therefore passable in public. I wear these comfortable pants in the kitchen, in the garden, and sometimes to bed (I'm not proud of that). My husband and my inner circle of friends know them well. These are the people who already love me, dressed up or dressed down.

The salads in this chapter are the comfortable sweatpants of my culinary repertoire. They are straight-up craveable, made with the basics (grains, canned and dried goods), or every-day ingredients available at your local supermarket. They will make you feel healthy and well taken care of without too much work. They can serve as a reasonable midweek meal or a welcome desk lunch packed the night before.

This is salad as comfort food—eat it out of a to-go container or a mixing bowl, pants or no pants—it's what's on the inside that counts.

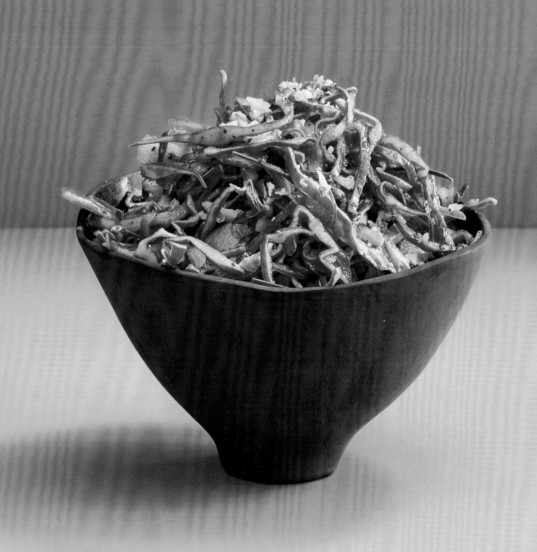

Pomegranate molasses is a thick syrup made from a reduction of pure pomegranate juice and lemon juice. It is a staple in the Middle Eastern kitchen. Stewed with lamb and drizzled on roasted vegetables, the unsweetened stuff is wonderfully tart, like dried cherries in gooey liquid form. Pomegranate syrup can be found in the international foods aisle of most large grocery stores or at any Middle Eastern grocer. The best part is that a bottle will only set you back about $4, so experiment with it, drizzle it on yogurt or oatmeal, or add it to marinades or soda water.

When slicing cabbage for this salad, the goal is to get it paper thin, creating a light and fluffy effect rather than a dense pile. Serve alongside roasted chicken to make a satisfying and simple meal.

Shaved Red Cabbage with Pomegranate Molasses, Sumac, and Crumbled Walnuts

1. Make the dressing: In a large bowl, combine the pomegranate molasses, vinegar, sumac, mint, and salt and whisk to dissolve the salt. Add the oil in a slow stream and whisk until emulsified.

For the dressing

2 teaspoons unsweetened pomegranate molasses

1 tablespoon red wine vinegar

2 teaspoons ground sumac

¼ teaspoon dried mint

1 teaspoon sea salt

1 tablespoon olive oil

For the salad

3 cups (280 g) thinly shaved red cabbage, sliced on a mandoline

3 tablespoons finely chopped toasted walnuts

2. Make the salad: Add the cabbage and walnuts to the dressing and toss to combine. Season with more salt if needed and serve.

Morocco produces hundreds of varieties of olives, but the standout for me is the dry black olive. Slowly cured in salt, not brine, and coated with olive oil, a Moroccan olive might look like a tiny prune, but it is actually a savory flavor grenade. A little goes a long way to season the farro and fennel in this dish.

This salad is more tart than most of my recipes, as I tend to think of farro as a neutral base that can take more seasoning than you would think. If you know your palate tends to shy away from citrus or acidity, reserve half of the lemons to squeeze over the salad at the end, tasting it first to gauge the intensity.

Pack this salad for lunch, a picnic, or air travel. It only gets better with time.

Tangy Farro Salad with Moroccan Cured Olives, Lemon Zest, and Fennel

1. Make the farro: Rinse the farro in a sieve under cold water. In a large pot, bring the broth, oil, and kosher salt to a boil, then add the farro. Lower the heat to a simmer and cook uncovered until the farro is tender, about 20 minutes. If foam appears on the surface of the cooking liquid, skim the surface. Drain the farro (reserving the broth for future use). Put the farro in a salad bowl and set it aside to cool.

2. Make the salad: While the farro is cooling, put the fennel seeds in a small skillet and toast them over medium heat until fragrant, about 2 minutes. Transfer them to a mortar and pestle and crush until they are the texture of coarse sand. Add the olives, red pepper flakes, lemon zest and juice, garlic, and olive oil. Using a fork or the pestle, mix to combine, smashing the olives. Toss the olive mixture with the farro and set aside.

For the farro

2 cups (400 g) farro

5 cups (1.2 L) chicken broth

2 tablespoons olive oil (or chicken fat if using homemade broth)

1 teaspoon kosher salt

For the salad

1 teaspoon fennel seeds

½ cup (75 g) coarsely chopped oil-cured olives

1 teaspoon red pepper flakes

Grated zest and juice of 2 lemons

1 large clove garlic, grated

6 tablespoons (90 ml) extra-virgin olive oil

2 large fennel bulbs

Sea salt

3. Trim the top and bottom from the fennel bulbs, reserving any fronds for garnish. Slice each bulb in half lengthwise and then crosswise as thinly as possible on a mandoline or with a very sharp knife. Add to the farro and toss.

4. Season the salad with salt to taste and garnish with the torn fennel fronds.

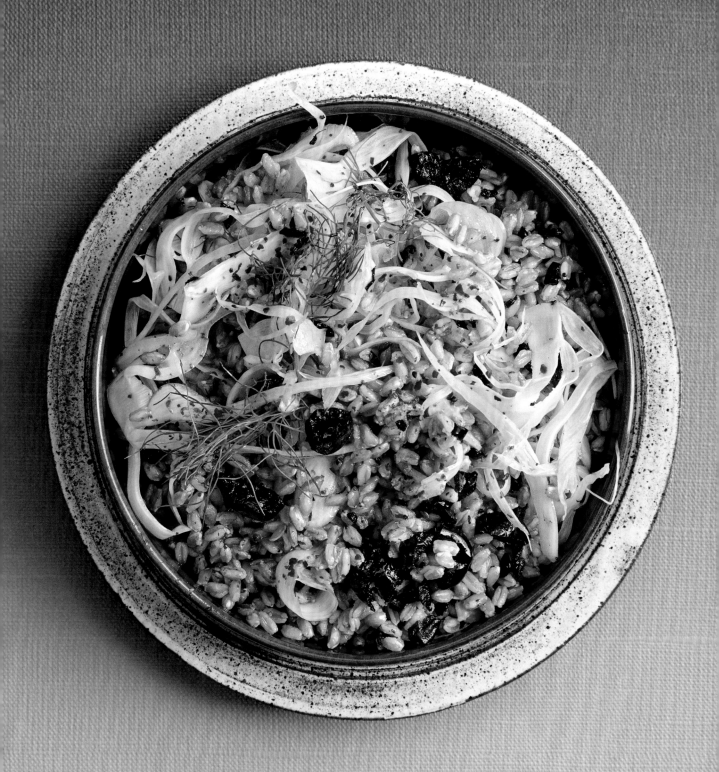

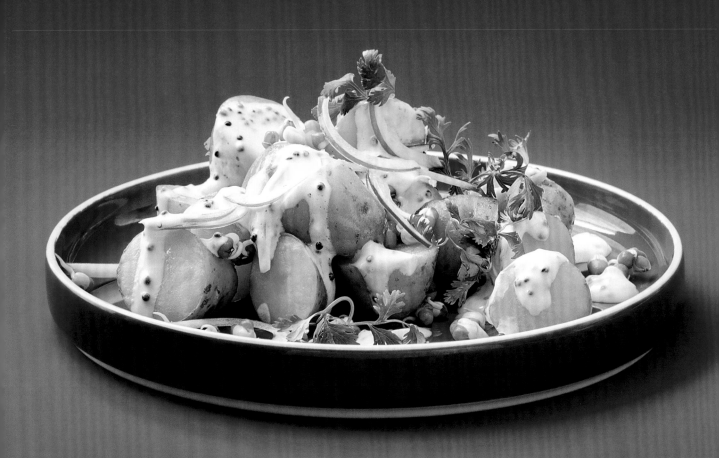

Serves
4

Prep Time
30 minutes

I love the idea of the classic potato salad. Tossed in mayo and sturdy enough to travel to a picnic, it is a real democratic crowd pleaser. But this is not that kind of salad book.

This recipe is my style of potato salad: Tangy with rich yogurt, crunchy with sprouted mung beans, bright with cilantro and red onion. Fried black mustard seeds, a staple in Indian cooking, taste like toasty popcorn with a slightly bitter, mustard aftertaste. They are one of my favorite spice additions, worth exploring on top of steamed rice and as a garnish on soups.

With a little planning, you can easily and affordably sprout your own beans, using a simple glass jar and a clean kitchen rag or cheesecloth (see Note). If you are short on time, you can find a sprouted legume mix at most supermarkets and health food stores (and if you can't, this salad will still be delicious with the potatoes and dressing alone).

Potato Salad with Sprouted Mung Beans, Yogurt, and Fried Black Mustard Seeds

½ small red onion

Sea salt

½ teaspoon sugar

2 tablespoons red wine vinegar

1 pound (455 g) fingerling or Yukon gold potatoes

3 tablespoons olive oil

Freshly ground black pepper

1 cup (150 g) mung bean sprouts (optional; see Note)

2 tablespoons black mustard seeds

¼ cup (60 ml) full-fat yogurt, preferably sheep's milk

2 tablespoons fresh cilantro leaves

1. Slice the onion as thinly as possible. Put it in a medium bowl, sprinkle with ½ teaspoon salt and the sugar, add the vinegar, and press down firmly with your fingers. Set aside to lightly pickle.

2. Put the potatoes and 1 teaspoon salt in a medium saucepan and add cold water to cover by 1 inch (2.5 cm). Bring the water to a rolling boil over high heat, then lower the heat to medium and cook for 15 minutes, or until the potatoes are fork tender. Drain and cut them into 1-inch (2.5-cm) slices. Put them in a large bowl and drizzle with 1 tablespoon of the oil; season generously with salt and pepper and gently toss to combine, trying to keep the potatoes from falling apart. Add the mung beans and set aside.

3. Put a small pan over high heat, add the remaining 2 tablespoons oil and the mustard seeds, and cook, covered, until you hear the mustard seeds start to pop, jumping up from the pan, about 1½ minutes. Remove from the heat immediately and scrape them into the bowl with the onion. Add the yogurt and whisk to combine. Spoon the dressing over the potatoes, scatter the cilantro over the top, and serve.

Note: To make your own sprouts, put dried mung beans in a glass jar and cover them with cold water. Cover the top of the jar with a breathable cloth and secure it with a rubber band. Allow the mung beans to soak for 6 hours or overnight. Drain the water and cover the beans again with water, the cloth, and the rubber band. Rinse and drain the beans two more times over the next 24 hours or so, covering them in between and leaving them on the kitchen counter to sprout. After about two days, the mung beans should have grown little tails and have tripled in volume. Rinse once more and drain. The sprouted beans will keep in the refrigerator, tightly covered with a lid, for up to a week.

Alice Waters

Occupation: Activist, author, chef
Location: Berkeley, California
Salad: Baked Goat Cheese with Garden Lettuces (page 53),
Leftover Salad Breakfast Taco (page 53)

My favorite thing about Alice Waters is the way she eats. Just when you think dinner is over, the ethereal chef will pick up a fish carcass and nibble methodically, working until the bones are dazzlingly clean. And when she gets to her famously minimal dessert, a ripe piece of seasonal fruit, conversation comes to a halt; nothing can interfere with the sensorial experience at hand. This is a woman after my own heart.

Alice is so much more than a chef or a restaurateur—she is the figurehead of the Slow Food movement and the inspiration for generations of us who care deeply for "the art of simple food." Yet, one might argue that, had Alice not been surrounded by artists, she might not have opened a restaurant at all. It was the 1960s in Berkeley, California, and she was cooking casual dinners for some of the most influential filmmakers of the time—Godard, Coppola, Varda. Alice wasn't a trained chef. She had never even worked in a restaurant, but she found herself hosting artists, filmmakers, activists, and friends and loving it. Like so many of us, Alice wondered if her hobby might become her job.

Thus, Chez Panisse was conceived as a modest neighborhood restaurant with lofty aspirations and set menu items that cost a mere $3 and change. At Alice's restaurant, politics were seamlessly integrated with the dining experience, from tableside debates of Berkeley's free speech movement to that of the provenance of the food on diners' plates. Unbound by convention, Chez Panisse was born with a purpose and has stuck to the same message for forty-five years: Eat seasonally, know your farmer, respect the earth, and learn to cultivate food yourself.

Alice's love affair with food began in France in 1963. There she tasted garden salads, fruit off the vine, and cheese as rich in tradition as it was in taste. She wondered how she might transplant

Waters gently drying garden greens in her Berkeley, California, kitchen.

this way of life to California, where most of our country's produce was (and still is) grown, but where TV dinners had taken hold at family tables. There were no consumer-driven local farmers' markets at the time, and American farmers had reduced the variety of their crops to cater to mainstream grocery store customers. Monoculture was defining the way Americans ate and the farmers had no choice—there simply wasn't a market for the diverse produce we take for granted today.

Upon her return from France, Alice did what any vegetable-loving girl would do—she smuggled mesclun salad seeds in her luggage and enlisted local farmers to cultivate her favorite exotic garden lettuces in her own backyard. These heirloom baby greens were a trademark of the Chez Panisse menu from day one, and with time, they changed the face of salad in America forever. The most forward-thinking farmers caught wind and word spread—there was a restaurant in Berkeley that wanted your less-than-perfect organic fruit, that would buy your Pixie tangerines and exotic herbs. Alice brought the farmer to the table, proving that good food begins with excellent sourcing.

Alice swears she had no idea what she was doing when she planted the seeds of this empire forty years ago. In talking to her about her life and work, it occurs to me—maybe therein lies the lesson of it all?

Julia Sherman: Of all the people I have interviewed, you must eat the most salad.

Alice Waters: Oh yes, I even make a salad taco for breakfast. I'll sauté leftover salad from the night before, char a tortilla, and eat it hot from the stovetop, standing up.

JS: Wow, leave it to Alice Waters to outdo me on salad for breakfast. How long have you been making the mesclun and goat cheese salad you're preparing today?

AW: I've been making it since the beginning of the café, about 35 years.

JS: I know that it's been years since you've cooked in the Chez Panisse kitchen. Do you consider yourself more of a visionary than a chef?

AW: Oh, absolutely. I think of my role as that of a director. It's my job to find the right people for the performance. I love that role and I love to create the scene.

JS: That's interesting, since filmmakers have long been part of your inner circle.

AW: Oh yes. My love of film began when I was living with [director, producer, and film archivist] Tom Luddy. He was deep into the New Wave film world and was screening all of those French films of the '60s and '70s. I was fascinated by the down to earth yet rich way of life I saw on screen, and I wasn't alone. Everybody was hungry and wanted to eat. From my point of view, it all happened around the table.

JS: Why do you love working with artists? Is there something special about that exchange?

AW: I always tried to build a community where art was in the center with food. Artists are attuned to taste and to beauty, and I always wanted them to be a part of the restaurant. They will certainly be vital to furthering the idea of edible education in this country. Artists push me to do things that are more complicated, and ultimately more interesting than what I would do on my

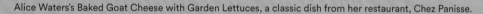

Alice Waters's Baked Goat Cheese with Garden Lettuces, a classic dish from her restaurant, Chez Panisse.

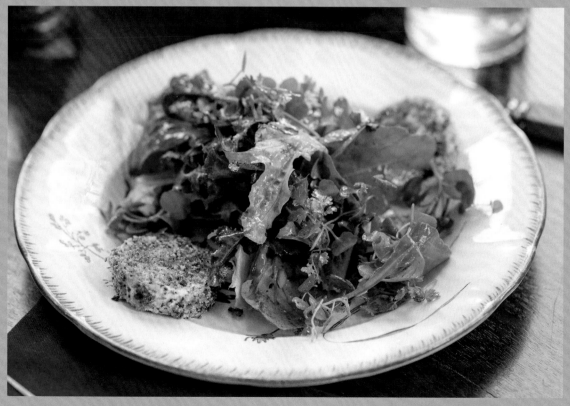

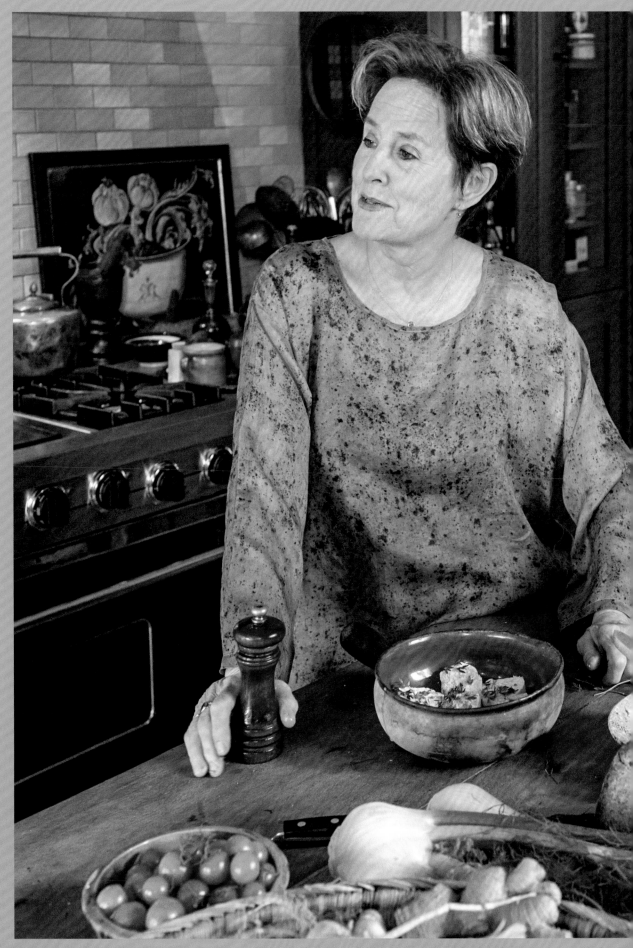

own. For example, when I worked in Vienna with [legendary theatre and opera director] Peter Sellars, the location he chose for our dinner in late November didn't have heat or electricity. We had to light the room with candles, cook in fireplaces, and reimagine the table. It was unbelievably challenging to work this way in a country whose language I didn't speak.

JS: Do you have a lot of former artists joining the staff of Chez Panisse?

AW: Yes as a matter of fact, and I'm always looking for those people. I want artists in the kitchen.

JS: Was there ever a moment where you thought about opening more restaurants?

AW: Truly never. I never imagined I would run a single restaurant!

JS: That is so refreshing to hear. These days, the moment someone makes something, their first thought is, "how can I scale-up?"

AW: Yes. I just hate the word "scalability." [Laughs.] I spend all my time thinking about how we can make this one restaurant better. Chez Panisse will always be a work in progress.

Waters prepares lunch at her kitchen island in Berkeley, California.

51

This salad broke boundaries in its time and continues to be a crowd-pleaser on the Chez Panisse menu. Make Alice proud and use the best goat cheese you can find and a seasonal array of tender local greens.

Alice Waters's Baked Goat Cheese with Garden Lettuces

1. Carefully slice the goat cheese into 8 disks, approximately ½-inch thick. Pour the olive oil over the disks so they are submerged and sprinkle with the chopped herbs. Cover and store in a cool place for several hours or up to a week.

2. Make the breadcrumbs ahead of time if possible. Break apart the baguette into small torn pieces and spread them out on a small sheet pan. Bake until the pieces are crisp and have turned a nice golden brown. When cool, put the toasted pieces in a food processor and pulse until they become fine enough to coat the disks of goat cheese. Careful not to blend them too fine! Toss the breadcrumbs with a generous pinch of salt to season.

½ pound (225 g) fresh goat cheese

1 cup (8 ounce/240 ml) high-quality extra-virgin olive oil

3 to 4 sprigs fresh thyme, leaves chopped

1 small sprig rosemary, leaves chopped

½ baguette

1 tablespoon (15 ml) red wine vinegar

1 teaspoon (5 ml) sherry vinegar

¼ cup (2 ounce/60 ml) olive oil

Kosher salt and freshly ground black pepper

½ pound (225 g) salad greens, washed and dried

3. Preheat the oven to 400°F (a toaster oven works well). Remove the cheese disks from the marinade and roll in the breadcrumbs, coating them thoroughly. Place the cheese disks on a small baking sheet and bake for 6 minutes, until the cheese is warm.

4. Add the vinegars to a small bowl and add a big pinch of salt. Whisk in olive oil and freshly ground pepper to taste. With your hands, toss the lettuces lightly with the vinaigrette, season with additional salt and pepper to taste, and arrange on salad plates. With a metal spatula, carefully transfer 2 disks of the baked cheese to each plate and serve.

This is Alice's preferred breakfast, and a smart way to make use of leftover salad that's too wilted to eat on its own. Toss those marinated greens and some avocado in a warm tortilla and you're golden.

Alice Waters's Leftover Salad Breakfast Taco

1. Toast the corn tortilla just to get it brown and sprinkle the cheese on top. Put the taco on a tray and put under the broiler or in the toaster oven until the cheese melts.

Corn Tortilla

Melting cheese

Leftover salad

1½ inch slice Hass avocado

Sea salt

Ground cumin

Ground coriander

Wedge of lime

2. Add a spoonful of salad and a slice of avocado and sprinkle with sea salt, a pinch of cumin and coriander, and a squeeze of lime, and eat immediately.

Serves
4

Prep Time
35 minutes

Sunchokes are earthy and funny looking. They have the flavor of an artichoke and the texture of a creamy potato without the starch. They have long been a favorite vegetable of mine, but just when I thought I knew all there was to know about this little tuber . . .

For a friend's wedding, I rented a house with five groomsmen and assumed the role of house-mom. On the morning of the wedding, I made a substantial breakfast to power these dudes through a marathon party. I roasted a pile of sunchokes, scrambled eggs, and tossed together an herb salad. Plates were licked clean, suits were thrown in the car, and I patted myself on the back for a job well done . . . or so I thought.

The morning after the wedding, we had a mystery to solve: Why was the entire wedding party "power-farting" through the ceremony, and into the wee hours of the night? Thirty seconds of internet research revealed sunchokes' colloquial name: "Fartichokes." And while not all of us are susceptible to a chemical found in sunchokes called inulin, it causes astounding gassiness in others. If you have eaten fartichokes before without repercussions, forge on. If this is a new vegetable in your repertoire, proceed with caution. In small quantities, most people will be unaffected. But I vowed to never again serve this vegetable without a disclaimer.

The success of this salad is in the uniform sizing of the potatoes and the sunchokes. You want them to cook at the same rate and blend together in the salad. This dish is best served warm or at room temperature.

Warm Roasted Butterball Potato and Sunchoke Salad with Watercress and Hazelnuts

1. Preheat the oven to 400°F (205°C).

2. Spread the hazelnuts on a rimmed baking sheet and toast them in the oven for 4 to 5 minutes, until golden brown. Transfer them to a plate. With the oven still on, return the empty baking sheet to the oven to heat.

3. Put the shallot and garlic in a small bowl, add the vinegar, and set aside to pickle lightly.

4. Bring a medium pot of lightly salted water to a boil. Drop the sunchokes into the boiling water, return it to a boil, and cook for 10 minutes, or until they are tender but still firm. Remove from the water with a slotted spoon.

3 tablespoons coarsely chopped peeled hazelnuts

2 tablespoons minced shallot

¼ teaspoon grated garlic

2 tablespoons red wine vinegar

Kosher salt

14 ounces (400 g) 2-inch (5-cm) sunchokes, scrubbed and trimmed

14 ounces (400 g) small butterball potatoes

4 tablespoons (60 ml) olive oil, plus more for the baking sheet

1 teaspoon minced fresh rosemary

2 cups (70 g) watercress, thick stems removed

Freshly ground black pepper

5. Bring the water back up to a boil, add the potatoes, and cook for 15 minutes, or until tender. The skins may start to tear, and that's okay. Drain well.

6. Toss the potatoes and sunchokes in a large bowl with 1 tablespoon of the oil, the rosemary, and ½ teaspoon salt. Remove the baking sheet from the hot oven, drizzle the surface with oil, and spread the potatoes and sunchokes on the pan. Roast for 20 to 25 minutes, until golden brown.

7. Whisk the remaining 3 tablespoons oil into the shallot mixture to make a somewhat thick dressing. Drizzle the sunchokes and potatoes with the dressing and toss with the watercress. Scatter with the hazelnuts, season with salt and pepper, and serve.

Za'atar is a Middle Eastern spice blend made of dried oregano, thyme, sumac, and sesame seeds. You might have had it sprinkled generously on pita bread or grilled meats or as garnish on hummus, but in this case, it adds complexity to an everyday salad.

When I call for "mild greens," I am referring to the likes of gem lettuce, baby spinach, butter lettuce, tatsoi—those less bitter or spicy varieties that won't compete with the taste of the za'atar. Feel free to add a handful of halved cherry tomatoes if they are in season, and add olives or torn parsley if you have them on hand. Add grilled chicken to this salad if you are looking to make a complete meal.

Green Salad with Za'atar and Lemon Vinaigrette

1. Make the dressing: In a serving bowl, whisk together the lemon juice, sugar, mustard, and garlic, if using. Add the oil in a slow stream, whisking until emulsified.

For the dressing

1 tablespoon fresh lemon juice

¼ teaspoon sugar

¼ teaspoon Dijon mustard

1 small clove garlic, grated (optional)

3 tablespoons olive oil

For the salad

4 cups (160 g) mild salad greens, washed and spun dry

1 teaspoon za'atar

Sea salt and freshly ground black pepper

2. Make the salad: Add the washed and dried salad greens to the dressing and gently toss with your hands to evenly coat them. Wipe down the edges of the bowl to remove any dressing residue. Sprinkle the za'atar on top, season with salt and pepper, and serve.

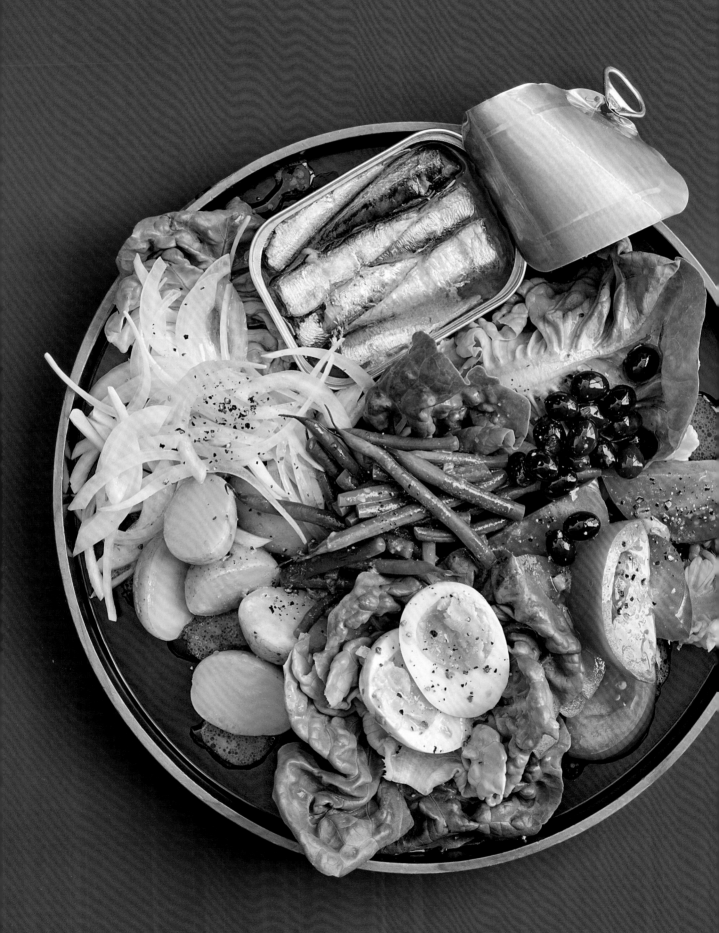

Serves
2

Prep Time
45 minutes

A niçoise salad is a fixture in the salad canon, but there are infinite variations on this *salade composée*. The defining characteristic of this salad is that it is assembled, not tossed. Each element is allotted its own private real estate on the plate, not thrown together willy-nilly. This is a purist's approach to salad, and it requires each element be prepared with care and plated with intention.

My niçoise is pretty classic until we get to the fish. Once in a blue moon, I splurge on the shockingly expensive oil-packed tuna in a precious glass jar. But in general, I opt for small fish, which are lower in mercury and far more abundant in our imperiled ecosystem. As a salad pundit, I encourage you to do the same. Purchase the fanciest domestic brands on the shelf, or imported sardines from Spain or Portugal—countries where canned seafood is elevated to the point where it's chic.

The tomatoes make this a summer dish but if you have a hankering for niçoise any other time of year simply omit the tomato and you have still got a winning main course.

Fancy Sardine Niçoise with Medium-Boiled Eggs and Fingerling Potatoes

1. Make the dressing: Mince the anchovies and smear them into a paste using the side of a broad chef's knife. Put the paste in a small bowl and whisk in the vinegar, mustard, and oil until emulsified.

2. Make the salad: Bring a 1-quart (960-ml) saucepan of water and the kosher salt to a boil. Drop the potatoes in the boiling water and boil for 20 minutes, or until they are tender. Remove the potatoes with a slotted spoon and put aside. Add the haricots verts to the boiling water. Cook for 30 seconds, then remove them with a slotted spoon to the ice water.

For the dressing

3 oil-packed anchovy fillets

2 teaspoons white wine vinegar

½ teaspoon Dijon mustard

3 tablespoons olive oil

For the salad

1 tablespoon kosher salt

3 small Yukon Gold potatoes

4 ounces (115 g) haricots verts, ends trimmed

2 large eggs

4 leaves Bibb lettuce

1 (4- to 5-ounce/115- to 140-g) can oil-packed sardines, drained

¼ cup (40 g) niçoise olives or halved pitted Kalamata olives

1 tablespoon very thinly sliced Vidalia onion

1 heirloom tomato, cut into wedges (optional)

Sea salt and freshly ground black pepper

3. Add the eggs (in the shell) to the boiling water and cook for 8 minutes, until they are medium-boiled. Remove them with a slotted spoon to the ice water and let them cool completely. Peel and cut them into halves.

4. Cut the potatoes and each haricot vert into halves.

5. Arrange the lettuce leaves on a platter and compose the potatoes, haricots verts, egg, sardines, olives, onion, and tomato in groupings on top. Spoon the dressing over the salad, season with sea salt and pepper, and serve.

Yuca, also known as *cassava*, is that mysterious, woody root vegetable you might have noticed incognito in the lowest bin at your local supermarket, barely passing as produce. What masquerades as a shamanistic walking stick is actually an everyday starch on the South American table; served boiled or fried, it proudly supplants the potato. But the fun doesn't stop there—yuca is the plant from which tapioca is made; those alien spheres of boba floating in your milk tea are actually plant-derived.

Yuca was introduced to me by a Colombian friend who showed up to a potluck many moons ago with something better than fries, and that's no small accomplishment. Yuca is easy to prepare, and it is an ideal vehicle for flavorful sauces and dips, this fennel seed, cilantro, and pepita pesto included. Serve yuca hot from the oven.

Crispy Yuca Spears
with Toasted Fennel Seed and Pepita Pesto

For the yuca

2 medium yuca
(about 1 pound/455 g total)

3 tablespoons olive oil

Sea salt and freshly ground black pepper

For the pesto

1½ teaspoons fennel seeds

1 teaspoon cumin seeds

¼ teaspoon whole white peppercorns

1½ cups (65 g) chopped fresh cilantro with tender stems

½ cup (25 g) packed fresh parsley leaves

¼ cup (60 ml) fresh lime juice

½ teaspoon sea salt

1 clove garlic, chopped

¼ cup (60 ml) olive oil

¼ cup (35 g) raw unsalted pumpkin seeds, lightly toasted

1. Make the yuca: Preheat the oven to 450°F (230°C).

2. Peel the yuca to remove the waxy skin. You can do this with a vegetable peeler or a kitchen knife. Cut it into spears about 4 inches (10 cm) long and about 1 inch (2.5 cm) thick. If the yuca cores seem very woody (or if there's a visible light-brown part in the center), trim the spears to remove them.

3. Fill a medium pot with water and bring it to a full boil. Add the yuca spears and cook for 10 minutes, or until the pieces are fork-tender. Drain and spread them out on a baking sheet to cool.

4. Toss the yuca with the oil and season with salt and pepper. Arrange the spears with 1 inch (2.5 cm) or more between them. Bake for 10 minutes. Flip each piece and bake for an additional 10 to 20 minutes, until golden brown.

5. Meanwhile, make the pesto: In a small, dry skillet, toast the fennel and cumin seeds over medium heat until fragrant, 3 to 5 minutes. Put them in a high-powered blender or a mini food processor, along with the white peppercorns. Blend on the highest setting to create a fine, powdery spice blend.

6. Add the remaining ingredients, reserving about 1 tablespoon of the cilantro for garnish. Pulse until you reach a smooth texture, with herbs still visible in the mix.

7. Arrange the yuca on a platter, overlapping the spears. Spoon the pesto over the yuca in a zigzagging line. Garnish with the reserved cilantro and serve warm with extra sauce on the side.

Serves
8

Prep Time
20 minutes

My family subscribed to the early-nineties school of nutrition that painted cholesterol as a deadly threat. To this day, I have never seen my parents enjoy an egg in its entirety, so my passion for eggs—yolks and all—is still a tiny act of rebellion.

This dressing delivers everything you want from a traditional Caesar, with the added zing of green parsley and garden chives. Be sure to use the best anchovies in the market, as they will be less fishy with maximal umami flavor. If you are hesitant about the fishiness, soak the anchovies in warm water for 5 minutes before adding them to the dressing; they will mellow out in the warm bath. Rather than dumping cheese into the dressing itself, I prefer to Microplane pecorino or Parmesan on the salad, making a light, fluffy, and salty finish on top.

Little Gems with Crispy Pancetta and Green Caesar Dressing

1. Make the dressing: In a food processor, combine the egg yolks, lemon juice, anchovies, parsley, chives, mustard, and vinegar and blend until the herbs are broken down into small green flecks. Add the oils in a slow stream with the motor running and blend to emulsify. Spoon the dressing into a plastic squeeze bottle or a cup with a pouring spout and refrigerate until you are ready to serve.

2. Make the salad: Pull apart the leaves of the lettuces; wash and thoroughly dry and arrange them on a large platter. Squeeze lemon juice and drizzle olive oil over the lettuce, and season with salt and pepper.

For the dressing

2 large egg yolks

2 tablespoons fresh lemon juice

5 oil-packed anchovy fillets, drained

3 tablespoons chopped fresh flat-leaf parsley, plus more for garnish

2 tablespoons chopped fresh chives

1 teaspoon Dijon mustard

1 teaspoon white wine vinegar

¼ cup (60 ml) high-quality extra-virgin olive oil

¼ cup (60 ml) grapeseed oil

For the salad

4 small heads Little Gem lettuce or romaine hearts, trimmed

½ lemon

Fancy extra-virgin olive oil

Sea salt and freshly ground black pepper

8 to 10 slices speck or prosciutto de Parma

Parmesan or pecorino cheese (optional)

3. Heat a large cast-iron pan over medium heat. When the pan is hot, add the speck in a single layer, working in batches. When the speck contracts and gets crispy, remove it from the pan and set it aside to cool.

4. To serve, squeeze or drizzle the Caesar dressing generously over the lettuce. Top each serving with a piece of crispy speck, finely grate cheese generously on top, and garnish with parsley. Serve extra dressing on the side if you have leftovers.

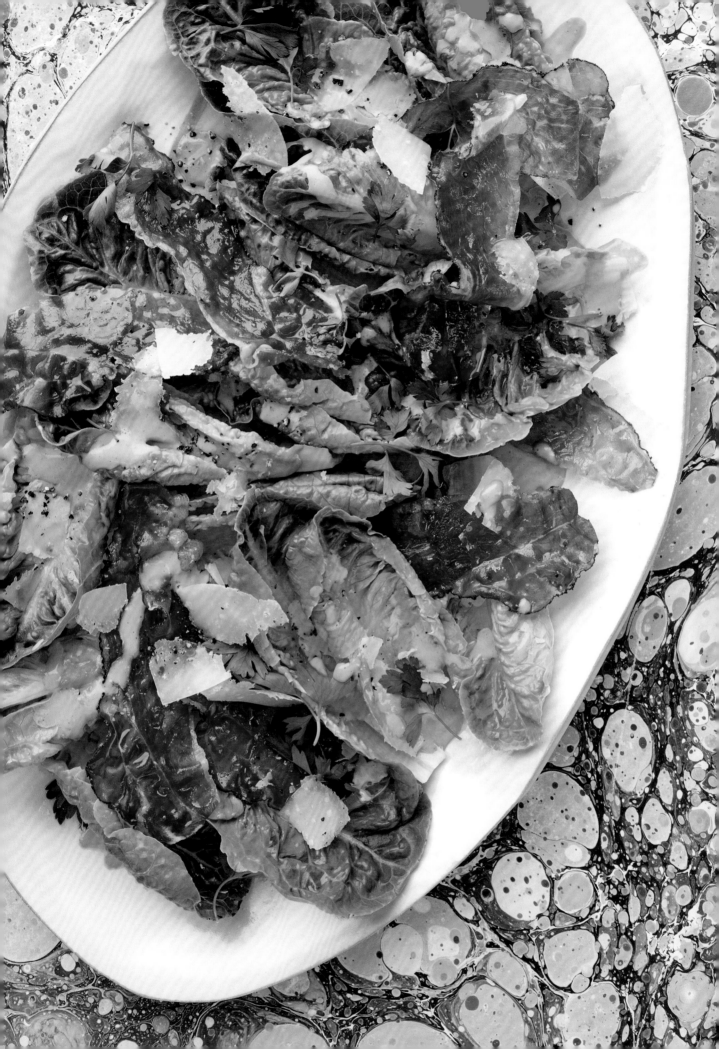

Serves
3 or 4

Prep Time
35 minutes

It was more than ten winters ago that I remember a chorus of recent college graduates begging our roommates, holistic orchardist Maya Nayak and musician George Langford, to make this salad in our unheated loft in Providence, Rhode Island. Potluck dining, bulk buying, and cooperative living had trained us well in the ways of roasted root veggies. But Maya's surprising addition of pickles was what made this salad a house favorite.

Earthy root vegetables and creamy yogurt are a balanced pair, so please don't attempt to substitute nonfat yogurt for the real thing; you will be sorely disappointed by a thin dressing that lacks body. Use high-quality pickles (I like half-sour pickles here, but full-sour kosher dills are great, too), and serve extra on the side.

Roasted Beet and Potato Salad with Dill Yogurt Sauce and Pickles

1. Preheat the oven to 400°F (205°C) and place a rimmed baking sheet in the oven to heat up.

2. Peel the beets. Cut the beets and potatoes into 1-inch (2.5-cm) cubes. Keeping the beets and potatoes separate, toss with garlic and 1 tablespoon of the oil and season with a generous pinch of salt and a fine dusting of pepper. Spread the beets out in a single layer on one side of the hot baking sheet, and spread the potatoes on the other side. Cook the potatoes for 20 minutes and remove from the pan with a spatula. Continue to roast the beets for an additional 10 minutes, or until fork tender.

4 medium red beets, tops removed

3 small Yukon Gold potatoes

1 clove garlic, quartered lengthwise

1 tablespoon olive oil

Kosher salt and freshly ground black pepper

¼ small red onion

1 tablespoon red wine vinegar

3 tablespoons full-fat sheep's milk yogurt

2 tablespoons torn fresh dill, plus more for garnish, stems removed

2 tablespoons ⅛-inch (3-mm) cubes half-sour pickles

3. While the veggies are roasting, slice the onion into thin half-moon slivers. Put the onion in a small bowl with the vinegar and ⅛ teaspoon salt, and set aside to pickle while the veggies cook.

4. Remove the veggies from the oven and set them aside to cool for a few minutes. Remove the onions from the vinegar.

5. In a serving bowl, whisk together the remaining 1 tablespoon oil, the yogurt, dill, and any excess vinegar from the onions. Whisk to combine.

6. When the veggies are no longer piping hot but still warm, toss them with the yogurt dressing.

7. Scatter the pickles and red onion on top, garnish with dill and/or dill flowers, and serve.

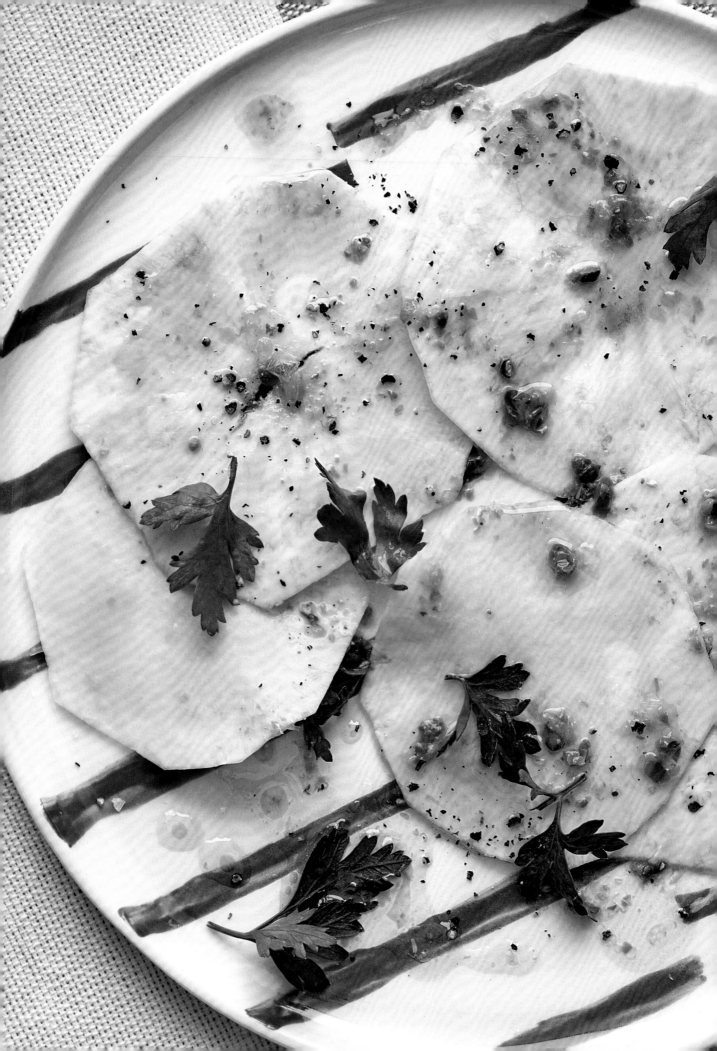

Serves
4

Prep Time
10 minutes

I know winter is upon us when I start eyeing celery root (aka celeriac) among the skeleton crew in the greenmarket and it actually entices me. It is not the prettiest vegetable, but once the hairy, dirty skin of the nubbly root is sliced away, the flesh is a snow-white sponge for savory dressing, with the added touch of earthy celery essence. The texture is dense and crunchy but takes well to being shaved thinly, and concentric circles make a lovely motif in a shallow serving bowl or platter.

This salad is for those of you who love the bold, salty taste of both anchovies and capers, and it takes just minutes to prepare. You will want to use a mandoline to cut paper-thin slices of celeriac consistently—because therein lies the beauty of this dish.

Paper-Thin Celery Root with Anchovy-Caper Vinaigrette

1. Make the dressing: Remove the anchovies from the oil and mince. Use the broad side of your chef's knife to schmear the anchovies to a paste, continuing to chop and schmear until you have a coarse paste. Roughly chop the capers with the anchovies and scrape the mixture into a small bowl. Add the lemon zest and juice, then add the oil in a slow stream and whisk with a fork to emulsify.

2. Make the salad: Scrub the celery root clean with a vegetable brush. Using a chef's knife, slice away all the exterior of the root so only the white flesh is exposed. Rinse the peeled root and pat dry.

For the dressing

6 oil-packed anchovy fillets

1½ teaspoons brined capers, rinsed and squeezed dry

Grated zest and juice of 1 lemon

3 tablespoons extra-virgin olive oil

For the salad

1 medium-large celery root (1 pound/455 g)

Sea salt

Freshly ground black pepper

1 teaspoon torn fresh flat-leaf parsley leaves

3. Using a mandoline slicer set to a very thin setting, cut the celery root into translucent rounds, stopping when the nub gets too small to hold comfortably. (This salad is excellent, but not worth losing a finger over.)

4. Scatter the sliced celery root in a wide, shallow serving bowl and spoon the dressing over the top. Season with the salt and pepper, garnish with the parsley, and serve.

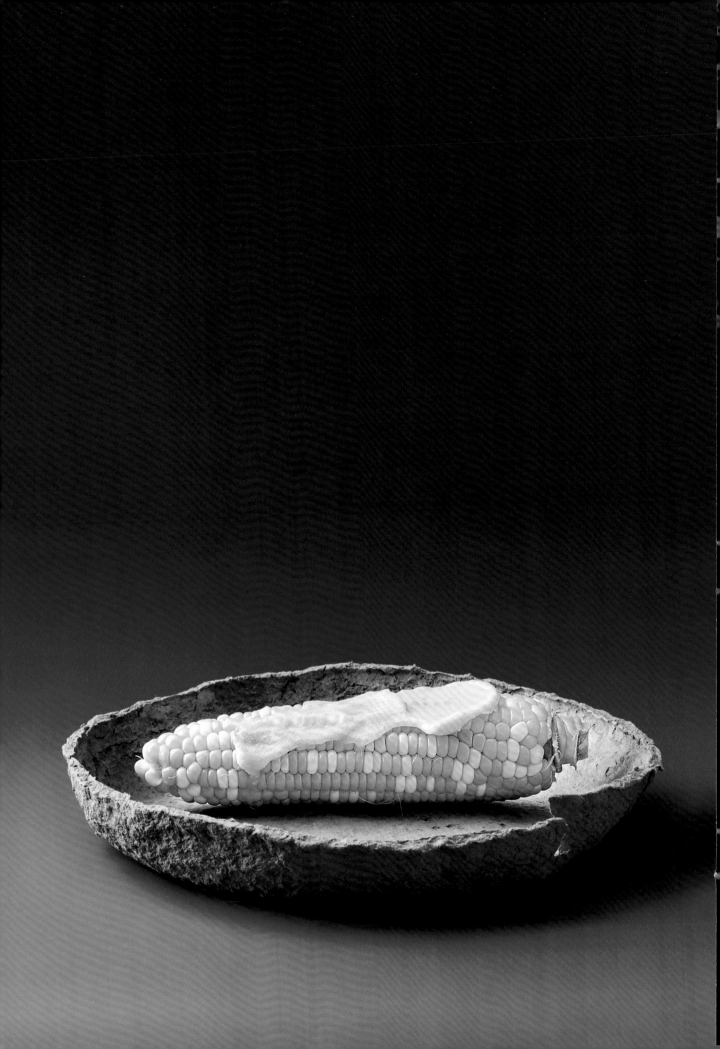

Slathering the synergistic combo of miso and ghee on fresh seasonal corn is like putting clothing on a puppy—of course it isn't necessary, but once you try it, you never let them go naked again.

I like to use ghee in lieu of butter because the flavor is more intense and it has added health benefits (see Pantry Staples, 249). If you want your house to smell like heaven, make your own ghee from scratch. Bring unsalted, cultured butter to a boil and reduce to a simmer for 10 to 15 minutes. As it cooks, the milk solids will become brown and fragrant (the richer-than-butter flavor develops as those milk solids caramelize). Strain the whole mixture through a cheesecloth-lined fine-mesh sieve and cool. Since the perishable milk solids have been strained from the oil, ghee is shelf stable and can be stored in a cool, dark place without refrigeration.

Miso-Ghee Corn on the Cob

Kosher salt

2 tablespoons ghee, at room temperature

1 tablespoon plus 1 teaspoon white miso

6 ears fresh sweet corn, shucked

2 limes, quartered (optional)

1. Fill a large pot three-quarters full with salted water and bring it to a boil.

2. In a small bowl, combine the ghee and miso, and whip them until smooth and fluffy.

3. Drop the corn into the boiling water and lower the heat to medium. Cover the pot and cook the corn for 4 minutes. (If you don't have a pot big enough for all six ears of corn, just do this in batches.) Drain.

4. While the corn is still hot, spread the ghee mixture all over each cob. Serve with the limes on the side for guests to squeeze themselves.

No Salad Too Small: Starts and Sides

Lighter dishes

No protein

Fun alternatives to garden salad or veggie sides

According to the nineteenth-century Russian theatre director Konstantin Stanislavsky, "There are no small parts, only small actors." I've never really believed that. But I do know that simply because a salad is a single element of a larger meal doesn't mean it can't steal the spotlight. Do you crave roast chicken? Or, do you crave roast chicken with a mountain of lightly bitter greens tossed in a sweet and tart dressing?

Right.

This chapter puts some tinsel on your side dish and makes it scream your name, even when it is playing a supporting role to a heftier entrée. Some of these salads make for a perfect light lunch on their own, or they take the place of those boring mesclun greens and balsamic vinaigrette that, as the proud owner of this book, you never, ever have to make again.

Serves
4 to 6

Prep Time
5 minutes

Ripe, seasonal watermelon is damn near perfect all on its own, but like most things, it's better with olive oil and flaky sea salt. Add a pile of wispy bronze fennel fronds and you've got yourself a salad you can eat with your hands.

Bronze fennel has anise notes similar to those of conventional fennel, with an extra blanket of sweetness and color that ranges from aubergine to, well, deep bronze. Unlike conventional fennel, it does not form a bulb and is grown for the fronds alone. It's easy to cultivate, but if you are not a gardener, bronze fennel is occasionally available at the farmers' market. If it is nowhere to be found, snip the tender green fronds from the top of a fresh fennel bulb for a very close substitute. Or, try this recipe using chervil, an anise-flavored herb with a similar airiness and delicacy.

Most watermelons sold at the farmers' market are ready to eat, but if you have to buy from the grocery store there are a couple of ways you can kick the tires. Just like the rest of us, if a melon has ripened in the sun for long enough it will show the signs of age. When you pick it up it should feel heavier than expected, and there should be one yellow patch of color on the side of the melon that rested on the ground deprived of sunlight. Lastly, always knock the melon with a closed fist and let it speak to you. The sound should be a hollow echo, the call of firm, light flesh hidden inside.

Watermelon Wedges with Bronze Fennel, Olive Oil, and Flaky Sea Salt

1. Arrange the watermelon slices on a large platter. Drizzle them generously with oil.

2. Sprinkle the watermelon with a pinch of salt and season with pepper.

½ medium watermelon, cut into wedges 1 inch (2.5 cm) thick

High-quality extra-virgin olive oil

Sea salt and freshly ground black pepper

1 cup (40 g) loosely packed fresh bronze fennel sprigs or chervil leaves

3. Plunge the bronze fennel into cold water and pat it dry with a kitchen towel. Remove the fronds from the central, thicker stalks. Scatter the fronds over the watermelon and serve.

Serves
2

Prep Time
5 minutes

When Claire Evans (writer, front woman of the band Yacht, and futures editor for the Motherboard website) described her "famous coconut oil dressing" to me over email, I will admit I was a bit dubious. The defining characteristic of coconut oil is its solid state when anywhere below about 80°F (30°C). It's tough to imagine tossing a leafy green salad with chunky oil, but like most things Claire touches, this recipe is gold. The trick is to warm the oil just enough for it to liquefy, mix together all of the ingredients, toss them with the salad, and then let the dressing return to its solid state, thinly coating each leaf with a velvety, rich texture and bright citrus-chile spice.

Yuzu kosho is a fermented Japanese condiment made from fragrant yuzu citrus peels, green chile, and salt. This is the most delicious condiment on the planet, served in Japan alongside ramen or sashimi; it has the perfect amount of heat and salt. You can buy this online or at any Japanese grocer, and I promise you will find use for it beyond this recipe.

Tatsoi, Macadamia Nuts, and Shaved Coconut with Yuzu Kosho Dressing

1. Make the dressing: If your coconut oil is solid, put it in a small microwave-safe bowl and microwave for about 30 seconds to melt it. (Alternatively, place a heatproof bowl over a small saucepan with simmering water, allowing the steam to melt the coconut oil. Remove from the heat.)

2. While the oil is still warm, whisk in the yuzu kosho, aminos, vinegar, and lime juice. If the dressing solidifies, rewarm it briefly over a pan or bowl of hot water, whisking just until it liquefies again.

For the dressing

1 tablespoon plus 1 teaspoon virgin, cold-pressed coconut oil

¾ teaspoon yuzu kosho

½ teaspoon Bragg Liquid Aminos or tamari

2 teaspoons unseasoned rice wine vinegar

Juice of ½ lime

For the salad

6 ounces (170 g) tatsoi, washed and spun dry

3 tablespoons toasted macadamia nuts, finely chopped, with a few larger chunks

1 or 2 fresh chive blossoms

2 tablespoons unsweetened dried coconut strips, lightly toasted

3. Make the salad: Arrange the tatsoi on a large serving platter. While the dressing is liquid, drizzle it over the tatsoi and sprinkle with the macadamia nuts. Using your hands, toss to coat the greens thoroughly. Allow the salad to sit for 3 to 5 minutes (the nuts should stick to the surface of the leaves as the oil returns to a solid state).

4. Pick the purple buds from the chive blossom and scatter them over the salad. Top with the toasted coconut. Serve immediately.

Serves
4 to 6

Prep Time
35 minutes,
including
inactive time

This idiotproof salad takes just minutes to assemble and it makes for an ideal light, healthy snack or a playfully plated hors d'oeuvre. I call for Persian cucumbers because they are nice and crunchy with very few seeds, but the same goes for all the cucumbers in the "slicing" category: English, Armenian, or Japanese kyuri. There is no need to peel these varieties; they have been bred to have little of the bitterness in the skin that can produce gas when digested, which is why these cucumbers are also referred to as "burpless."

The pre-salting eliminates some of the water in the cucumber, preventing any pooling of liquid at the bottom of the finished dish, but if you're short on time, skip the salting, rinsing, and draining of the cucumbers and this becomes a five-minute dish: Just season the salad generously with sea salt before serving.

Cucumber Salad with Tahini and Sriracha Drizzle

1. Put the cucumbers in a bowl and sprinkle them with the kosher salt, tossing to coat. Let stand for 30 minutes, then rinse and drain well. Spread the cucumbers on a serving platter.

2. Put the tahini in a small bowl. Whisk in 5 tablespoons (75 ml) lukewarm water, 1 tablespoon at a time, until it reaches a pourable consistency. The tahini will thicken a bit at first, but just keep adding the water until it is completely smooth and can thinly coat the back of your fork.

8 to 10 Persian cucumbers, cut into ¾-inch (2-cm) chunks

1 teaspoon kosher salt

¼ cup (60 ml) tahini

Sriracha sauce

Sea salt

3. Drizzle the thinned tahini over the cucumbers. Squeeze Sriracha directly out of the bottle over the salad sparingly. Season with sea salt and serve.

Madeleine Fitzpatrick

Occupation: Artist, gardener, couture collector
Location: Marshall, California
Salad: Wild-Seeded Greens and Edible Flowers (page 84)

Madeleine Fitzpatrick's greens are not for sale. The one-hundred-plus varieties in her wild-seeded salad forest are priceless. A few lucky friends and members of the San Francisco culinary elite (Alice Waters included) are blessed every so often with a bag full of choice edible flowers and greens grown on Madeleine's oasis in Marshall, California, north of the city. Digging into her bounty of greens is unpredictable and invigorating, like spending time with Madeleine herself. Each bite is different from the next. This salad is served at the end of the meal, not before. You have to wait for it.

On my recent trip to visit Madeleine and her sprawling compound, the former home of a 1960s cult community, I drove around in circles before parking my car in a muddy ditch. I ran to the top of a hill, hoping to find an aerial perspective on the labyrinthine terrain; I was entirely lost and without a lick of cell service. When I finally found the house, there was Madeleine, flanked by a posse of enormous dogs, standing under an ancient tree trunk that had been carved into a passageway by her husband, arborist Evan Shivley. We headed straight for the garden, following a winding path where delicate sprigs of chervil, micro-parsley, and shiny, red mustard leaves intercepted my every step. These plants have gone to seed year after year, dispersing themselves, multiplying infinitely. They now colonize every inch of land around Madeleine's house. It is not often one encounters a rambling edible forest. This was a salad mecca.

Madeleine is a painter, a gardener, and a performer of sorts. Her life is her art, from her every plate of salad to her Mylar-covered living room, to her large-scale expressive paintings. She wears many hats, quite literally. After two days spent digging in the dirt in jeans and flannel shirts, Madeleine revealed her collection of more than three hundred fancy hats and just as many shoes.

When I picked up a 1950s fascinator covered in mustard feathers, she offered casually that this particular hat was an exact match to her Alexander McQueen couture suit. Clad in her garden work wear, she hadn't struck me as a fashionista. But Madeleine is full of surprises, and there is not an inch of her life uncolored by her singular aesthetic.

Madeleine and Evan have been together for more than thirty years, and recently they were married. For the occasion, guests were asked to wear their own wedding gowns. Some reached back into their closets, while several male guests headed to vintage stores to find dresses just for the occasion. Madeleine herself created a twenty-foot train out of Spanish moss, embedded with sweet peas and flowers she grew herself. She glued feathers to her eyelashes, dusted off her tiara, put the leash on her Great Dane, and walked down the aisle. Salad was served at dinner, of course.

View of Fitzpatrick's studio and her series of paintings inspired by her vintage, couture feather hats.

Julia Sherman: How did you learn to garden, and how did you develop this really specific salad garden?

Madeleine Fitzpatrick: After art school, I lived on one of the first biodynamic and organic farms in California. We grew a fancy salad mix for high-end restaurants, Chez Panisse included. So that's what started it. I continued to keep a garden of my own when I left.

JS: Did you grow salad exclusively then, or did this focus develop over time?

MF: Always simply oil and vinegar. There's really no need for much else. There are ten or twenty spicy greens in the mix depending on the time of year. I am also always adding garlic and onion chives, so there's no need to add those things to the dressing. I prefer to keep it clean because the flavors in the salad itself are so interesting.

JS: Do you ever sell the greens?

MF: No, I never sell them. I give them to friends; sometimes those friends have restaurants, but I don't sell them.

The entrance to Fitzpatrick and Shivley's jungle kitchen in Marshall, California.

MF: No, I was always focused on salad.

JS: And the wild seeding—how did that method of gardening come about?

MF: I moved toward plants that were going to seed intuitively. It's good energy for the garden to let the plants live out their full cycle. If you're always pulling plants out thinking, oh, there's nothing more to eat here, you will have a clean, orderly garden—but that's not nature. The way my garden grows, I might have parsley coming up all year long, all over the place.

JS: I love that your famous salad is only dressed with oil and vinegar. Is that a rule?

JS: You know the bag of salad you gave me? In my car I had olive oil, a lemon, some salt—and I ate it out of the plastic bag on the beach at sunset. It was the best dinner I've ever had.

MF: Oh, wonderful. I know some people who eat it with nothing on it at all. I guess I do that too, especially in the garden—I just eat salad straight from the ground.

JS: So, outside of the garden, you have a few other obsessions—like collecting hats and beautiful clothing?

MF: When you get older you want to have fewer things, and I finally started to feel that. But then

Fitzpatrick and her dogs harvest salad in her garden.

a professional collector informed me that I didn't have enough shoes. Big mistake! Now I have a lot of four-inch heels.

JS: I had no idea you liked to get that dressed up. How often do you do that?

MF: I'm a nut when it comes to dressing up. It's an art. As a young girl, my mother taught me about the great artists of couture, and she made costumes for parades like the Rose Parade. True couture is the making of a beautiful fantasy. You're creating mystery, just like you do in a painting or a garden. Dressing up generates wonderful intrigue as long as you have a nice palette.

JS: Well, judging by your wedding outfit, you don't just rely on expensive designer brands; you create something entirely unique.

MF: The week before the wedding, I found a dress that fit. Then I went out with some friends and collected Spanish moss off the trees. A local farmer gave me some seasonal flowers, sweet peas, and sweet williams, and I picked my own hydrangeas. At four a.m. the night before the ceremony, my friends and I were weaving the flowers into my gown and cape. My cape ended up being fifteen feet of moss and blooms.

JS: What did you do with the gown when the ceremony was over?

MF: We used it as a bed spread at the after-party.

JS: What about the project you just started: paintings of your incredible feather hats? That sounds like another body of work where nature and art collide.

MF: When I see these amazing colors created by nature, I photograph them, and then I paint them. When you let plants go to seed, they go wild and create amazing abstract color patterns. It's the same thing with the feather hats.

JS: So the garden and the studio are pretty closely connected?

MF: The garden feeds me—it feeds my body, it feeds my soul, it feeds my creativity. The pride that I feel in the garden when a new plant comes up on its own, when I see a beautiful lettuce in a rosette shape, I take with me when I go into the studio. In a conscious or unconscious way, the garden inspires me—its shapes, its colors, and its surprises.

Yui Tsujimura

Occupation: Master ceramicist
Location: Nara, Japan
Salad: Persimmon Caprese (page 97)

I had been in Japan for two weeks and my *Let's make a salad together!* tack had been met with mixed results. Japanese people rarely entertain at home, and it's altogether unheard of to invite yourself to lunch at a stranger's house. But Yui Tsujimura's gallerist said that if I were willing to travel through the mountains and on the unmarked roads to Yui's home and studio in Japan's Nara region, he would receive me. After seeing Yui's solo show of slumped vessels, large and small, and craggy ceremonial tea bowls (called *chawans*), I was eager to meet the artist who is my age exactly but whose work exists in an ancient lineage of Japanese art history. So I hit the road. (Rather, I convinced a Japanese curator friend to drive me.)

We knew the exact moment when we had arrived at the home Yui designed and built. The roadside was suddenly scattered with piles of glazed vessels, thousands of Yui's works that had not survived the kiln. Together they formed a terrain so foreign, we appeared to be driving on the surface of the moon. The practice of making ceramics requires acceptance of an inherently volatile process. Imperceptible cracks in the clay, air bubbles, and dripping glaze are all cause for disaster—even explosion—in a kiln that can reach upward of 2,500°F (1,370°C). In other words, no matter how precious or valuable the artist's work, a master ceramicist is no stranger to the concept of "letting go." Yui had taken this one step further, repurposing his failed efforts to shape his surrounding environment, the ground itself a tribute to the unpredictability inherent to his work. The shards of handmade ceramics scattered all over the pathway had permanently altered the landscape of his studio, making an encounter with a successful piece that much more contemplative.

Yui's father is master ceramicist and national treasure Shiro Tsujimura. This work is in his blood, even if he never imagined following in his father's footsteps. Yui came to the art on his own, which is quite unusual for Japanese men born into legendary artisan families. The normal path would be to apprentice in the family studio at an early age and continue the style and legacy of the generations that came before. Instead, Yui developed his own process and cosmic palette of organic, mineral textures. Each one of Yui's pieces is an entirely unique record of the process of its own making, which involves tossing ashes in a wood-fired kiln over the course of an eight-hour firing. It is unpredictable, a chance operation, and one that never yields the same result twice.

Having only previously seen Yui's work presented on pedestals in a stark white gallery, it was jarring to see this same pottery casually serving spring water to his pet corgi, filled with coals heating the kettle, or even stacked on the table ready to serve this elegant persimmon salad. But it was fitting for the artist, who truly doesn't distinguish between the art we display and that which enables our everyday rituals.

Below: Tsujimura refines ceramic bowls in the studio attached to his home.
Opposite: Tsujimura walking among shards of broken pottery on his way to the kiln.

Julia Sherman: Do you feel a responsibility to the tradition of pottery in Japan? What is your relationship to history?

Yui Tsujimura: No, I don't feel a responsibility. I am influenced by the tradition of Japanese ceramics, but I would rather create something that is relevant now. If you create artwork that is deeply connected to the contemporary world, it will not fade with time.

JS: What do you do when you are not making pottery? Do you ever experiment with other materials besides clay?

YT: When I am not in the studio, I go fishing, I forage for mushrooms and wild vegetables in the mountains surrounding my house, and I cook. I really do not practice anything besides ceramics, and I have never tried to.

JS: Can you tell me a little about the process for glazing and firing your work? It seems there is an important element of chance inherent to all ceramic work, but particularly the way you use ash.

YT: I practice reduction firing, the famous technique of the Shigaraki and Iga regions. I throw ash into the hot kiln, and the ash reacts with the naturally occurring minerals in the clay. That reaction causes the clay's own minerals to rise to the surface of the vessel, turning into glass, or glaze, in the extreme heat. I try to manipulate and exaggerate that chemical reaction by opening up the kiln door and throwing ash in many times over the course of one firing. When the pieces are baked, before I extinguish the fire in the kiln, I always toss in some extra wood and shut the kiln door. The burning wood consumes all the oxygen in the kiln and causes the appearance of the blue-green mineral glass you see in so much of my work. I do not actually apply any additional glaze to the work, it is all natural.

JS: Where does your clay come from?

YT: It mostly comes from Iga, Shigaraki, and Nara, the areas surrounding my home and studio.

JS: Is there a distinction for you between the pieces that you use in your everyday life and the work you show in the gallery? Is it more rewarding for you to serve a salad on your pottery or to see it displayed on a pedestal?

YT: I do not see a distinction between the work in the gallery and the work on this table. I put the same effort and care into everything I put into my kiln. I love to see people finding their own ways to appreciate or make use of the things I make. For example, I used *katakuchi bachi* (bowl with a spout) to serve my salad today. But I love to know that someone else will use that same bowl as a vase, or just put it on display as an art object.

JS: Tell me about this salad. Where did the ingredients come from, and what inspired you to make this dish?

YT: The persimmons are from Nara, the basil is from my garden, and the mozzarella cheese comes from Hokkaido. I made the salad because it is persimmon season, and the color of the fruit complements the color of the mineral glaze in the bowl.

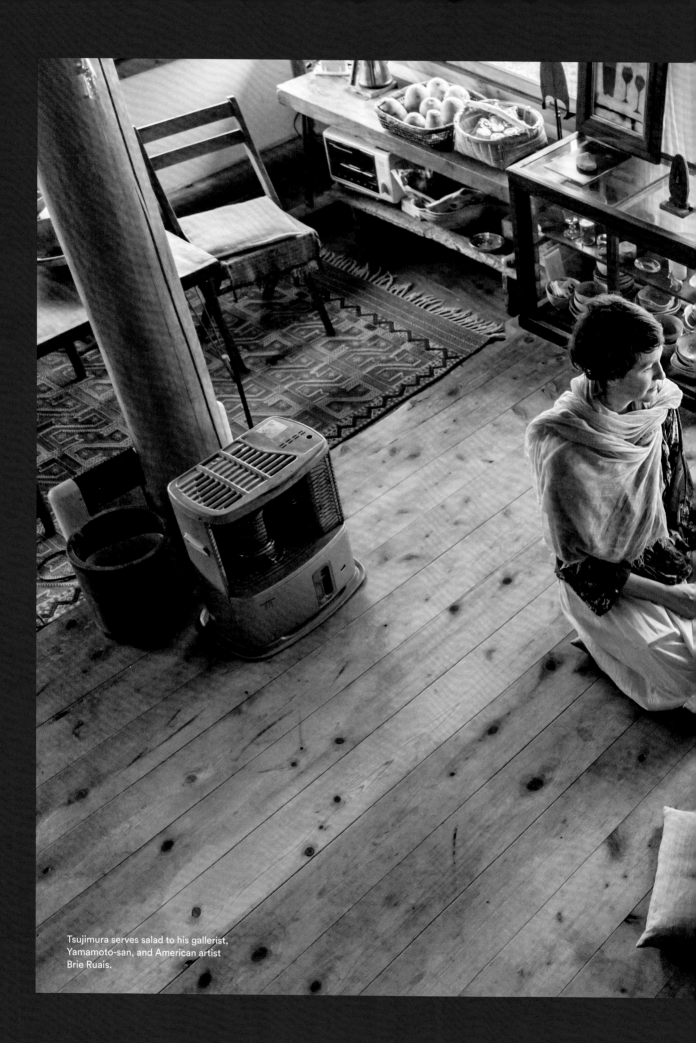

Tsujimura serves salad to his gallerist, Yamamoto-san, and American artist Brie Ruais.

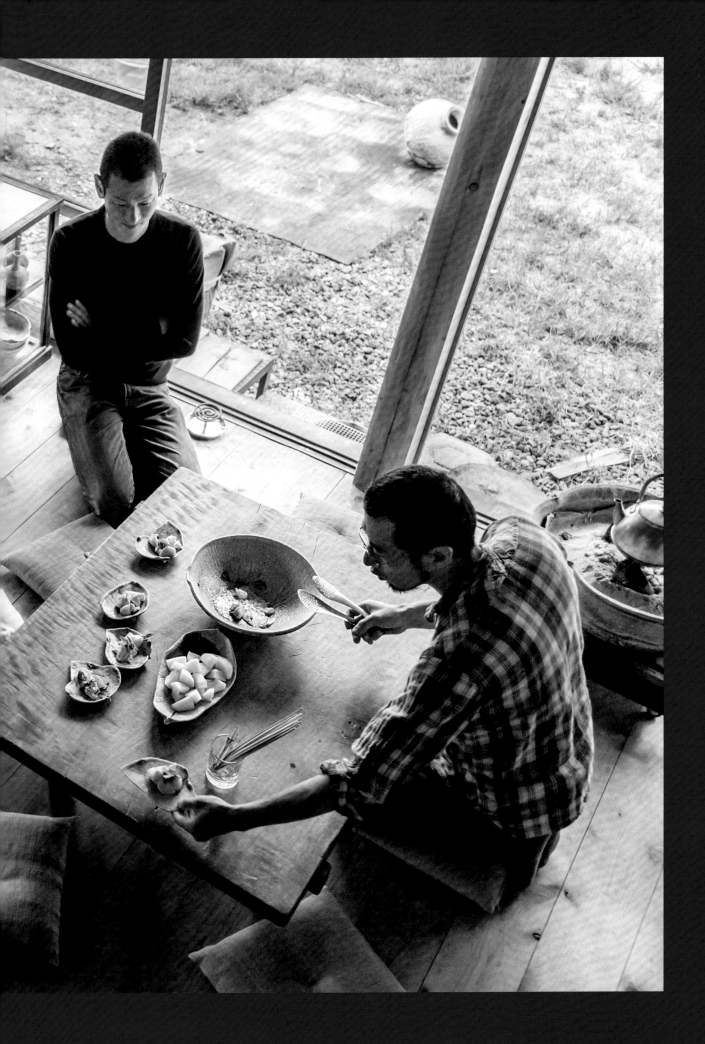

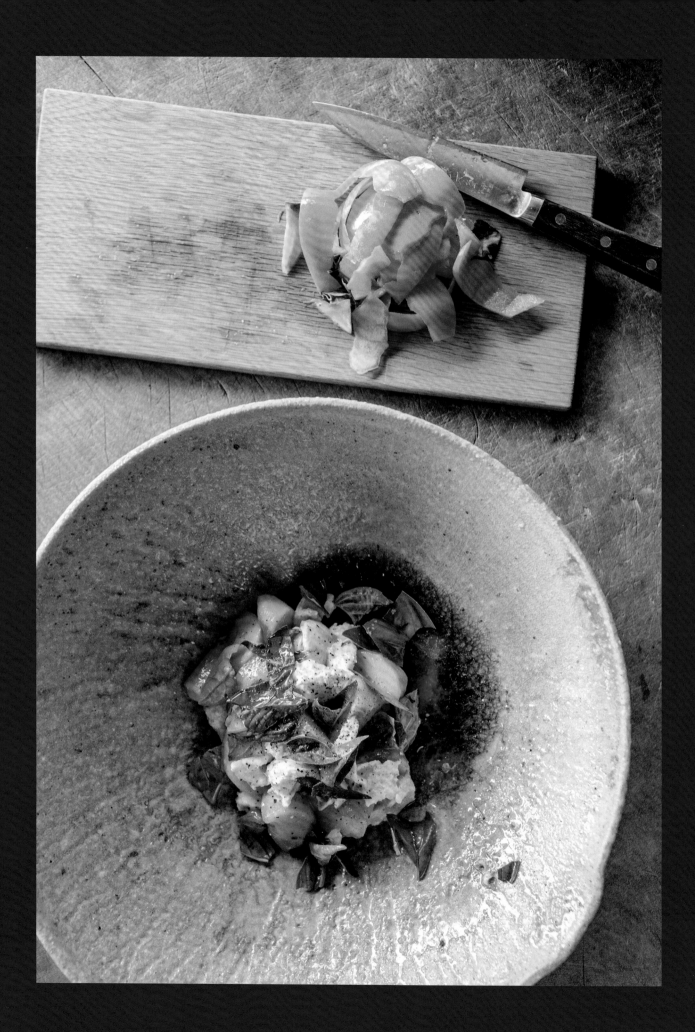

Serves
2 or 3

Prep Time
5 minutes

Caprese salad does not have to live and die with summer. In his interpretation of the classic salad, artist Yui Tsujimura used local persimmons in the place of tomatoes and it really worked. They have vibrant color and a tame flavor that complements the fresh mozzarella cheese in this salad. Persimmons are generally available from October to February, at which point they vanish without a trace for the rest of the year. I urge you to experiment with them as much as possible while you can. If you want to make a fruit-based Caprese in the summer months, substitute juicy white nectarines or peaches for persimmons.

With a dish this simple, use a really fruity, fragrant extra-virgin olive oil, the best you can find or afford. The oil will really pop against these subtle ingredients.

Yui Tsujimura's Persimmon Caprese

1. Using a paring knife, peel the persimmons and remove the stem caps. Either slice them thinly or cut them into irregular ¾- to 1-inch (2- to 2.5-cm) chunks and put them on a platter. Scrape any of the juices left on the cutting board onto the platter, too.

2. Tear the mozzarella into bite-size pieces and add them to the platter, tucking them in around the fruit. Tear the basil leaves and scatter them on top.

3 ripe (slightly soft) Fuyu persimmons

1 (8-ounce/225-g) ball very fresh mozzarella cheese

Large handful of fresh basil leaves

3 tablespoons high-quality extra-virgin olive oil

1 tablespoon white wine vinegar

½ teaspoon sea salt

Freshly ground black pepper

3. Drizzle the salad with the olive oil and vinegar. Season with the salt and black pepper, if needed, and serve.

Serves
4 to 6

Prep Time
20 minutes

In Japan they say that umeboshi plums possess magical healing powers, the ability to cure everything from ancient Samurai battle fatigue to the modern-day hangover. Umeboshi are shockingly expensive, but a little of their concentrated, salty tartness goes a long way.

When I buy cashews for cooking, I always opt for the broken cashew pieces as opposed to whole nuts; they are more affordable and taste just as good. Black garlic is fermented, and has twice as many antioxidants as raw garlic; its flavor is much sweeter and milder, like garlic candy, in a good way. You can find this at your Asian grocer, but it is widely available in mid-range supermarkets as well (they even sell it at Trader Joe's). If you can't find it, just substitute roasted garlic cloves with an added pinch of sugar.

Cucumber Umeboshi Salad with Cashew Crunch

1. Preheat the oven to 375°F (190°C).

2. Using a mortar and pestle, make a paste out of the black garlic, fish sauce, and habanero.

3. Roughly chop the cashews and toss them in a bowl with the sesame seeds. Cut the nori into thin shreds and add them to the cashew mixture. Add the black garlic paste and stir to combine it with the other ingredients as evenly as possible. Line a baking sheet with foil and coat it evenly with the sesame oil. Spread the nut mixture out on the foil and toast it on the middle rack of the oven for about 10 minutes, until the nuts start to brown lightly. Remove them from the oven and let them cool to room temperature. The nuts should go from sticky and soft to crunchy clusters as they cool.

For the cashew crunch

2 cloves black garlic, peeled

1 teaspoon fish sauce

1 teaspoon minced habanero pepper (or more if you love spice)

½ cup (65 g) raw cashew pieces

1 tablespoon plus 1 teaspoon toasted sesame seeds

1 (8 x 7½-inch/20 x 19-cm) sheet unseasoned nori

1 tablespoon untoasted sesame oil or vegetable oil

For the salad

2 pounds small cucumbers (about 6 lemon or Kirby and 10 Persian), chilled

2 umeboshi plums

1 tablespoon brown rice vinegar

4. Working with the cold cucumbers, remove every other strip of the skin with a vegetable peeler. Cut the cucumbers in half lengthwise. Scoop out the seeds with a teaspoon and discard (if using Persian cucumbers, you won't need to do this). Cut the cucumbers into 1-inch (2.5-cm) chunks, as shown, or into ribbons and put them in a salad bowl.

5. Remove the pits from the plums and discard. Mince the plums into a chunky paste and toss them with the cucumbers. Add the vinegar and toss to coat evenly (you might want to use your hands to break up the plums here). Top with the crunchy cashew topping and gently toss to combine.

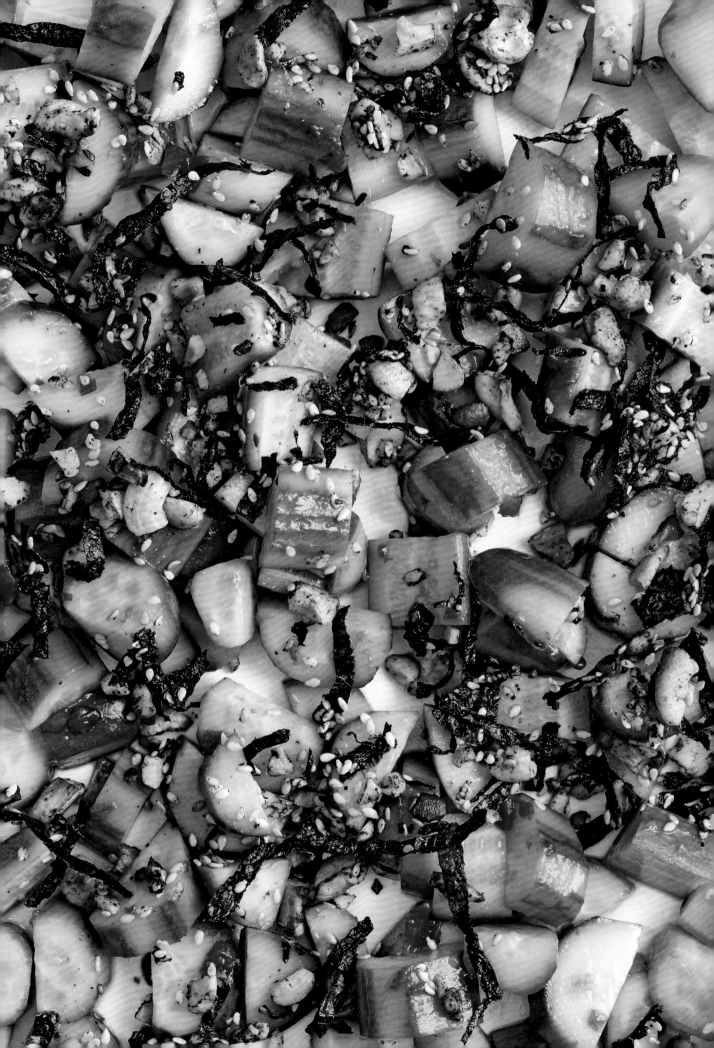

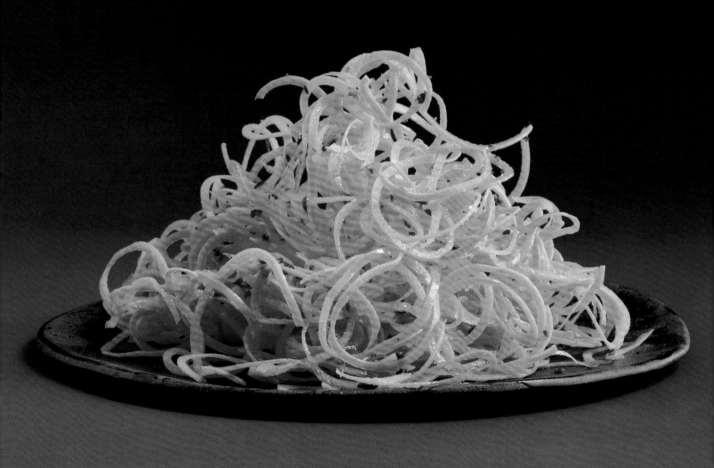

This recipe calls for a vegetable spiralizer, which is, admittedly, the stuff that infomercials are made of, but it does in fact work magic when trying to get some height on the salad plate (and you can now get a spiralizer attachment for some stand mixers). Dainty carrots aren't actually the best for this recipe; large carrots are much easier to work with on the spiralizer. If you just can't bring yourself to purchase another appliance, use a vegetable peeler to create long, thin strips along the length of the vegetable.

Curly Carrots with Candied Cumin

1. Put the vinegar and oil in a large bowl; whisk vigorously to combine. Add the carrots, tossing gently to coat with the dressing. Season with the salt.

2. Put the cumin in a small sauté pan and toast over medium heat, moving the seeds around constantly, until fragrant, 1 to 2 minutes.

1 tablespoon cider vinegar

3 tablespoons extra-virgin olive oil

4 large carrots (about 12 ounces/340 g), spiralized

½ teaspoon sea salt

1 teaspoon cumin seeds

1 teaspoon brown sugar

Freshly ground black pepper

Grated tangerine or orange zest (optional)

3. Add the brown sugar and 1 teaspoon water to the cumin. The mixture should bubble a bit. Remove from the heat and continue to stir until you have a sticky caramel-like substance. Let cool completely in the pan.

4. Once cool, scrape the candied cumin seeds into a mortar and pestle and grind for about 20 seconds, enough to crush most of the seeds. Scatter the sweet cumin on top of the salad, season again with salt and pepper, and finish with a light dusting of the zest, if using.

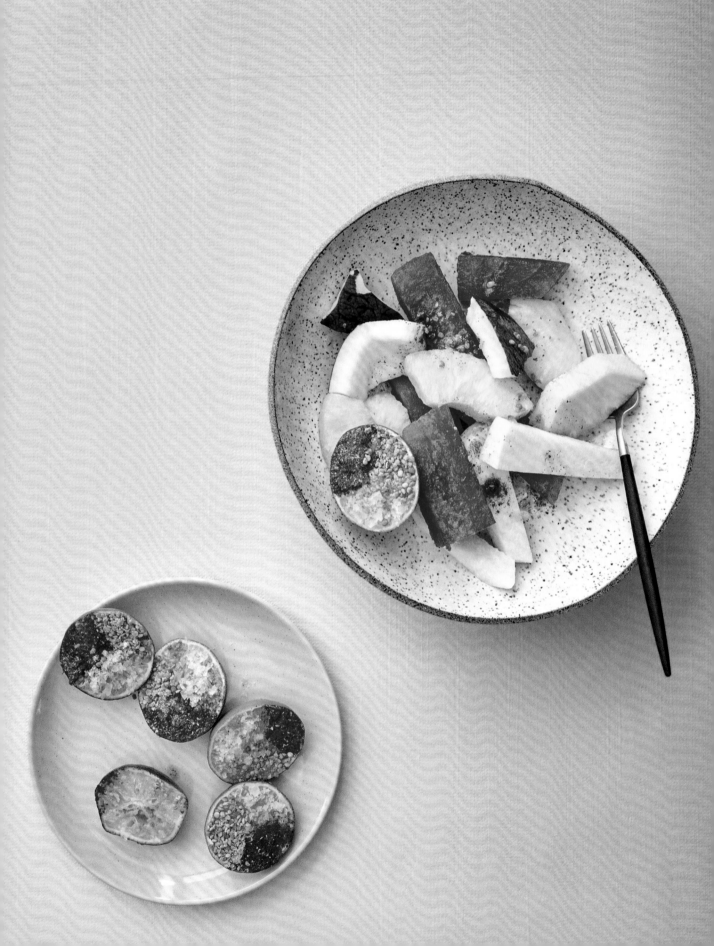

This is a riff on the classic Mexican street cart snack, served in plastic bags on the go. I skipped the plastic bag and put the fruit on a platter, using the sliced limes as a vehicle for Tajín, salt, lime juice, and bee pollen. Guests can add spices and limes themselves.

If you don't have Tajín—a packaged dried mix of lime, mild chile, and a little salt—go get it! This is the secret to any self-respecting Michelada (use it to rim the glasses), and it is magic on fresh cut fruit and veggies. The fruits below are just suggestions: Feel free to serve just one of them, or any combination, or one that I hadn't thought of (most tropical fruits work well).

Look for coconut that has been removed from the shell, often sold at Asian markets and health food stores. I don't recommend buying and cracking a whole coconut yourself, unless you are in desperate need of a labor-intensive project.

Mexican Fruit Salad with Spiced Lime Pinwheels

1. Cut the watermelon, pineapple, coconut, and jicama into equal-size pieces. Arrange them on a platter.

2. Create piles of the pollen, Tajín, and salt on a small plate—the three seasoning piles should be arranged in a circle. Dip the limes face down onto the center of the spices. You should get a pretty tri-toned effect on the face of each lime, as the spices stick to the exposed flesh.

1 mini watermelon, or ¼ regular watermelon

⅓ pineapple, peeled and cored

Flesh of 1 coconut

1 small jicama, peeled

1 teaspoon bee pollen

1 teaspoon Tajín or a mild powdered chile

1 teaspoon fine sea salt

3 limes, halved

3. Arrange the limes on the fruit platter and encourage your guests to squeeze them over their fruit before eating.

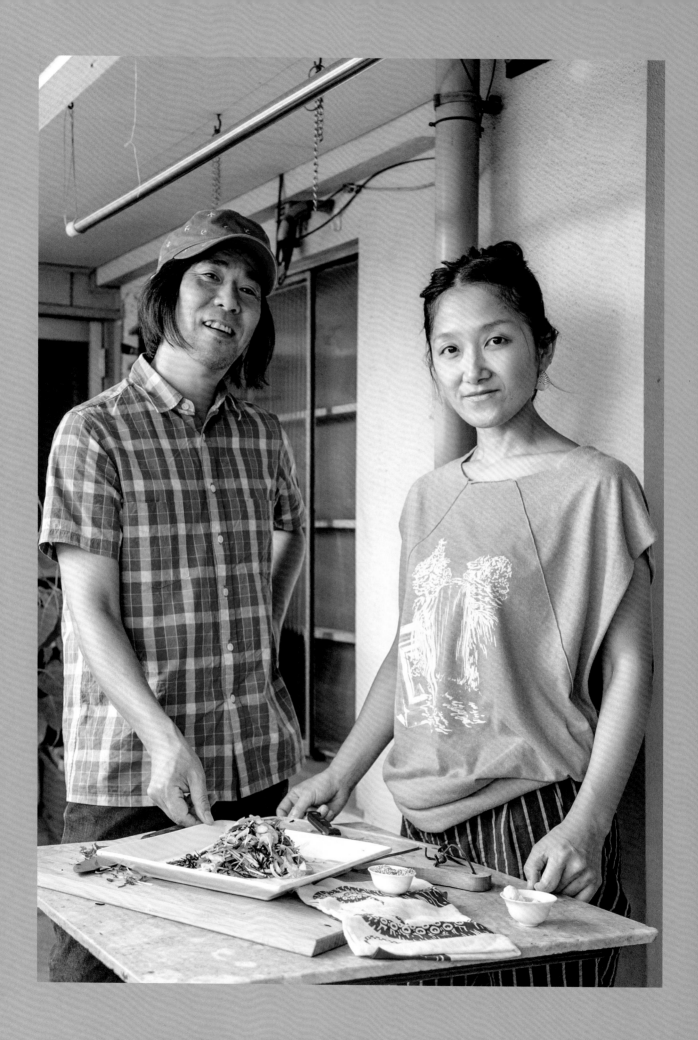

Shinji Masuko and Maki Toba

Occupations: Musicians
Location: Osaka, Japan
Salad: Mizuna Salad with Konbu Tea Dressing (page 111)

Shinji Masuko and Maki Toba are members of Boredoms, one of the loudest bands I actually enjoy. As longtime leaders in the underground Japanese noise music scene, Boredoms scream and moan at a decibel that makes your organs tremble. The band's chaos is balanced by its rhythm; the energy goes up, up, up, until it melts into a million pieces. It's an artful analog to my own manic energy. In 2008, I lay on the grass at the La Brea Tar Pits and listened to the band's 88BoaDrum performance. Eighty-eight exceptional musicians drummed in a massive circle in a spectacle that transcended space and time. This was one of the most memorable musical experiences of my life.

So I was honored when Shinji and Maki picked me up in their white tour van and drove me to their home on the outskirts of Osaka. What I didn't realize was that along with lodging came Shinji and Maki's undivided attention and services as tour guides, including countless home-cooked meals and a three a.m. escort to see the fishermen's auction.

In our correspondence leading up to the trip, I had asked Shinji and Maki if they would contribute to this book. Their polite reply addressed everything but that request. I was perplexed. I broached the topic once more the morning after we arrived—again, total evasion. I have never felt quite so American as I did

105

in this moment—persistent, nosy. And I realized that, despite their identities as performers, these two did not crave offstage attention at all.

They didn't leap at the idea of promotion; it was simply not part of being an artist for them. If they were to make a salad, it would be for different reasons entirely, and I would have to wait and see. I let the idea go, a little more crestfallen with each delicious home-made meal, aching to pull out my camera and jot down notes. On my final day in Osaka, Shinji turned to me and said, "We were thinking we could make a salad this afternoon." Exercising all my restraint, I said, "That sounds lovely," and I let them lead the way.

Below: The Masuko and Toba kitchen.
Opposite: The couple's guest room.

Julia Sherman: What was your first memorable sound experience?

Shinji Masuko: I had trouble with my ear when I was a child, so I had monthly checkups at the ear clinic. I would go into a dark, small, silent room alone and put on these oversize headphones. A tenuous high-frequency sine wave would come from a mysterious vacuum through the headphones, like a sound from outer space—scary but special at the same time.

JS: Is it strange to be an internationally acclaimed musician whose work is lesser known at home than it is abroad?

SM: By the time I discovered noise music, three or four generations of Japanese noise artists had already released great albums with small music labels. These artists gained more recognition overseas than they did in Japan, so I thought maybe I could do that too.

JS: Is it a challenge for contemporary artists to live in a culture that values tradition and craftsmanship over the avant-garde?

SM: Yes, it's different than it is in the U.S. and Europe. Japanese contemporary artists have always been in a very difficult position since contemporary art is too abstract and inaccessible for the common people in Japan. Avant-garde music and art are especially unpopular.

JS: Why do you find it healthy and necessary to make noise?

SM: Noise is not an irregular element for me. However, my purpose is not to just make noise—sound has to have both tonality and atonality.

JS: You seem to live by that same principle. I was surprised to find two artists who play in a band often referred to as "nihilistic" could also be the most polite, civilized people I know. How do you negotiate the clash between your onstage personae and the people you are in everyday life? Or is it a clash at all?

SM: [Laughs.] Um, I can't answer that question because this is just my life. And most of the Japanese musicians I know are exactly the same way!

JS: Well, I love your shows, but I really loved spending so much quiet time with you at home with your cat. This book is less about artists' salads and more about artists' pets . . .

SM: Please don't ask me about my cat. I can't answer calmly because I am crazy about my cat.

[Laughs.] My cat always accepts me generously. But sometimes it feels like I am kept by him, more than he is kept by me.

JS: I know the feeling [laughs]. You guys have traveled the world playing music. I like to imagine touring the world not "site-seeing" but "site-listening." What sounds in the world excite and inspire you?

SM: These are some of the places I would like to hear again: Distorted azan calls to prayer and Koran chants piping from cheap speakers in a Cambodian village. Mockingbird songs that sound like car engines in Nevada; a squall over the rainforest in Thailand. Sea waves in the mechanical room of a big Russian cruiser boat; uproarious crowd-sounds in the Moroccan market; water rushing into a cave in Wakayama; a lightning storm erupting around our tour van in Missouri.

JS: Wow, you have an incredible catalog of sound memories! Do you ever get sick of all the touring?

SM: Touring and traveling are always exciting for me. I have never gotten sick of it, and at the same time, I love my daily life in Osaka equally. Maybe my life's ambition is to position myself at the intersection of the everyday and the extraordinary.

Masuko and Toba enjoy a quiet breakfast with their cat.

109

Konbu cha (seaweed tea), is a superfine kelp powder used to make a warm, brothy beverage in Japan. Shinji and Maki use the powder as a base for a light dressing that tastes like miso of the sea.

Hijiki is the second form of seaweed used in this salad. There are two different types of dried hijiki seaweed that will work (I like both). Nagahijiki is more substantial and a bit less common, and the other, mehijiki, is flaky, less assertive, and served in most Japanese restaurants as a dish called hijiki no nimono. Nagahijiki is the "stems" of the hijiki plant, spindly twigs that plump when reconstituted. They are spaghetti-like, mild in flavor, and easy to chew. Mehijiki is dried hijiki leaves with a finer texture, similar to that of a loose black tea. When reconstituted, mehijiki softens more than it plumps (think of steeped loose tea leaves), but once tossed in the salad it will blend evenly with the greens and the myoga.

Hijiki and konbu cha can be purchased at pretty much any Japanese market or bought online. Myoga, Japanese ginger flower, should be available at your Japanese grocer starting in late spring through the summer. I fell in love with myoga in Japan. It is a transcendent ingredient worth seeking out, but this salad will be more than flavorful enough without it.

Shinji Masuko and Maki Toba's Mizuna Salad with Konbu Tea Dressing

1. Make the salad: In a small bowl, cover the dried hijiki with 2 inches (5 cm) warm water and set aside.

2. Trim the bottom stems off the myoga flowers. Slice each myoga in half lengthwise, then slice it into strips as thinly as possible.

3. Make the dressing: Whisk the konbu cha, vinegar, sesame oil, and grapeseed oil together in a small bowl.

For the salad

⅓ cup dried hijiki

4 whole myoga flowers

4 ounces (115 g) green mizuna, stems trimmed

1½ cups (28 g) radish sprouts

1 tablespoon plus 1 teaspoon toasted sesame seeds

For the dressing

1 teaspoon konbu cha (powdered kelp tea)

2 teaspoons seasoned rice wine vinegar

2 tablespoons toasted sesame oil

1 tablespoon grapeseed oil

4. Strain, rinse, and briefly spin the hijiki (or pat it dry with a towel). Put the hijiki into a large salad bowl with the sliced myoga, mizuna, radish sprouts, and sesame seeds.

5. Drizzle the dressing over the salad, toss to thoroughly coat, and serve immediately.

I recently learned that lots of people dislike turkey. That said, people do love the flavors of Thanksgiving—the marriage of citrus and tart cranberries in particular. This salad is for all the haters out there: Take the holiday favorites and leave the turkey in her coop. If cranberries are out of season, use frozen, not dried. If you can't find frisée, substitute another chicory-like endive or escarole; it is all about the sweet and tart dressing paired with the lightly bitter greens.

Frisée with Toasted Sesame Seeds and Cranberry-Citrus Vinaigrette

1. Using a mortar and pestle, crush the cranberries until they become pulpy and release some liquid. Add the orange zest and honey and pound them together until they are completely combined. Transfer them to a bowl and stir in the vinegar, shallot, and mustard. Whisk in the oil.

2. Pull apart the frisée and radicchio and tear the leaves into bite-size pieces. Wash and spin them dry and put them in a large salad bowl.

For the dressing

15 fresh cranberries

½ teaspoon grated orange zest

1 teaspoon honey

2 teaspoons cider vinegar

1 teaspoon minced shallot

½ teaspoon Dijon mustard

¼ cup (60 ml) good-quality extra-virgin olive oil

For the salad

1 head frisée lettuce

½ head radicchio

2 teaspoons untoasted white sesame seeds

Kosher salt and freshly ground black pepper

3 to 4 ounces (85 to 115 g) chèvre cheese (optional)

3. Toast the sesame seeds in a dry sauté pan over low heat, moving them around constantly in the pan until they start to turn golden brown, about 3 minutes.

4. Toss the frisée and radicchio with the dressing until completely coated. Add the sesame seeds and season with salt and pepper. Crumble the cheese, if using, over the salad and serve.

Tauba Auerbach

Occupation: Artist, publisher
Location: New York City
Salad: Shredded Brussels Sprouts Salad with
Lemony Almonds and Shaved Apple (page 132)

I met Tauba Auerbach in a chance encounter in Rome, where she was scouting the location of her upcoming show with the gallery Indipendenza. She was actually sleeping in the gallery itself, a family home only partially transformed into an exhibition space with perfectly peeling floral wallpaper and patches of original mosaic tile on the floors. Despite her extraordinary grasp of design and construction in both 2-D and 3-D, Tauba insists on visiting a space before conceptualizing the show that will live there. She feels it out, visualizing her work in each unique site. I made a plan to picnic with her on the gallery roof for dinner. Tauba is a committed vegan, so we indulged in a spread of marinated vegetables, breads, seasonal fruit, and lots of wine. Her company, and our view of the city from that rooftop, made it a meal I will never forget.

When the sun set, we went in search of the Aventine Keyhole, a storied opening in a locked garden gate said to perfectly frame a view of the Vatican far off in the distance. Tauba had been assured that it did really exist; she just didn't know where it was. We spent hours roaming the city. When somehow we happened on the tiny keyhole at the end of a pitch-black residential street, it was four a.m., and the only people to be found were in parked cars with steamed windows (apparently, this was the Roman take on "make-out point"). We took turns peeking at the Duomo through the hole, and then we parted ways. It was a romantic way to meet an artist whose work I had long admired.

Tauba's work is as alluring as it is smart, drawing on mathematical and architectural theory, linguistics, and tetrachromaticism manifest in handmade glass, woven canvases, spray paint, and

musical instruments. She is right-brained and left-brained all at once—and to the max. I have to admit, I was relieved when she assured me that, despite the incredible volume and range of her creative output, she is "not a morning person."

As much as I gravitate toward her mystifying objects and canvases, it is Tauba's side project, Diagonal Press, that most aptly speaks to who she is. All of her critical and market success has inspired Tauba to pour more energy into an endeavor that bucks the commercial art market. The works she makes under the aegis of Diagonal are thoughtful, personal, and meant to be distributed as widely as possible. For every coveted painting Tauba sells through her blue-chip gallery, she sells thousands of enamel pins, ornate rolling papers, books, and posters. These are inexpensive and often sold by the artist herself, from behind a folding table at the Los Angeles and New York Art Book Fairs. I sat down with Tauba in her Chinatown studio to make a cruelty-free vegan meal and talk about the optimism inherent in her parallel practices.

Previous page: Auerbach and photographer Lele Saveri enjoy their morning coffee in their Soho apartment.
Below: Auerbach pulls open the plastic curtain that seals off her airbrush room from the rest of her studio.

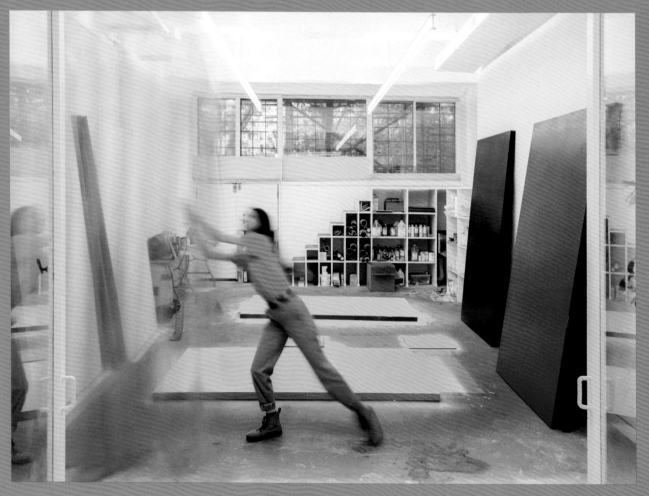

Julia Sherman: I'm interested in how you think about your life's work as compared to your artwork? What does success look like for you, and how has it changed since you started showing your work?

Tauba Auerbach: This is such a big and great question! I can't imagine trying to answer it all at once though. Maybe an answer will just sort of emerge as we talk?

JS: That's fair; I guess I jumped in with a mega-existential inquiry right off the bat . . . Taking a step back then: Can you tell me about Diagonal Press?

TA: Diagonal publishes books, type-specimen posters, paraphernalia, mathematical models, and enamel pins with topological/ornamental symbols. The publications are as inexpensive as possible, mostly made in my studio with office supplies and generic binding machines. I think it's fun to do ambitious things with simple resources.

JS: I love that. In some ways, you could see it as an insurance policy against the temptation to make things bigger and more elaborate, just because you can. I can think of so many artists whose work became flashier over time, but their best work is usually their early, more modest experiments.

TA: I agree. I think it's a very corporate-minded mistake. I personally want to work with as small a team as possible. I have no ambition to run an empire.

JS: Some silly people might find it surprising that you would spend your time, resources, and energy on an endeavor designed in opposition to the very market that has embraced your work. How did Diagonal Press come to be, and what role does it play in the way you shape your own career?

TA: I started Diagonal in 2013 after receiving a crash course in the distinct ugliness that the art world has to offer. It was my dream since childhood (other than being an astronaut) to spend all my time making art, and I'm overjoyed that I get to do that. But, when I started having shows, I was as green as a person can be, and I've had some painful learning experiences. I was just kind of feeling my way along, figuring it out as I went, and then suddenly people went nuts over a certain series of my paintings. A few months

later, my New York gallery announced that it was closing. Then the craziness began.

JS: How so?

TA: I received creepy mail at my house and threatening emails from collectors who couldn't get paintings. Basically, I just saw a lot of people wielding the power of their wealth in unkind and destructive ways.

JS: Why was this happening? What caused the frenzy?

TA: One reason was that I had kept my prices much lower than they could have been, as some kind of misguided gesture of sincerity. I wanted it to be clear that I was making art for the right reasons, not to get rich. But people saw an opportunity to flip my work for huge profits, and it slowly became evident that my strategy had encouraged the greed I had intended it to stand against. It also created an instance of great wage disparity—as the artist, I had done all the work, but the flippers were making twenty to one hundred times as much as I was. Eventually I decided to get over my embarrassment at the fact that people were willing to pay a lot for my paintings, and just use the opportunity to treat my employees well and support causes I believe in.

JS: Why is it embarrassing to know that people value your work, and that they are willing to pay for it?

TA: I worried that people were valuing my work for reasons I don't agree with. So to answer your original question: The press is an experiment intended as a counterweight to all of this—something that I could build from scratch using all the knowledge and experience I'd acquired while bumbling naively through the first part of my career. A key feature of the business structure is that Diagonal publishes everything in open editions, and nothing is signed or numbered.

JS: Why is it important that your editions remain open?

TA: I wanted to remove the secondary market from the equation. Since buying from Diagonal is not a financial investment, one would only bother to purchase something if they valued the thing itself, which is the kind of exchange I'm after. I want people to own the Claude Bragdon books I just republished because they want to experience

his thinking. I'm trying to create the circumstances for a straightforward transaction.

JS: It must also give you the opportunity to expand your audience exponentially. I mean, what percentage of the population feels comfortable walking into galleries, let alone collecting art? Even I find it intimidating!

TA: Yes! I love being at the book fair and talking to everyone from design students to antiquarian booksellers to people who just came because it was something to do with their weekend.

JS: So, with the typefaces you design, for instance, you are making something that would typically fall under the umbrella of "design" more than "art," but I think it is actually one of your most personal projects. How do you make the fonts, and how are they supposed to exist in the world? What don't people understand about them?

TA: They just kind of happen along the way as a natural document of where my head is at a particular moment in time. It's like the fonts are different voices. Fig Font—the font I made in 2006—was the voice that narrated that year for me. And, a few years later, when I was making a lot of woven paintings in the studio, I found myself making a woven-style typeface. I don't sell them as usable typefaces, just as specimens.

I'm too emotionally attached to sell them for use. I once spotted a copy of one on a magazine cover, and it felt like seeing someone else's lips move and my voice come out.

JS: I like that. Our experience of the world is never fully separated from language, so the fonts are like a visualization of a complex moment in your life. Somehow beyond words, but rooted in them.

TA: They are indeed very personal, but I didn't expect that would register with anyone. Thanks for noticing!

JS: I am curious how you became vegan. What led to that decision?

TA: It was something I thought about a lot over the course of fifteen years as a vegetarian. I agreed with veganism in principle, but my favorite food was cheese, and I thought it would be just too difficult. Then a few years ago I had a conflict with a fashion house that led me to do a lot of research about animal welfare. I had some money to give away, and I didn't know what the most pressing issues were, or what forms of activism were most effective. In the research process I learned and saw so many things that I just can't un-know and can't un-see. I simply cannot enjoy a milk product, knowing what dairy cows experience. It's not delicious anymore.

Left: A pile of decorative pins produced by Auerbach's publishing project, Diagonal Press.
Right: Auerbach's work shoes and respirator, covered in airbrush paint residue.

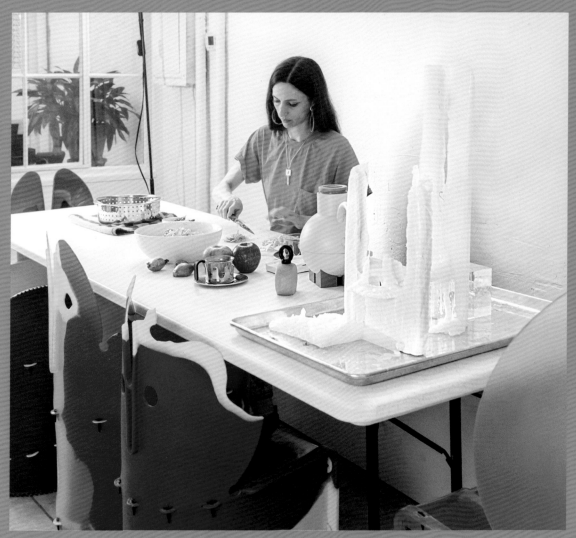

Auerbach prepares her favorite vegan salad in her studio.

These products are a result of pain; it's just that simple.

JS: Vegans get a bad rap for being a buzz kill, but the truth is out there; it's just a matter of choosing to pay attention.

TA: Well, it's hard to find a non-alienating way to talk about this issue. My decision was not only one of compassion but of logic. Raising animals for food produces more greenhouse-gas emissions than all forms of transportation combined. Most of the land deforested in the Amazon is used for raising cattle. There are a million damning facts, and I could go on and on, but basically the industry is a disaster on all levels, and I can't support it.

JS: Any tips for people looking to make the plunge to give up animal products?

TA: I started by committing to it for just a month to see how I liked it. I highly recommend this experiment! And honestly, I wasn't optimistic that I could stick with it, but I quickly felt much healthier and much happier because my behavior was more aligned with my thinking. Maybe to answer your very first question, I think my life's work is figuring out how to live in this surreal, fucked-up world in a way that's both ethical and fun. The circumstances of our time make that really difficult, so this is a lifelong project.

JS: If you weren't an artist, what would you be?

TA: My astronaut dreams are still intact.

Serves
4

Prep Time
15 minutes
active

50 minutes
passive

The genius of this recipe is in the lemon-soaked almonds, toasty and crunchy, tart and salty. Tauba keeps these on hand as a healthy, high-protein way to graze throughout the day. After baking for 20 minutes the nuts will be a very dark brown, almost burnt. Don't worry; that's just what you want. You can make them up to a week ahead of time, cutting down on the prep time for the salad.

When purchasing Brussels sprouts, select the tightest, most compact little dudes you can find. As long as they are a nice green, not yellow, the big ones should still be good, but they lose some of their sweetness with time. Brussels sprouts are available from September to March, but they taste best after they have lived through the first frost, making this an ideal winter or spring salad. Chervil, my favorite salad herb with a delicate fresh anise taste, will be nearly impossible to find in the winter. But as soon as it is in the greenmarket, grab as much as you can and you will find yourself tossing it into all your basic salad greens and on top of soups.

Tauba dresses her salad simply with the juice of one Meyer lemon and 5 tablespoons of olive oil alone. I included a sherry vinaigrette with this recipe, just in case you are like me and crave a little sweetness with your winter salads. The choice is yours.

Tauba Auerbach's Shredded Brussels Sprouts Salad with Lemony Almonds and Shaved Apple

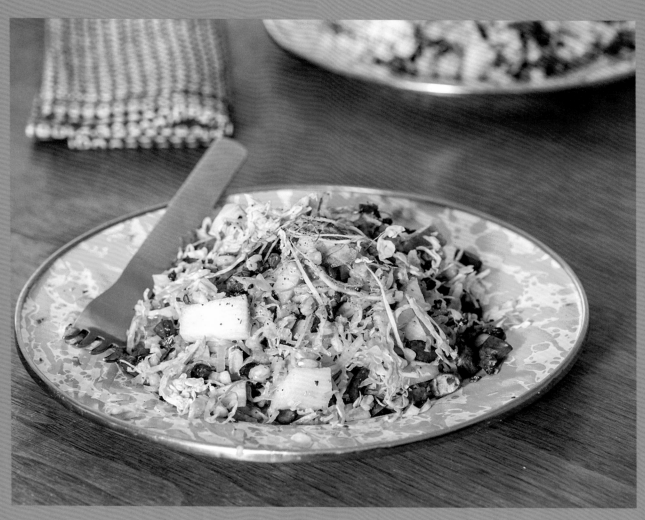

1. Make the almonds: Coarsely chop the almonds, making sure each almond is chopped at least in half. Put them in a small bowl. Add the lemon zest and juice to the almonds. Set them aside to marinate for 30 minutes.

2. Make the dressing: Put all the ingredients in a medium salad bowl and whisk until the oil is emulsified.

3. Make the salad: Add the Brussels sprouts to the dressing and toss to evenly coat them. Season with the salt and set aside.

4. Finish the almonds: Preheat the oven or a toaster oven to 325°F (165°C). Add the salt and oil to the almonds and stir to combine. Spread the nuts evenly on a baking sheet and bake on the center rack for 20 minutes, stirring them around halfway through the cooking time to prevent burning on the edges, until they are very dark. Let cool completely.

For the almonds

¾ cup (105 g) whole raw almonds

Grated zest and juice of 1 small lemon

½ teaspoon fine sea salt

1 tablespoon olive oil

For Julia's dressing

¼ cup (30 g) thinly sliced shallot

2 tablespoons sherry vinegar

1 tablespoon plus 1 teaspoon cider vinegar

2 teaspoons Dijon mustard

1 teaspoon maple syrup

5 tablespoons (75 ml) extra-virgin olive oil

For the salad

4 cups (370 g) trimmed and thinly shaved Brussels sprouts

½ teaspoon sea salt

1 medium, firm, sweet apple, such as Gala, Fuji, Jazz, or Cameo

1 cup (200 g) cooked farro

2 teaspoons Pickled Mustard Seeds (optional, page 255)

¼ cup (13 g) loosely packed fresh chervil leaves

Freshly cracked black pepper

5. Finish the salad: Cut the apple in half. Cut each half into thirds, cut out the core, and slice the wedges crosswise ½ inch (12 mm) thick.

6. Toss the apple pieces into the salad, along with half of the toasted almonds and the farro. Scatter the pickled mustard seeds on top, if desired, then top with the remaining nuts and the chervil. Season with salt and pepper to taste.

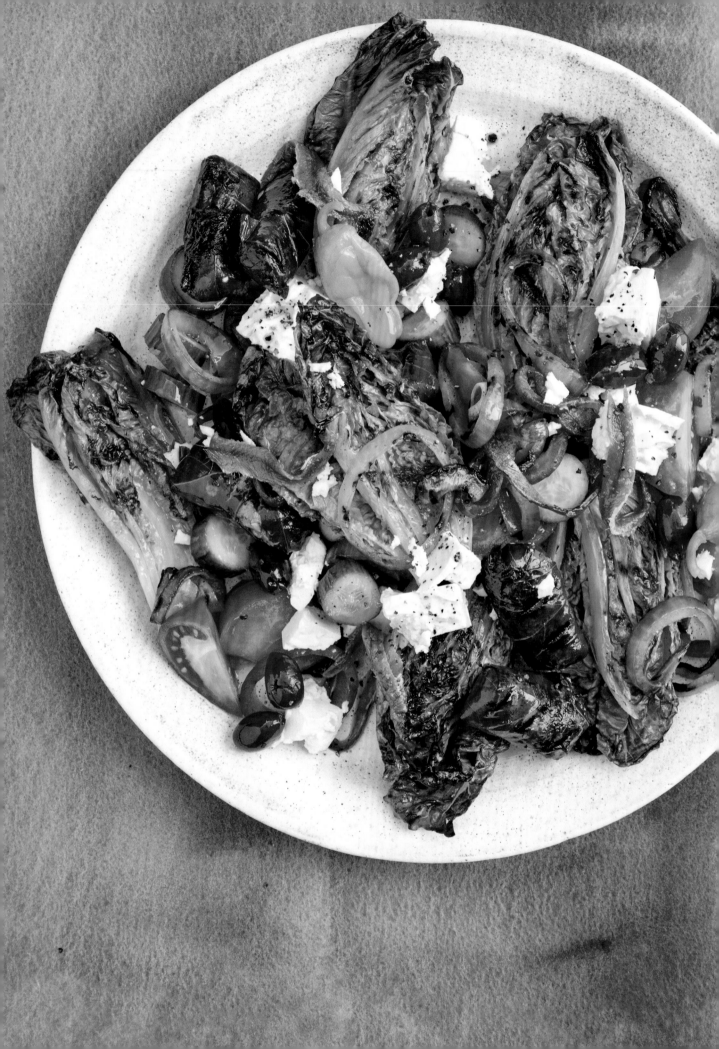

Serves
4

Prep Time
15 minutes

This salad proves that rules are meant to be broken. I have always considered the classic Greek salad to be the Platonic ideal. I balk at fancy upgrades since the cheap red wine vinegar, Kalamata olives, and romaine are fundamental to the dish. Hell, I even prefer dolmas (stuffed grape leaves) from a can to those from the deli counter.

Then one day I had a few vegetarian dolmas left over in the fridge, and I tossed them on the grill to warm them up. The oil-marinated leaves crisped, the rice steamed and softened inside, and I had somehow managed to improve upon my favorite snack. With the rules out the window, I tossed all the veggies on the grill (save the cucumbers and tomatoes), and it worked. It's not a replacement for the fresh Greek salad, but with the old-school Greek diners becoming a thing of the past, this is a fun variation to make at home.

Greek Salad on the Grill

1. Prepare a charcoal fire, heating until the coals turn white.

2. While the coals are heating, brush the romaine and onion rounds with oil and season with kosher salt, pepper, and the oregano. Place the feta and and the olives on a rectangular piece of aluminum foil and fold the edges upward to create a shallow boat. Drizzle them with oil (see Note).

3. Spray the grill grate with cooking-spray oil or brush with vegetable oil.

4. Place the stuffed grape leaves, romaine, onion, and feta/olive packet on the grill and cook until the vegetables have a nice light char on all sides, 4 to 5 minutes total. The feta should be warm through-out. Remove from the grill with tongs.

4 hearts of romaine, bottoms trimmed, cut in half lengthwise

1 small red onion, cut into rounds ¼ inch (6 mm) thick

Extra-virgin olive oil

Kosher salt and freshly ground black pepper

1 teaspoon dried oregano

One 6-ounce (170-g) slab sheep's milk feta cheese, 1 inch (2.5 cm) thick

¼ cup (50 g) Kalamata olives

8 to 10 canned or fresh vegetarian stuffed grape leaves (dolmas)

1 medium ripe heirloom tomato, cored and cut into 1-inch (2.5-cm) chunks

2 to 3 small Kirby or Persian cucumbers, cut into 1-inch (2.5-cm) pieces

4 or 5 oil-packed anchovy fillets (optional but highly recommended)

Pepperoncini (optional)

Red wine vinegar

Sea salt

Breadsticks or Melba toast (optional)

5. On a large platter, make a bed of the grilled romaine (keeping the halves intact) and top with the tomato, cucumbers, grilled onion, olives, and stuffed grape leaves. Cut the feta into 1-inch (2.5-cm) cubes and toss them on top. Drizzle the whole mess generously with oil and season very lightly with sea salt (the olives, feta, and anchovies add lots of salt) and black pepper to taste.

6. Top with the anchovies and pepperoncini, if using. Serve with red wine vinegar and oil on the side (you can also dress the salad for your guests, but I like to do it myself), and breadsticks or Melba toast if you want to make a nod to the salad's roots.

Note: Tossing the cheese on the grill is optional, but it's a nice way to warm it up before serving. Feta cheese sticks to the grill, so be sure to use tinfoil if you decide to do this step.

Serves
4 to 6

Prep Time
1 hour 15
minutes active

overnight
passive

When soaking and cooking dried beans, use the highest quality available to ensure that they cook consistently. Keep an eye on them as they simmer and take them off the stove if they start to break apart. Beans can be cooked ahead of time and kept in the fridge (I drizzle mine with olive oil to keep them moist); just bring them to room temperature before serving.

Preserved lemon has the most beautiful, funky floral flavor, and a little goes a long way (see Pantry Staples, 255). This recipe uses a dash of the lemon brine in the dressing, so if purchasing preserved lemons from a barrel at the Middle Eastern grocer, spoon up some of the liquid, too.

White Bean Salad with Preserved Lemon, Mâche, and Seared Calamari

1. Put the beans in a pot and cover them with water by at least 2 inches (5 cm). Let them sit overnight.

2. Drain the beans and transfer them to a saucepan. Add the stock (they should be covered with 3 inches/7.5 cm of liquid; add water if needed). Bring them to a low boil over medium heat, then reduce the heat and simmer, partially covered, for 45 minutes to 1 hour, or until the beans are creamy but have not yet burst. If the cooking liquid reduces and the beans peek out, add more water to cover.

2. Meanwhile, put the onion in a small bowl, sprinkle with the sugar and a good pinch of salt, and pour the vinegar over the top. Smash the onions down with your fingertips a few times to really get the pickling started. Set aside while you assemble the rest of the salad.

3. When the beans hit their sweet spot, fully cooked and no longer starchy, drain the liquid (if using broth, you can reserve the broth for future use) and return the beans to the saucepan with the olive oil, 1 teaspoon salt, the preserved lemon, and lemon brine. Gently toss, being careful not to mash the beans, and cover to keep warm.

8 ounces (225 g) high-quality dried cannellini beans

3 cups (720 ml) unsalted or low-salt Chicken Stock (page 253) or vegetable stock

2 tablespoons thinly sliced Vidalia onion

⅛ teaspoon sugar

Kosher salt

3 tablespoons white wine vinegar

¼ cup (60 ml) olive oil

2 tablespoons plus 1 teaspoon minced Preserved Lemon rind (page 255)

1 tablespoon preserved lemon brine

8 ounces (225 g) cleaned calamari

Freshly ground black pepper

4 tablespoons grapeseed oil

½ cup (60 g) minced celery, plus 1 tablespoon chopped celery leaves

1 cup (30 g) mâche

High-quality extra-virgin olive oil

1 lemon, cut into wedges

4. Slice the calamari into ¼-inch (6-mm) rounds; rinse, and pat dry. Season with salt and black pepper. In a medium cast-iron skillet, heat 2 tablespoons of grapeseed oil over high heat until it begins to smoke. Toss half of the calamari into the pan, spread into a single layer, and cook on one side for 1 minute. Flip the calamari and cook for 2 minutes on the other side, until they are golden brown on the surface, then remove with a fish spatula or slotted spoon and place on a paper towel to absorb excess oil. Add the remaining 2 tablespoons of grapeseed oil to the pan, and cook the remaining calamari.

5. Toss the celery in with the beans. Taste and season with more salt if needed. Spoon the mixture onto a platter or shallow serving bowl, scraping the bottom to get all that oil. Place the mâche around the edges and a few smaller leaves on top. Scatter the calamari and pickled onion on top and garnish with the celery leaves. Finish with a generous drizzle of olive oil and serve warm with the lemon wedges.

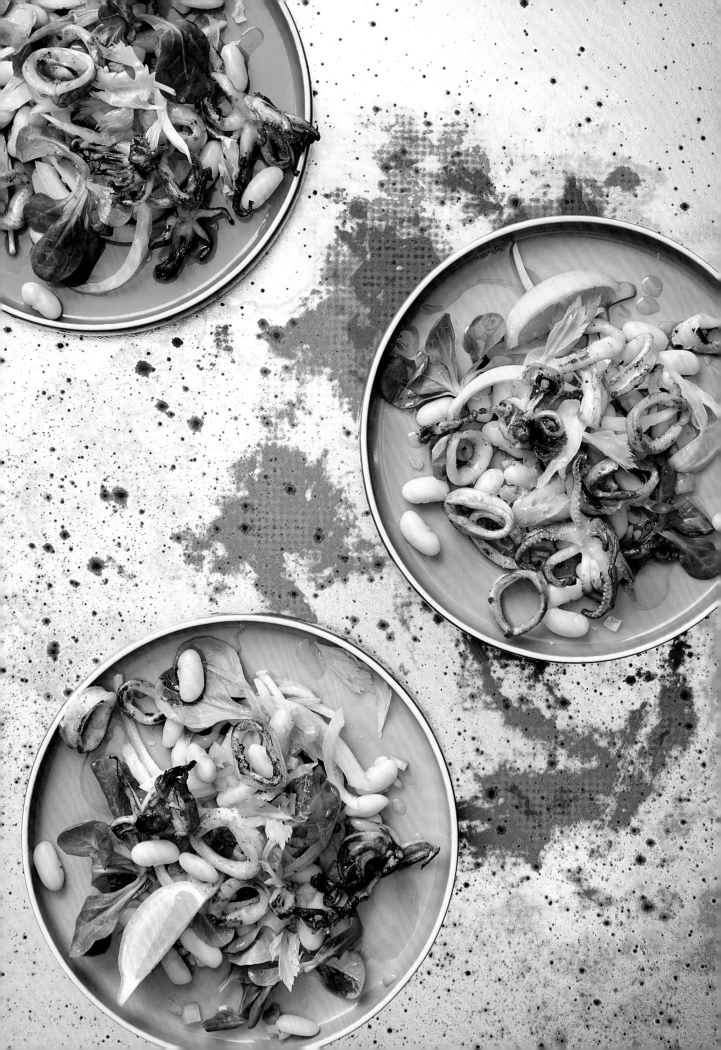

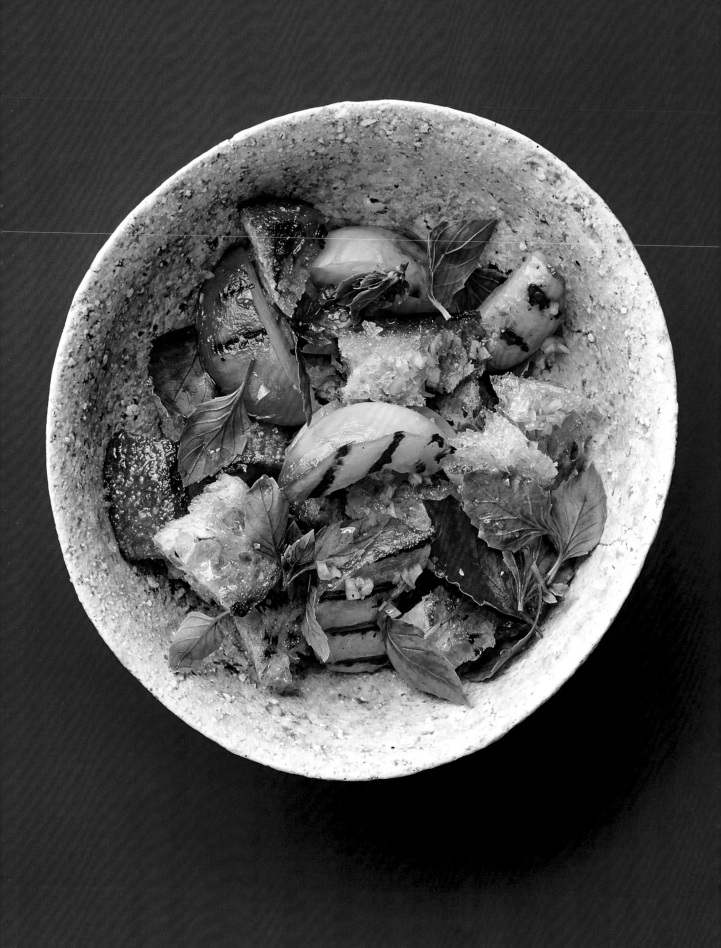

Serves
2

Prep Time
30 minutes

In the pastry world, peaches and almonds are a classic pair, so it's no surprise that they work well in salad too. The almond flavor is subtle, introduced with a dash of almond extract (there are no actual nuts here at all). The sugar in the peak-season peaches caramelizes on the grill and their juices run, making a sweet and tangy marinade for crusty chunks of sourdough.

If you don't feel like heating up the coals, broil the peaches cut-side up in the oven or sear them on a well-oiled grill pan (cut-side down). Purple basil (also known as opal basil) tastes just like classic Genovese basil, but the color is a nice touch against the hue of the fruit.

Grilled Peach Panzanella with Almond Essence and Purple Basil

1. Prepare a very hot charcoal fire, heating until the coals are white-hot. Distribute them evenly in the bottom of the grill.

2. While the coals are heating, make the dressing: Whisk the almond extract, vinegar, shallot, and oil together in a small bowl.

3. Make the salad: Halve the peaches along the line of the cleft (stem to bottom). Remove the pits and put the fruit in a large bowl. Drizzle with 1 tablespoon of the oil, season with a pinch each of salt and pepper, and toss to coat. Drizzle the remaining 1 tablespoon of the oil on both sides of the bread slices and season with salt and pepper.

4. Spray the grill grate with cooking-oil spray and let it heat up for a minute or two. Arrange the bread slices on the outer edges of the grill grate and the peaches cut-side down in the center (don't rinse the bowl;

For the dressing

¼ teaspoon almond extract

2 teaspoons sherry vinegar

2 teaspoons minced shallot

1 tablespoon extra-virgin olive oil

For the salad

1 pound (455 g) ripe yellow peaches (7 or 8 very small, or 4 medium)

2 tablespoons extra-virgin olive oil

Sea salt and freshly ground black pepper

2 (1-inch/2.5-cm-thick) slices crusty sourdough bread

2 tablespoons fresh roughly torn purple or Genovese basil

set it aside). Grill the bread for 1 minute on each side, until lightly toasted. Grill the peaches until the bottoms are caramelized and lightly charred, about 3 minutes. Flip the peaches and cook for an additional 3 minutes on the opposite side.

5. Cut the toasted bread into 1-inch (2.5-cm) cubes and put them in the peach bowl along with all the crusty crumbs left behind on the cutting board. Slice each peach half in half again, or into large chunks if the peaches are larger, and put them in the bowl.

6. Drizzle the dressing over the peaches and bread and set aside to marinate for 5 to 10 minutes.

7. Toss the torn basil on top, season with additional salt and pepper if needed, and serve.

Serves
4 to 6

Prep Time
15 minutes

Collards, the most treasured vegetable in Southern cuisine, do not have to be stewed in pork fat to be tempting. Sliced super thin and massaged until tender, they are wonderful served in raw salad form. Tossed with homemade bread crumbs (so much better than the packaged kind!) and lots of finely grated pecorino cheese, this salad passes as an indulgent party dish while also serving up a healthy dose of dark leafy greens.

Collard Chiffonade Salad with Roasted Garlic Dressing and Crunchy Crouton Crumble

1. Make the bread crumbs: Preheat the oven to 350°F (175°C).

2. Drizzle the oil over the bread and season it with salt, black pepper, the red pepper flakes, and oregano. Spread the bread on a baking sheet and bake until golden brown, about 15 minutes. Let cool, then transfer to a food processor and pulse until you have coarse, golden crumbs.

3. Make the dressing: Put the anchovy fillets in a small bowl and cover them with warm water for 5 minutes. Remove the anchovies from the water and pat dry. Chop them with the roasted garlic, smearing them to a paste with the broad side of your knife until smooth. Transfer to a medium bowl, add the lemon juice and mustard, and whisk in the oil in a steady stream until emulsified.

For the bread crumbs

2 tablespoons olive oil

5 inches (12 cm) stale sourdough bread (about 6 ounces/170 g), torn into 1-inch (2.5-cm) or smaller pieces

Kosher salt and freshly ground black pepper

½ teaspoon red pepper flakes

¼ teaspoon dried oregano

For the dressing

6 oil-packed anchovy fillets

3 to 4 cloves Roasted Garlic (page 254)

Juice of 1 lemon

¼ teaspoon Dijon mustard

½ cup (120 ml) olive oil

For the salad

About 1 pound (455 g) collard greens (the smaller the leaves, the better)

Olive oil

Sea salt

Pecorino Romano or Parmesan cheese

¼ cup (13 g) flat-leaf parsley leaves, torn

1 tablespoon minced fresh chives (optional)

Cracked black pepper

4. Make the salad: Remove and discard the center stalks from the collards. Stack the leaves and slice them as thinly as possible (this is called a chiffonade). Put the collards in a large bowl.

5. Massage the collards with your hands, adding a drizzle of oil and ¼ teaspoon of sea salt. Be aggressive. Taste the collards as you go, and stop when they are soft to the bite and wilted.

6. Add the salad dressing and toss to coat. Add the bread crumbs just before serving and toss to combine.

7. Grate cheese over the salad with a Microplane and top with the parsley leaves and chives, if using. Taste the salad and season with additional salt and cracked black pepper if needed.

Serves
4 to 6

Prep Time
30 minutes

This salad is my nod to Chinese chicken salad, an American favorite that will forever hold a place in my heart. Instead of wontons, play with this super-healthy crunch-alternative made from unsweetened puffed rice cereal (I used generic Quaker's) and Thai red curry paste, available in the Asian foods section of your grocery store (it's magic in soups and veggie marinades). Hulled hemp seeds are a nutty superfood that can be found in any health food store next to the chia and the flax (you know the aisle). If you are doing meal prep for the week ahead, be sure to store the crunchy topping separately from the salad to keep it crispy, and add the topping just before serving.

When it comes to the chicken, you have options: If you are so savvy as to have adopted my ritual of making homemade chicken broth, you might already have pulled chicken in the fridge (see page 254). Or, if you want chicken with a little more character, add aromatic herbs like makrut lime leaves, lemongrass, galangal, and ginger to your poaching liquid (see page 254). Not up for all that? Take the Sandra Dee approach: Buy a prepared rotisserie chicken and shred the dark and light meat with a fork in seconds flat. Rotisserie chicken is economical, even if/when you buy the best quality. (Don't forget to save the bones in the freezer to make stock later.)

Pulled Chicken Salad with Napa Cabbage and Red Curry Puffed Rice

1. Make the puffed rice: Preheat the oven to 350°F (175°C). In a medium bowl, combine the puffed rice, hemp seeds, chia seeds, and salt.

2. In a small saucepan, heat the coconut oil, honey, turmeric, curry paste, and flax meal and whisk to combine. The curry paste won't dissolve completely, but that's okay. Simmer for 1½ minutes, letting the ingredients bubble and thicken. Using a rubber spatula, pour the sauce over the puffed rice mixture, scraping down the sides of the pan. Stir to coat well. Once the wet ingredients cool, you can use your hands to mix evenly.

3. Spread the mixture out on a baking sheet in a single dense layer, and bake on the center rack of the oven for 4 minutes. Use a spatula to fold the outer edges in toward the center of the sheet pan to encourage even browning. Bake for another 4 minutes, until fragrant and a shade darker in color. Remove from the oven and let cool completely (as the mixture cools, it sticks together, forms clumps, and gets crispy).

For the red curry puffed rice

2 cups (35 g) unsweetened puffed rice cereal

2 tablespoons hulled hemp seeds or sesame seeds

2 teaspoons chia seeds

½ teaspoon kosher salt

¼ cup (60 ml) coconut oil

4 teaspoons honey

1 teaspoon ground turmeric

2½ teaspoons Thai red curry paste

1 teaspoon ground flax meal

For the dressing

3 tablespoons fresh lime juice

3 tablespoons seasoned rice wine vinegar

2 teaspoons fish sauce

1 teaspoon maple syrup

1 to 2 teaspoons minced seeded serrano chile

2 teaspoons minced fresh cilantro stems

1 small clove garlic

3 tablespoons sesame oil or grapeseed oil

For the salad

4 cups (300 g) ½-inch (12-mm) napa cabbage strips

¼ red onion, thinly sliced

3 cups (585 g) shredded cooked chicken, white and dark meat (see Note)

Sea salt and freshly ground black pepper

Handful of torn fresh cilantro leaves

Extra limes for serving

4. Make the dressing: In a large bowl, combine the lime juice, vinegar, fish sauce, maple syrup, chile, and cilantro stems. Grate the garlic into the mixture using a Microplane. Add the sesame oil in a slow stream and whisk until combined. This dressing will be on the thin side, not super oily.

5. Make the salad: Add the cabbage, onion, and chicken to the dressing and toss well to combine all the ingredients and coat them with the dressing. Season with salt and pepper. Top the salad with the puffed rice, scatter it with cilantro leaves, and serve with extra lime on the side.

Note: If you made your chicken ahead of time and stored it in broth as described on page 254, strain the meat and give it a tight squeeze with your hands before tossing it into the salad. If you skip this step, the dressing will be greatly diluted and the salad will lose its oomph.

Serves
4 to 6

Prep Time
15 minutes

Boquerones—the Spanish white anchovies—are the covert star of this dish, stuffed between the leaves of the treviso before they are bundled tightly with prosciutto and tossed on the grill. Cured in vinegar and then packed in oil, boquerones are less pungent (and prettier) than common anchovies, and they can usually be found in the deli case in specialty or Italian markets.

Treviso, radicchio's longer, thinner cousin, can be found in the fall and early spring at the farmers' market. Treviso's bitterness, a sign of high antioxidant levels, is tamed when cooked. If you can't find it, substitute radicchio cut into quarters (bottom nub intact so the leaves hold together), or Belgian endive. Endive has a higher water content than treviso, so it won't crisp in the same way, but the prosciutto will, so who's complaining?

Grilled Prosciutto-Wrapped Treviso with Hidden Boquerones

1. Prepare a very hot charcoal fire, heating until the coals are white-hot. Distribute them evenly in the bottom of the grill.

2. Wash the treviso and thoroughly pat it dry. Drizzle them with oil and use your hands to make sure each head is evenly coated.

3. Select 2 or 3 boquerones per head of treviso. Slice the treviso lengthwise and tuck the fish inside and between the treviso leaves. Be gentle—you want to keep the shape of the treviso intact while getting those fish deep in there.

4 to 6 heads treviso

1 (3- to 4-ounce/85- to 115-g) package boquerones

4 to 6 slices prosciutto or speck

Olive oil

Aged balsamic vinegar

Sea salt and freshly ground black pepper

4. Lay a slice of prosciutto on a cutting board and place the fish-stuffed treviso on top at one end. Roll gently, creating a tight bundle. Use a toothpick to fasten the ends together if necessary. Repeat for each treviso.

5. Place the wrapped treviso on the grill and cook until the leaves char and the prosciutto is nicely grill-marked all over, turning it carefully with tongs, about 5 minutes on each side.

6. Remove the treviso to a serving platter, drizzle with a little more olive oil and some balsamic vinegar, season with salt and pepper, and serve.

Serves
4

Prep Time
30 minutes

I never thought I could love raw cauliflower until I took the florets to the mandoline slicer to make coral-like cross sections with stellar bite. Sliced Chioggia beets, otherwise known as candy cane beets, make charming little spirals of shocking fuchsia color. They are sweet, less earthy than red beets, and their color won't bleed all over that pristine white cauliflower.

This salad takes the place of a slaw and pairs well with any protein, in this case, arctic char. Char, also known as sea trout, is akin to salmon, but better. It has a similar pink hue and high fat content, but it is more sustainable and, in my opinion, more refined than salmon.

Shaved Cauliflower and Candy Cane Beet Salad with Seared Arctic Char

1. Make the salad: Trim off the bottom ½ inch (12 mm) of the cauliflower stalk and all of the leaves and discard. Cut the cauliflower in half from top to bottom, and then cut one of the halves in half again (you should now have one half and two smaller quarters). Slice them all into large pieces ⅛ inch (3 mm) thick on a mandoline, the large piece cut-side down. When the tips of the florets start to fall off, just gather them on your cutting board and roughly chop them into pea-size bits; put them in a salad bowl with the sliced cauliflower. Thinly slice the beets on the mandoline and set aside.

2. Make the dressing: In a small bowl, combine the vinegar and mustard. Add the lemon zest and sorrel stems, if using. Whisk in the oil until emulsified. Spoon the dressing over the cauliflower, season with the sea salt and pepper and toss to combine. Set aside to marinate while you prepare the fish.

3. Make the arctic char: With a mortar and pestle, pound the pink and black peppercorns, salt, and garlic together to make a paste. Whisk in 2 tablespoons of oil and coat the fish fillets all over with the mixture.

For the cauliflower salad

1 head cauliflower

2 or 3 small Chioggia or golden beets, tops removed, scrubbed

1 to 2 tablespoons Pickled Red Onions (page 255)

2 tablespoons fresh tarragon leaves

1 teaspoon sea salt

Freshly ground black pepper

For the dressing

2 tablespoons plus 2 teaspoons tarragon or white wine vinegar

1½ teaspoons Dijon mustard

Grated zest of 3 lemons

1 tablespoon minced sorrel stems (optional)

⅓ cup (75 ml) extra-virgin olive oil

For the arctic char

2 tablespoons pink peppercorns

1 teaspoon whole black peppercorns

2 teaspoons kosher salt

2 teaspoons minced garlic

4 tablespoons (60 ml) olive oil

4 (8-ounce/225-g) arctic char fillets

1 lemon, quartered

4. Heat 1 tablespoon of the oil in a large cast-iron skillet over medium-high heat. When the oil is sizzling, add two fish fillets to the hot skillet, skin side down, and cook without moving until the skin is crispy, 3 to 4 minutes. Flip the fish and cook just until the fish turns opaque, 2 to 3 minutes more. Add the last 1 tablespoon of the oil to the pan and repeat with the remaining two fillets of fish (see Note).

5. Add the tarragon, beets and pickled onions to the cauliflower and gently toss to combine. Serve with the fish atop the salad and lemon wedges on the side.

Note: Grilling arctic char is also a great option. To cook on the grill, prepare a grill with a medium fire. Lightly oil the hot grill grate. Place the fish skin side down on an area of the grate that is not directly over the hottest coals, cover and cook until the fillets easily separate from the grill, 2 to 4 minutes. Flip and cook flesh side down for another 2 to 4 minutes. The centers should still be a bit rare, but you should have nice grill marks on the top of the flesh and crispy skin.

146

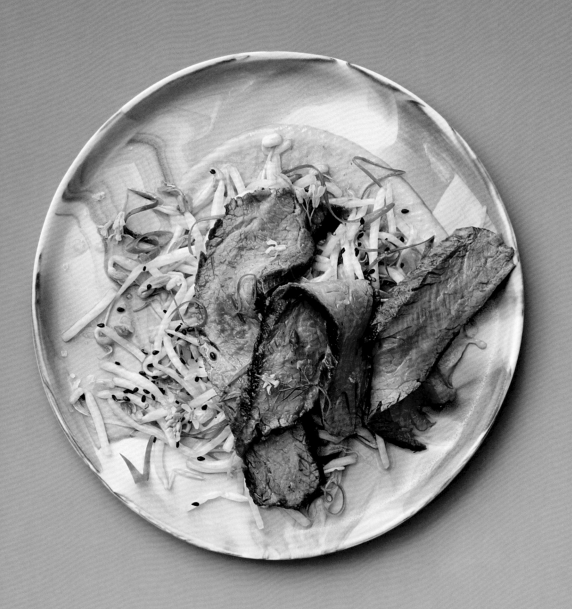

Serves
4

Prep Time
30 minutes

I like flank steak for all the reasons it is underrated: It's a thin cut of beef, which means it cooks quickly, and it is very lean. Ask your butcher to ensure that the meat is well-trimmed before you take it home.

The kimchi-miso dressing is spicy and salty (once described by a friend as tasting like Asian Doritos, in a good way). It would make a great dip for crudités of cucumbers, carrots, or celery. Nigella seeds, tiny and charcoal-black, could pass for black sesame seeds, but surprisingly taste of charred onion. I use broccoli blossoms as garnish on the salad, so while they are not entirely compulsory, they are worth trying if you can find them. Better yet, let your own homegrown broccoli and broccoli rabe plants go to seed and trim the tiny yellow buds.

Flank Steak with Bean Sprouts and Kimchi-Miso Dressing

1. Prepare a very hot charcoal fire, heating until the coals are white-hot. Distribute them evenly in the bottom of the grill.

2. Make the steak: Pat the steak dry and sprinkle it all over with the salt and pepper.

3. Make the dressing: In a high-powered blender or a mini food processor, combine the kimchi, vinegar, miso paste, grapeseed oil, and 2 tablespoons water and blend until smooth. If you'd like, transfer the dressing to a squeeze bottle.

4. Grill the steak for 5 to 7 minutes per side, depending on the thickness, for medium-rare. Remove to a cutting board and let rest for 5 minutes.

For the steak

1 (2-pound/910-g) flank steak, well trimmed

2 teaspoons kosher salt

½ teaspoon freshly ground black pepper

For the dressing

¼ cup (30 g) kimchi

2 tablespoons brown rice vinegar

2 tablespoons white miso paste

¼ cup (60 ml) grapeseed oil

For the salad

12 ounces (340 g) mung or soy bean sprouts, washed well and spun dry

2 teaspoons toasted sesame oil

2 to 3 green onions, thinly sliced on the bias

2 teaspoons nigella seeds or black sesame seeds

Sea salt

¼ cup (10 g) broccoli blossoms (optional)

5. Make the salad: Toss the bean sprouts, sesame oil, green onions, and nigella seeds together in a bowl and season lightly with sea salt. Spread the bean sprouts on a serving platter or individual plates. Slice the steak across the grain into ¼-inch (6-mm) pieces and lay them on top of the sprouts.

6. Squeeze or spoon the dressing over the steak and sprouts in a zigzag pattern. Garnish with the broccoli blossoms, if using, and serve.

Serves
2 to 4

Prep Time
45 minutes

An ideal fall or winter salad using seasonal citrus and hearty wintry greens, the kumquat relish here is sweet and sour with a subtle kick of chile. If you live in a warm climate, go ahead and cook the greens on the grill (you bastards), but if not, the broiler will work just fine. The strong mustard flavor of the greens is tamed when they are cooked, so don't be turned off by their spiciness if you nibble on them raw.

This recipe calls for cooked quinoa, so be sure to do that ahead of everything else. When boiling quinoa that I plan to later fry, I cook 1 part quinoa to 1½ parts liquid (as opposed to the normal 1:2 ratio). The drier it is after this first stage of cooking, the crispier it will get in the frying pan later. The only problem with fried quinoa is that you will want to put it on top of every salad you make going forward.

Grilled Mustard Greens with Crispy Quinoa and Kumquat Relish

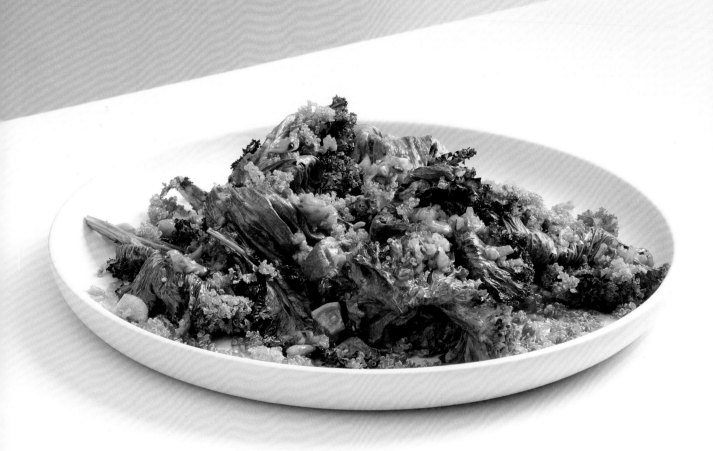

1. Rinse the quinoa in a fine-mesh sieve under running water, then put it in a small saucepan with 1½ cups (360 ml) water and a pinch of salt. Bring to a boil, then lower the heat to low, cover, and cook for 15 to 20 minutes, until the grains are tender and the water is absorbed. Spread the quinoa out on a sheet pan to dry.

2. Preheat a medium charcoal fire or preheat the broiler or gas grill to high.

3. In a small bowl, combine the shallot, chile, vinegar, and 1 teaspoon of the maple syrup. Set aside to lightly pickle.

4. Wash and thoroughly dry the mustard greens, trimming the tough ends and discarding them. Rub the leaves with the olive oil and season lightly with salt and pepper. Place the greens on the grill grate and cook each leaf for about 1 minute, letting them get nice and crispy on the edges but not blackened. Arrange the greens on a serving platter. (If using the broiler, arrange half of the greens on a lightly oiled baking sheet in a single layer and broil for 30 seconds, checking to make sure they don't burn. Transfer to a serving platter and cook the remaining greens.)

1 cup (170 g) white quinoa (see Note)

Sea salt

1 tablespoon minced shallot

1 Thai bird or small serrano chile, deseeded and minced

1 tablespoon plus ¾ teaspoon red wine vinegar

2½ teaspoons maple syrup

1 bunch (about 12 ounces/340 g) purple or green mustard greens

1 tablespoon olive oil

Freshly ground black pepper

7 kumquats

⅓ cup (75 ml) grapeseed oil

1 teaspoon minced garlic

Juice of ½ lemon

5. Cut the kumquats in half lengthwise and remove the seeds. Slice them again into quarters. Toss them in a bowl with the remaining 1½ teaspoons maple syrup and spread them on a small foil-lined baking sheet or other pan set in the top third of the oven. Broil until the juices are bubbling and starting to brown at the edges, 5 to 7 minutes, watching them carefully so they don't burn. Transfer the kumquats to a cutting board, coarsely chop them, and add them to the shallot mixture with all their juices.

6. Line a large plate with paper towels. Put the grapeseed oil in a medium skillet over medium-high heat. When the oil just starts to smoke, add the quinoa and fry it, stirring frequently with a spatula, until crisp and a couple shades darker brown, 5 to 7 minutes; add the garlic and cook for 30 to 60 seconds, then immediately spoon the quinoa from the pan, leaving as much oil as possible behind, and spread it on the paper towels to drain.

7. Squeeze the lemon juice over the greens, spoon the fried quinoa over the top, and tuck the crispy grains all around the greens.

8. Spoon the kumquat relish over the whole mess and season with sea salt and pepper to taste. Serve immediately.

Note: If you don't have a pan small enough to cook a lonely cup of quinoa correctly, I suggest cooking 3 cups (510 g) quinoa and saving the excess for future use.

Serves
4 to 6

Prep Time
2 hours
15 minutes,
including
inactive time

Unlike traditional croutons, these cornmeal croutons are complex: The coarse grind of the cornmeal creates a craggy textured surface, protecting an interior that is soft to the bite (and hopefully still warm by the time you get to them). You can make the molded cornmeal a few days ahead, and then cut it up and bake the croutons just before serving. As with any tomato salad, this one relies on peak-season, sweet heirloom tomatoes, with their full spectrum of color and excess of juices. If it is not tomato season, go ahead and use these croutons with a wintry kale salad or tossed with roasted squash.

Heirloom Tomato Salad
with Crunchy Cornmeal Croutons

1. Make the croutons: In a saucepan, bring the broth, vegetable juice, 1 cup (240 ml) water, and the salt to a boil. Gradually whisk in the coarse ground cornmeal. Reduce the heat and simmer gently for 10 minutes, stirring frequently with a wooden spoon to prevent sticking at the bottom of the pot and clumping. Whisk in the instant polenta and cook over low heat for 3 minutes. Remove from the heat and stir in the ghee and parsley.

2. Pour the mixture into a well-oiled loaf pan and let cool for 5 minutes, then place in the refrigerator uncovered until the bottom of the loaf pan is cool to the touch, about 2 hours or overnight.

3. Slide a sharp knife around the perimeter of the chilled cornmeal polenta and turn the loaf pan upside down onto a cutting board. Cut the polenta into 1-inch (2.5-cm) cubes.

4. Turn the oven on to 425°F (220°C) and pour the grapeseed oil on a rimmed baking sheet, swirling it around to make sure the oil is evenly coating the surface. Place the baking sheet in the oven while it heats up.

For the cornmeal croutons

2 cups (480 ml) Chicken Stock (page 253) or vegetable broth

½ cup (120 ml) tomato-based vegetable juice (organic is better)

½ teaspoon kosher salt

1¼ cup (135 g) coarse-ground cornmeal (try Bob's Red Mill)

¾ cup (150 g) instant polenta

½ tablespoon ghee

1 tablespoon minced fresh flat-leaf parsley and/or basil

2 tablespoons grapeseed or vegetable oil

Pinch of flaky sea salt

For the tomato salad

2 medium heirloom tomatoes (about 1 pound/455 g total), cut into 2-inch (5-cm) pieces

1 cup (145 g) heirloom cherry tomatoes, halved

1 teaspoon flaky sea salt

1 clove garlic, smashed

½ red onion, thinly sliced

1 tablespoon sherry vinegar

3 tablespoons high-quality extra-virgin olive oil

Freshly ground black pepper

Fresh basil leaves

5. When the oven reaches temperature, place the polenta cubes on the baking sheet, sprinkle with a pinch of sea salt, and bake for 15 minutes on one side. Using a spatula, flip the cubes. Continue to bake for an additional 15 minutes, or until the cubes are lightly browned and crispy.

6. Meanwhile, make the salad: Put the tomatoes, salt, garlic, onion, and vinegar in a medium bowl. Use your hands to gently combine. Let sit for 5 to 10 minutes, until the tomatoes have released some of their juices. Remove the garlic from the bowl and discard.

7. Make the dressing: Drain 2 tablespoons of the tomato juice runoff into a small bowl and add the olive oil. Whisk until the mixture is thick and emulsified.

8. To assemble, arrange the cornmeal croutons on a serving platter. Using a slotted spoon, top them with tomato salad (reserve excess liquid for another use). Drizzle the dressing over the whole dish and season with salt and pepper. Roughly tear the basil leaves and scatter them on top. Serve immediately.

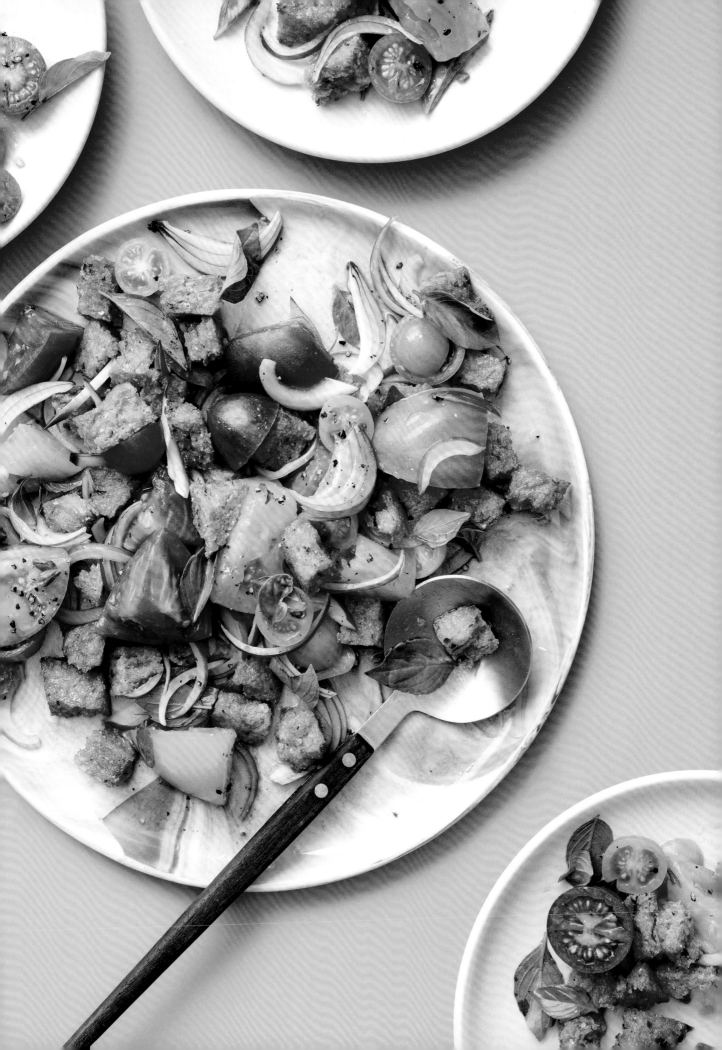

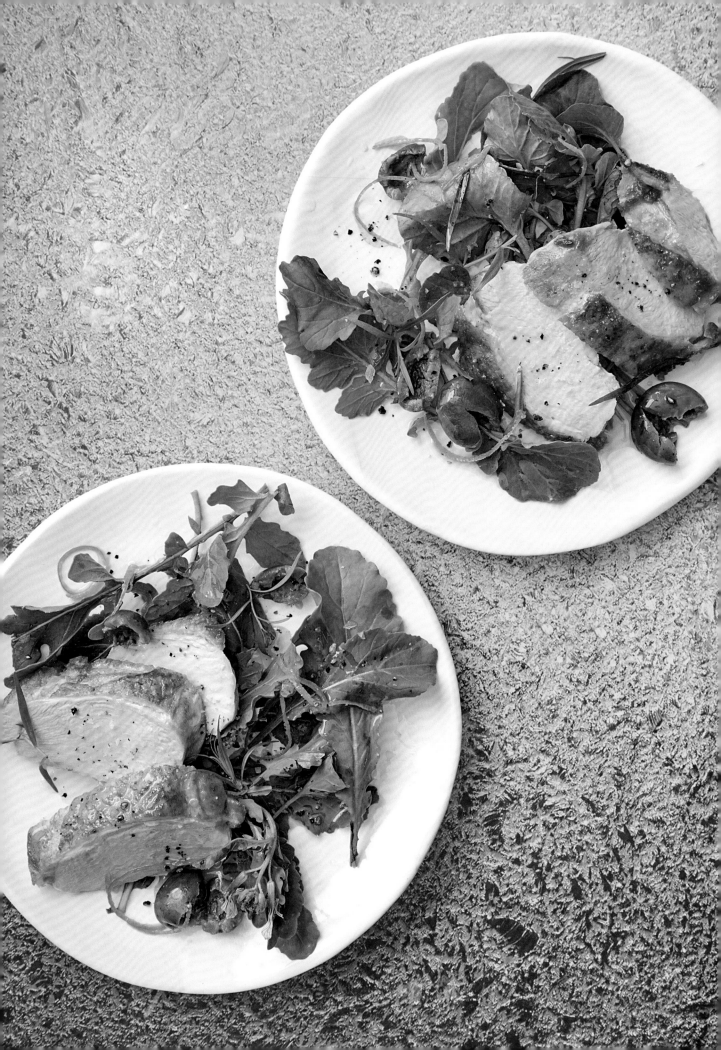

If you cannot find pitted Castelvetrano olives, buy them whole and pit them yourself, just be sure to do so before marinating (it will be much more difficult later). These olives are great on their own, so make extra and refrigerate for a couple of weeks. Their flavor will only improve. Be sure to take them out of the fridge at least 15 minutes before serving, so the oil can come to room temperature.

Mature arugula (as opposed to the commonly bagged baby arugula) is spicy and hearty enough to hold its shape well after it has been dressed. If you can't find it, substitute another spicy green like dandelion or mizuna.

Roast Chicken, Arugula, and Citrus-Marinated Olives

1½ Valencia oranges

3 cups (460 g) pitted Castelvetrano or other mild green olives

½ cup (120 ml) olive oil

¾ cup plus 6 tablespoons (270 ml) grapeseed oil

1 bay leaf

1 tablespoon whole black peppercorns, crushed

4 tablespoons (13 g) chopped fresh tarragon

4 (7-ounce/200-g) boneless chicken breasts, skin on

Kosher salt and freshly ground black pepper

8 ounces (225 g) mature arugula, washed and dried

½ lemon

1. Use a vegetable peeler to remove the orange zest, leaving the white pith behind, then cut the zest into thin slivers. Heat the olives, orange zest, olive oil, ¾ cup (180 ml) of the grapeseed oil, the bay leaf, and peppercorns in a saucepan. When the oil reaches a low boil, lower the heat and simmer for 30 minutes. Add 2 tablespoons of the tarragon and remove from the heat.

2. Preheat the oven to 350°F (175°C).

3. Pat the chicken breasts dry with a paper towel and set aside. (Don't skip this step, or you won't get a nice crispy skin.)

4. Heat a large ovenproof sauté pan or cast-iron skillet over medium heat. After 5 minutes, add the remaining 6 tablespoons (90 ml) of the grapeseed oil and swirl it around in the pan. Just before cooking, season the chicken breasts with salt and a light coating of pepper. Add the chicken breasts, skin side down, to the hot pan. To get a nice sear on the skin, push the breasts down in the pan for a few seconds, and then allow the chicken to cook for 10 minutes without moving or flipping them.

5. After 10 minutes, flip the breasts so the skin side is up and transfer the pan to the oven to cook for another 8 to 10 minutes, until the internal temperature of the meat is 150°F to 160°F (66°C to 71°C). Remove from the oven, transfer the breasts to a cutting board, and let rest for at least 5 minutes.

6. Put the arugula on a large, shallow platter or in a serving bowl. Squeeze the lemon over the arugula and drizzle it with 1 tablespoon of the oil from the marinated olives. Season with salt and pepper, and use your hands to gently toss, making sure all the leaves are coated.

7. Cut the chicken breasts into ½-inch (12-mm) slices and arrange them on top of the arugula, tucking the slices into the leaves. Using a slotted spoon, top with the marinated olives. If you have extra, just place those in a separate bowl off to the side, so guests can add more if they like. Top with the remaining 2 tablespoons tarragon and serve.

Chapter Five

Dress to Impress: Salads for Special Occasions

Specialty or expensive ingredients

Require extra attention to plating or presentation

Kinda fancy

People often ask me where I look for inspiration for new recipes. My answer is: Not on the internet, in a book, or with a TV personality—it's really at the market and in my garden. I stare blankly at what's available, scanning for hyper-seasonal—the rare or heirloom varieties that really get my wheels turning. I do this at home in New York, and I do this abroad, filling my suitcase with edible contraband everywhere I go. I discovered yuzu, a floral Japanese citrus, in Japan; I had a ceviche with a rich, green herby sauce in Oaxaca; and I decided to candy citrus when a friend's tree was overflowing with Meyer lemons in East L.A. These are the extra-special recipes I picked up along the way, adapted, and perfected for special occasions.

This chapter features those recipes that get you extra credit. These are the ones where I'm flexing my muscles, showing off at the market, stepping back from the plated dish, and saying, "Hey, now how much would that cost at a restaurant?"

This seafood salad is, in its essence, the classic Italian *insalate di mare*. The addition of the boiled potato is borrowed from the Peruvian preparation of ceviche, which is always accompanied by a round of plain white or sweet potato. The starchy vegetable sops up the fish juices and citrusy marinade, so none of that precious flavor goes to waste.

Insalate di Mare

1. Put the mussels and clams in a colander with a handful of ice cubes. Run under cold water, scrubbing each clam and mussel thoroughly with a brush. Remove beards from mussels, yanking the little rough tuft out from between the two shells.

2. Rinse and drain the shrimp and the calamari and set aside. Soak the scallops in cold water for a few minutes and drain off the water; repeat with fresh water.

3. In a large sauté pan, combine ¼ cup (60 ml) of the wine and ¾ cup (180 ml) of the stock. Set over medium heat, bring to a simmer, and add the clams and mussels. Cover and simmer for about 8 minutes, checking every minute to remove the shellfish that have opened, putting them in a large bowl. Discard any shellfish that haven't opened after 8 minutes.

4. Transfer the cooking liquid to a smaller, 2-quart (2-L) saucepan. Add the remaining ¼ cup (60 ml) wine and 2¼ cups (540 ml) stock and bring to a boil.

5. When your broth has come back to a boil, add the shrimp and cook for about 2 minutes, until the flesh turns pink and is no longer translucent. Remove from the broth with a slotted spoon and set aside to cool. Bring the broth back to a boil and add the scallops; cook for 1 to 2 minutes, until just firm

2 pounds (910 g) mussels

12 small clams

12 ounces (340 g) large shrimp, shelled and deveined

8 ounces (225 g) cleaned calamari

5 large scallops

½ cup (120 ml) white wine

3 cups (720 ml) seafood stock

2 cloves garlic

¼ cup (60 ml) high-quality extra-virgin olive oil

2 tablespoons minced red bell pepper

2 stalks celery, minced

Juice of 1½ lemons (about 6 tablespoons/90 ml)

Freshly ground black pepper

1 russet potato

1 teaspoon kosher salt, plus more to taste if needed

2 tablespoons chopped fresh Italian parsley

to the touch, and remove with the slotted spoon. Bring the cooking liquid back up to a boil once more. Drop your calamari into the cooking liquid, cook for 2 minutes, and remove with the slotted spoon.

6. When the calamari is cool, slice into rounds ¼ inch (6 mm) thick. Remove the tails from the shrimp and cut the flesh into ½-inch (12-mm) pieces. Cut the scallops in half, remove the clams and mussels from their shells, and put all the seafood in a large bowl. Smash the garlic cloves with the broad side of a knife and add to the seafood along with the oil, bell pepper, celery, and lemon juice. Season to taste with black pepper and stir to combine. Cover with plastic wrap and refrigerate.

7. Put the potato and salt in a saucepan, cover with cold water, and bring to a boil over high heat. Reduce the heat to a simmer and cook uncovered until cooked through, checking the doneness by sliding a paring knife into the center, 25 to 30 minutes. Drain, peel, and slice into ½-inch (12-mm) rounds.

8. Line a serving platter with the potatoes. Remove and discard the garlic cloves from the seafood salad. Taste the seafood salad and season with salt if needed. Spoon the rest of the salad on top of the potatoes. Garnish with parsley and serve at room temperature.

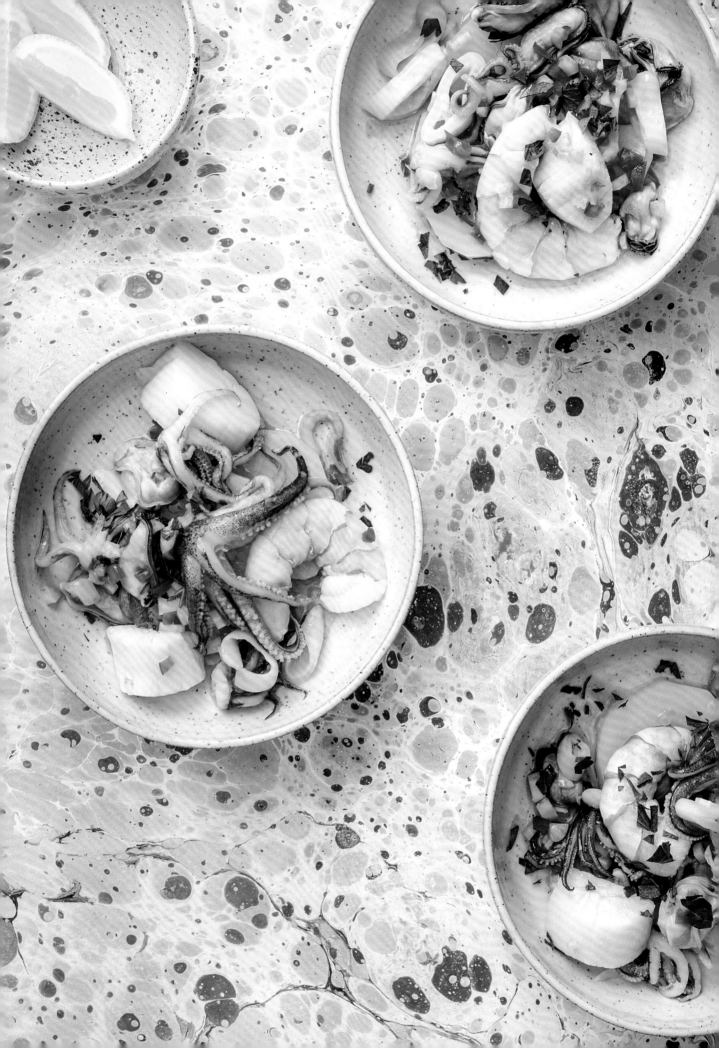

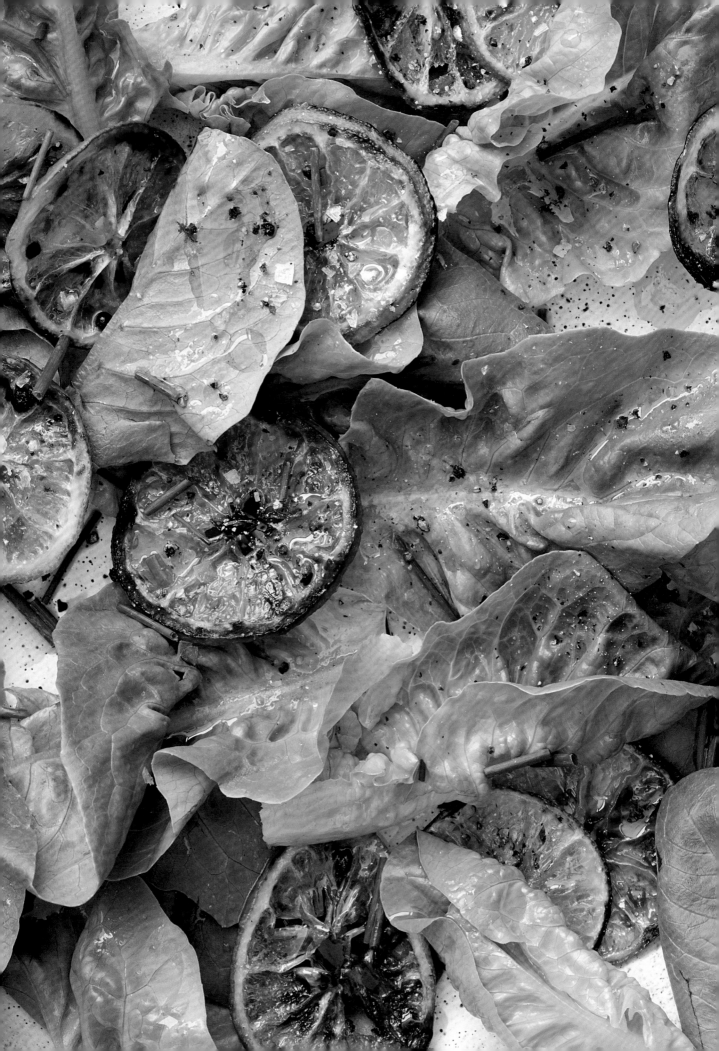

Serves
2 or 3

Prep Time
15 minutes

Colorful pinwheels of candied citrus are a little chewy, tart, and sweet, and they could easily double as edible jewelry. Set them atop a simple green salad and you just can't make a prettier dish. Experiment with different types of citrus, but go for those that are thin-skinned—Pixie, Honey, or Dancy tangerines; Valencia oranges; or Pink Lemonade lemons—and be sure to slice your rounds as thinly as possible.

The pink peppercorns add a floral note; nothing like conventional black peppercorns, this spice is vibrant in color and aroma.

Pink Peppercorn Candied Citrus Salad

1. Make the salad: Preheat the broiler to high.

2. Slice the lemon and tangerine as thinly as possible and arrange the slices in a single layer on a foil-lined baking sheet.

3. Crush the pink peppercorns using a mortar and pestle. Add the sugar and grind the two ingredients together. Sprinkle them over the citrus slices and place them under the broiler, keeping an eye on the slices to make sure they don't burn. Broil for 2 minutes, then rotate the pan 180 degrees and continue to broil until the citrus is light brown and the sugar is bubbling, 3 to 5 minutes longer. Remove from the oven and use a spatula to transfer the slices

For the salad

1 Meyer lemon or pink lemon

1 thin-skinned tangerine

1 teaspoon pink peppercorns

1 tablespoon sugar

3 heads baby Little Gem lettuce, or 1 head Boston Bibb lettuce

1 tablespoon snipped fresh chives

For the dressing

Juice of ½ Meyer lemon

1 teaspoon raw honey

3 tablespoons extra-virgin olive oil

Sea salt and freshly ground black pepper

to a cutting board before they cool. This prevents them from sticking to the foil. Once they cool, they should go from gooey and soft to chewy and almost crunchy.

4. Arrange the leaves of the lettuce in a bowl, and scatter the chives on top.

5. Make the dressing: Combine all the ingredients for the dressing, whisking to emulsify the oil, and drizzle it on top of the lettuce. Season with salt and pepper and top with the candied citrus. Serve immediately.

I know too many people who consider the labor involved in peeling and eating the leaves of a steamed globe artichoke to be "too much work." Baby artichokes, on the other hand, are tender, and once their outer leaves are removed, they can be shaved thin and the entire thing eaten raw; it's a little more work for the cook on the front end, but far less labor for your guests. I am not usually a fan of raw mushrooms, but once they soak up all the marinade they appear cooked, not dry. Don't bother washing the mushrooms; we want them to absorb the dressing, not tap water. Just brush them gently with a mushroom brush or your fingers to remove any visible dirt. If you are using nice organic mushrooms, a little soil won't kill you.

Shaved Baby Artichoke and Marinated Mushroom Salad

1. In a medium bowl, combine the lemon juice and vinegar. Whisk in the oil until well blended. Add the parsley, oregano, garlic, and mushrooms. Season with salt and pepper and toss to coat. Let stand at room temperature for 15 minutes. Discard the garlic clove.

2. Meanwhile, fill your salad spinner (with the strainer inside) with cold water. Squeeze the lemon half into the water; add the lemon to the spinner. Working with one artichoke at a time, cut off and discard the stems. Pull off the dark outer leaves until you reach the tender yellow leaves. Using a serrated knife, cut 1 inch (2.5 cm) off the top of each artichoke, then very thinly slice the artichokes vertically and add them to the lemon water.

1½ tablespoons freshly squeezed lemon juice, plus 1½ lemons

2 tablespoons red wine vinegar

6 tablespoons (90 ml) extra-virgin olive oil

3 tablespoons chopped fresh parsley

1 teaspoon chopped fresh oregano

1 clove garlic, smashed

6 ounces (170 g) white mushrooms, trimmed and sliced

6 ounces (170 g) oyster mushrooms, trimmed and torn into small pieces

Sea salt and freshly ground black pepper

1 pound (455 g) firm, super-fresh baby artichokes

4 celery ribs, thinly sliced

High-quality extra-virgin olive oil

Shaved Parmigiano-Reggiano cheese

3. Drain the artichokes and spin them dry. Add the artichokes and celery to the mushrooms. Squeeze the juice of 1 lemon over top, season with salt and pepper to taste, and toss. Transfer the salad to plates, finish with olive oil, top with cheese shavings, and serve.

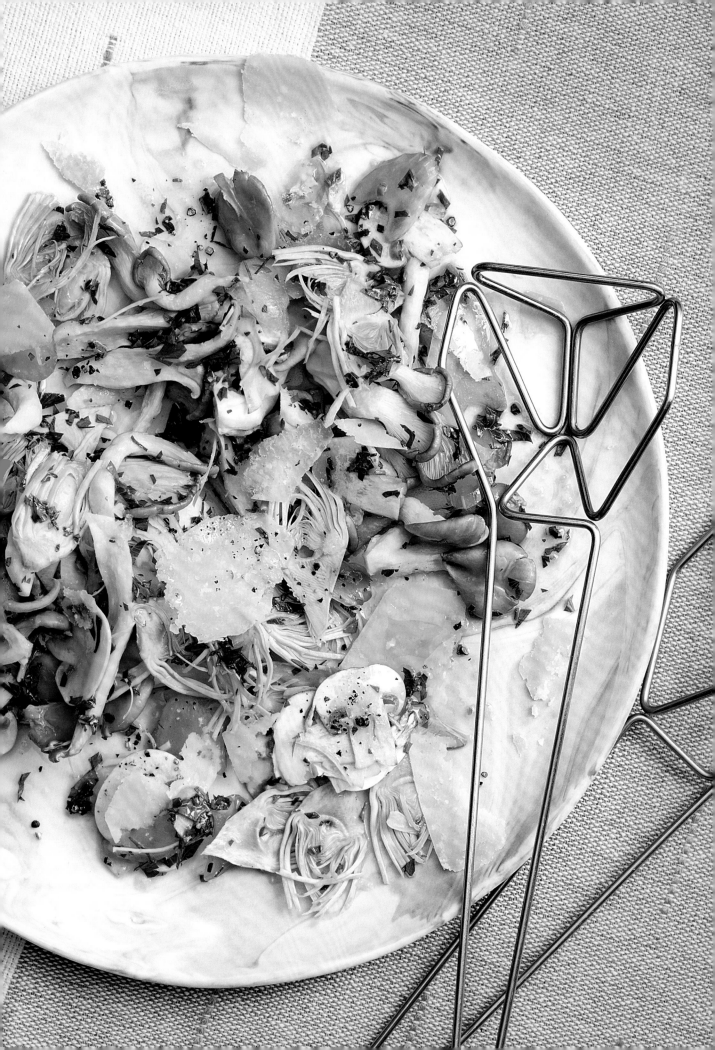

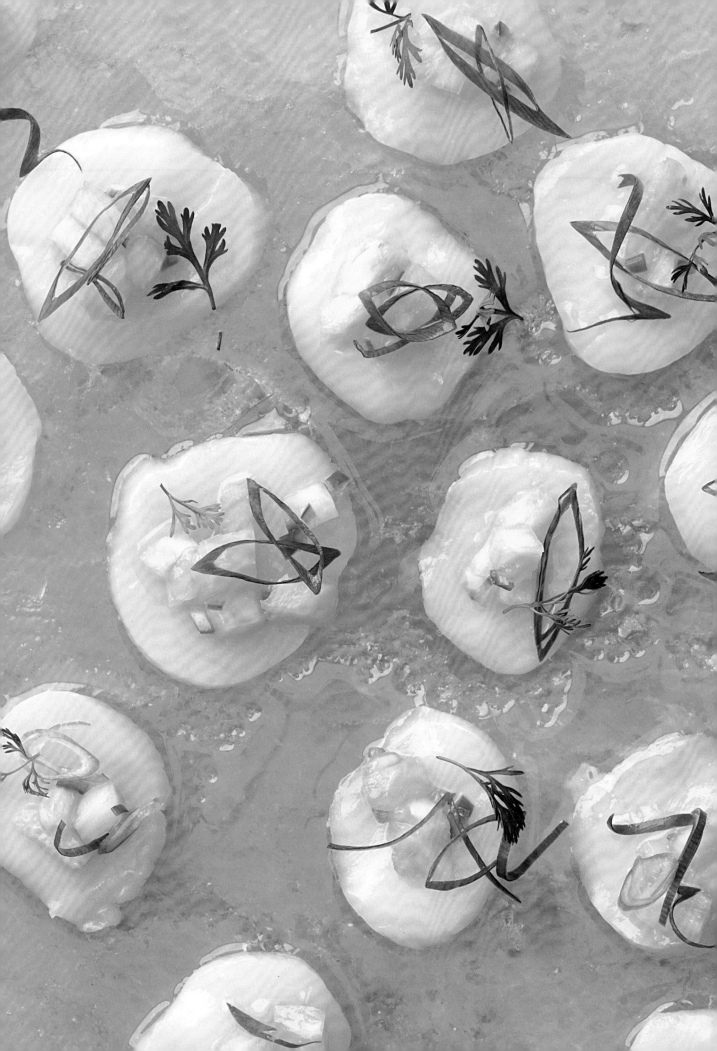

Turns out, if you buy the best-quality seafood, you don't even need to cook it. Crudo is just a fancy excuse to skip a step in the kitchen, so don't be intimidated—I actually prepare this dish when I am feeling lazy (and maybe a little self-entitled). If you are a scallop skeptic, I will tell you that they are my favorite seafood to eat raw, not the least bit fishy or chewy. To make the slicing of the scallop even easier, place the cleaned scallops in the freezer for ten minutes. If you can't find scallops, substitute a skinless fillet of red snapper, or even sliced raw sweet shrimp.

The key to a sweet crudo is in using a citrus reamer rather than a citrus hand squeezer. The squeezer extracts bitter oils from the lime peel as it juices, whereas the reamer only comes into contact with the lime flesh, leaving the acrid peel out of it. And while you have all that fruit out on the countertop, toss some of the extra pineapple into a martini shaker, muddle it with lime and vodka, and serve it up in a chilled coupe glass. (Feel free to put on a silk robe and feather boa to enhance the experience.)

Spicy Scallop Crudo with Pineapple

2 tablespoons finely diced
fresh pineapple

¼ cup (60 ml) fresh Meyer lemon
or regular lemon juice

¼ cup (60 ml) fresh lime juice

1 tablespoon fresh tangerine juice

1 tablespoon minced seeded
serrano chile

1 teaspoon honey, if needed

8 to 10 diver scallops

High-quality extra-virgin olive oil

1 green onion, thinly sliced
at an angle

½ teaspoon torn fresh cilantro
leaves (optional)

Flaky sea salt or pink Himalayan
salt for color

1. Combine the pineapple, citrus juices, and chile in a small dish; taste and add honey if needed, ¼ teaspoon at a time, stirring to dissolve and tasting until you like the level of sweetness.

2. Gently rinse the scallops, submerging them in cold water and draining to remove all sand. Repeat once or twice (no one likes a sandy scallop). Pat dry.

3. Using a sharp fish knife, slice the scallops into rounds as thinly as possible, about ¼ inch (6 mm) thick, arranging them in a shallow serving bowl, overlapping at the edges in a, um, "scalloped" pattern.

4. Spoon the pineapple and citrus mixture over the scallops and drizzle them with oil. Scatter the green onion and cilantro, if using, on top and season with salt. Serve immediately with chopsticks.

Ron Finley

Occupation: Gardener, artist, and community organizer
Location: South Central, Los Angeles
Salad: Banana Blossom and Green Mango Salad (page 172)

Ron Finley is a gardener, artist, advocate, public figure, and neighbor. But more than anything, he is a force to be reckoned with. Located in South Central Los Angeles, with a former life as a men's fashion designer, Ron wasn't the obvious candidate to become the voice of urban farming, healthy eating, and hands-on food education that he is today.

It all began with a modest garden Ron planted outside his home in a public median. Unbeknownst to him, the city of Los Angeles owns these so-called parkways, which are really just patches of dirt on the side of the curb. As a result, Ron was cited for "gardening without a permit," an infraction that he never could have imagined. He started a petition, awakening his neighbors to the hypocrisy of a system that does nothing to help the conditions of what he calls a "food prison," and penalizes individuals when they take matters into their own hands. Eventually, the city let him continue; little did the city know, he had spawned a movement.

Only someone with Ron's confidence and unbridled energy could dub himself "The Gangsta Gardener," drive around town on a three-wheeled motorcycle, and speak about the art and politics of growing your own vegetables. His TED talk has two and a half million views, and his voice has inspired a generation of people to transform food deserts into community hubs, where anyone and everyone has the right to "plant some shit" (as it is emblazoned on the steps outside his home). Ron frees organic gardening from any twee associations and reminds us that self-sufficiency and ownership over your own body and destiny is punk as hell.

Where I hesitate to call my garden practice my "art form," Ron has no qualms about it. He believes in the power of urban farming to heal, awaken the senses, and expand your mind.

Finley picks a banana blossom from a tree in his infamous garden planted in the median outside his home.

Julia Sherman: Are you an accidental activist? Did you have any idea the garden outside your house would cause such an uproar?

Ron Finley: No, I am not an accidental activist. I have been an activist all my life—I just didn't know it. I had no idea that this garden outside my house would create such a movement and be the inspiration that it has. It is amazing to me that my garden has inspired people around the world to not only talk about their health, their food, and their communities, but engage in those things as well. All of that came from planting food.

JS: Why do you think your garden was so controversial?

RF: Because it goes against the status quo. Feeding yourself has become a foreign concept. Especially in these "underserved areas" that have been designed to be unhealthy. The proliferation of drug and liquor stores is by design, and I think it's up to us to change the design.

JS: Can you tell me a bit about your fashion line? Are you still designing or has the Ron Finley Project taken over your time?

RF: I'm still a designer, although I have not been actively designing fashion. The garden is just another outlet for creative expression. At one point, I am going to get back to fashion, but the garden has encompassed most of my life, and that is definitely for the good.

JS: You and I have very similar gardening styles— kind of messy, a bit rogue. Do you have any desire to become more "professional" when it comes to technique? Or is the improvisational aspect of the garden important to you?

RF: I am a motherfuckin' professional! But I have no desire to change because that wouldn't be me. My whole message is about designing your own life. Not the life that somebody else has designed for you or living the life that somebody else wants you to live. I try to replicate Mother Nature and a lot of the things that I do are based off the idea of bio-mimicry.

JS: Do you consider yourself an artist? Does that even matter?

RF: Undoubtedly! We are all artists. Gardening, to me, is an art form, a means of self-expression, and a healing place. I tell people all the time, you don't need meds, you need a garden. The garden itself is a creative practice—it's an incubator, my inspiration, my solace, sometimes my refuge. It's my go-to place. It's one big experiment. One big cultural shifter.

JS: What do you cook from your garden?

RF: I suggest people only grow what they like because otherwise you won't eat it. I grow everything from apples to Brussels sprouts, carrots, Chinese purple mustard greens, pomegranate, bananas. There's a pomegranate-cranberry dressing recipe that I like to use my pomegranates for. It all depends on the season. That's what's beautiful about the garden—it's ever changing.

JS: What is the biggest misconception that people have about you?

RF: That I'm white, ha! But seriously, the biggest misconception that people have of me is that all I do is grow food. People think I'm just one thing, some one-dimensional being. All they see is a guy that grows food. It's bigger than food.

JS: Tell me about the organization you founded, Ron Finley HQ. What is the vision for that?

RF: The vision behind HQ is to change culture from the soil up. To bring back stewardship for this planet, we have to re-engage culture to show everyone that they are an artist. To have people build communities. Help people realize that their health is their own responsibility and that they can change their lives with food. Change your food, change your life. Heal your mother, heal yourself. I want HQ to be a catalyst. I want it to be the epicenter for this global change.

When I visited artist Ron Finley at his South Central L.A. home, his famously "illegal" parkway garden was in transition. He didn't think he had any salad material to offer, but I spotted two large banana blossoms hovering above our heads. Ron brought these flowers to the Getty Salad Garden, where we gathered the remaining ingredients for our own twist on a Vietnamese banana blossom salad, the Southeast Asian salad of my fantasies.

 If you don't have a banana tree of your own (I don't have one, either), then look for the blossoms at your local Asian grocery store. Sometimes you have to ask the grocer to bring them from the back. They are really fun to work with, and you can even present the dish as a salad boat, serving in one of the reserved outer leaves instead of a plate. If you can't find banana blossoms anywhere, sub red cabbage and plan to take your next vacation in Hanoi.

Ron Finley's Banana Blossom and Green Mango Salad

1. Make the dressing: In a mortar and pestle, combine the chile, lime leaves, garlic, and palm sugar and grind them to a paste. Add the fish sauce and lime juice and stir until well combined.

2. Make the salad: In a small skillet, heat the coconut oil over medium-high heat. As soon as the oil is warm, add the shallots and cook, stirring constantly, until light golden brown, 3 to 4 minutes. Using a slotted spoon, transfer them to a paper towel and set aside.

3. If using the banana blossom: Fill a large bowl with ice water and a generous splash of vinegar. Remove the stem, the dark-colored outer leaves, and the long, thin stamens between the leaves, peeling off leaves until you reach the more tender, cream-colored heart of the blossom. Cut the blossom into quarters and immediately transfer it to the ice water. Working with one quarter at a time, cut the quarters crosswise into very thin strips (it's okay if there are still small white buds between the inner leaves) and return the strips to the ice water. Once all the blossoms are sliced, agitate them in the water with your hands to remove any extra stickiness. Drain the shreds in a colander and rinse with cold water. Be sure to drain all the excess water.

For the dressing

1 Thai bird chile, minced, with most seeds removed

3 makrut lime leaves, tough center ribs removed, minced

1 clove garlic, roughly chopped

1 tablespoon palm sugar (grated if it's very hard)

1½ teaspoons fish sauce

3 tablespoons fresh lime juice

For the salad

3 tablespoons coconut oil

2 shallots, thinly sliced

1 fresh banana blossom, or 1 cup (95 g) shredded red cabbage

Ice water (if using banana blossom)

Distilled white vinegar (if using banana blossom)

1 cup (110 g) peeled and julienned green mango or green papaya (see Note)

¼ red onion, very thinly sliced

1 cup (150 g) cold Pulled Poached Chicken (optional, page 254)

1 tablespoon chopped fresh cilantro leaves, plus more for garnish

2 teaspoons chopped fresh mint leaves, plus more for garnish

2 tablespoons unsalted peanuts, toasted and crushed

4. Transfer the banana blossoms to a large bowl along with the mango, onion, and chicken, if using. Pour the dressing over the mixture, toss with the cilantro and mint, and spoon the salad onto a serving platter. Top with the crushed peanuts, crispy shallots, and more herbs, if desired.

Note: Use a mandoline or a Thai hand-shredder (available at most Asian grocery stores) to cut the green mango or papaya into long, thin julienne strips— you don't even need to pit or seed the fruit first, just stop scraping when you reach the pit or seedy center.

Serves
4

Prep Time
45 minutes

As a child of the nineties, chicken paillard will never go out of style in my eyes. But what if we gave it a little kick in the pants with some added sorrel, and the optional addition of some blistered padrón peppers? And who doesn't want to seize the opportunity to use a mallet in the kitchen?

As with all salads that call for fresh tomatoes, please wait until it is tomato season to indulge, *especially* for this dish that relies on the sweet, acidic runoff from the perfectly ripe fruit.

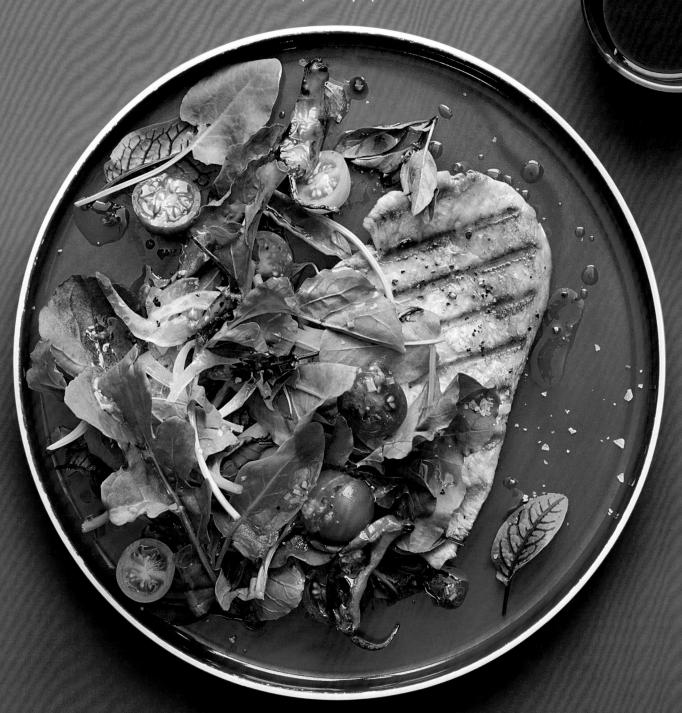

Chicken Paillard with Sorrel and Arugula

1. Make the dressing: With a mortar and pestle, mash the garlic cloves into a paste. Transfer it to a bowl, add the remaining dressing ingredients, and whisk to combine.

2. Make the salad: Wash and spin the sorrel and arugula, tear them into bite-size pieces, and put them in a large bowl. Toss in the basil and onion and set aside.

3. Make the tomatoes: Cut the tomatoes in half and put them in a small bowl. Toss them with the salt, sugar, and vinegar and set aside to macerate.

4. Place a large skillet over medium heat. Add the padrón peppers and flip them as they cook, until tender and blistered on all sides, 8 to 10 minutes. If they start to smoke, lower the heat. Remove them from the pan to cool.

5. Make the chicken: Lay a 16-inch (40.5-cm) -long sheet of plastic wrap on the kitchen counter. Set a chicken breast on the right third of the plastic, the long side of the breast parallel with the long side of the plastic. Fold the left end of the plastic over the breast, leaving 2 inches (5 cm) of space between the meat and the folded edge. Using a mallet, gently pound the chicken until it is ¼ inch (6 mm) thick, starting at the center and working your way outward, taking care not to rip the flesh. Season the chicken with salt and pepper on both sides. Repeat with the remaining breasts.

For the dressing

3 cloves Roasted Garlic (page 254)

½ teaspoon sugar

2 tablespoons fresh lemon juice

¼ cup (60 ml) olive oil

2 tablespoons minced sorrel stems (from the sorrel below)

For the salad

3 cups (60 g) sorrel, stems removed and reserved

2 cups (40 g) mature arugula

¼ cup (10 g) basil, stems removed, roughly torn

½ small white onion, thinly sliced

For the tomatoes

1 cup (145 g) cherry tomatoes, halved

¼ teaspoon sea salt

¼ teaspoon sugar

1 teaspoon sherry vinegar

6 to 8 padrón peppers (optional)

For the chicken

4 (8-ounce/225-g) boneless skinless chicken breasts

1 teaspoon kosher salt

Freshly ground black pepper

1 tablespoon ghee, plus more as needed

6. Set a grill pan over medium-high heat. Brush it with the ghee, and when the ghee melts, toss the first pounded chicken breast on there. Using a pair of tongs, press the breast down to make sure it is making even contact with the pan, and cook for 5 minutes. There should be nice brown grill marks on the surface of the flesh if you peek underneath. Flip the breast and cook for an additional 3 to 5 minutes, until grill-marked on the underside and cooked through (check with a paring knife). Transfer the breast to a dinner plate (the darker grill-marked side up). Repeat with the remaining chicken breasts, adding more ghee to the pan as needed.

7. Once all the chicken has been cooked and plated, spoon some of the tomato runoff juice over each piece. Toss the salad greens with the dressing and season them with salt and black pepper. Pile a large handful of salad on top of each piece of chicken, scatter the cherry tomato mixture and the padrón peppers on top, if using, and serve while warm.

Sometimes you just want to walk into the fancy fishmonger with your head held high and throw down for a pricey tub of jumbo lump crabmeat. Living in New York, lord knows it's still cheaper than eating out.

This salad, inspired by a recipe by Salad for President contributor Kaitlyn Goalen, is proof that salad-eating is no sacrifice. This is as indulgent as salad gets, while making use of the entire radish, root to greens. And hey, who said salad can't be dressed in butter?

Fresh and Roasted Radish Salad with Brown Butter and Lump Crab

1. Preheat the oven to 450°F (230°C).

2. Make the salad: Remove and discard the tops from 12 ounces of radishes (about six). Thinly slice the radishes; set aside.

3. Remove the tops from the remaining radishes. Halve the radishes and transfer them to a bowl. Add the whole radish tops and drizzle them with the oil. Season with salt and pepper and toss to coat. Spread the mixture out on a baking sheet and roast for 15 to 20 minutes, until the radishes are fork tender and blistered.

4. While the radishes are roasting, make the dressing: In a medium saucepan over medium heat, melt the butter and cook until it darkens to a light caramel brown and smells toasty, about 5 minutes. Be sure to remove from the heat before the butter starts to burn.

For the salad

3 bunches (36 ounces/1 kg) radishes

3 tablespoons olive oil

Sea salt and freshly ground black pepper

1 pound (455 g) lump crabmeat

3 tablespoons roughly chopped fresh garlic chives

For the dressing

½ cup (1 stick/115 g) unsalted butter

⅓ cup (75 ml) olive oil

¼ cup (60 ml) red wine vinegar

¼ cup (60 ml) fresh lemon juice

1½ teaspoons Dijon mustard

Sea salt and freshly ground black pepper

5. In a food processor, combine the oil, vinegar, lemon juice, and mustard and process to combine. With the motor running, slowly drizzle in the browned butter until the mixture is emulsified. Season to taste with salt and pepper.

6. Combine the sliced fresh radishes, roasted radishes and their greens, crabmeat, and garlic chives in a large bowl. Drizzle with the brown butter vinaigrette and toss the mixture gently to coat. Season to taste with salt and pepper.

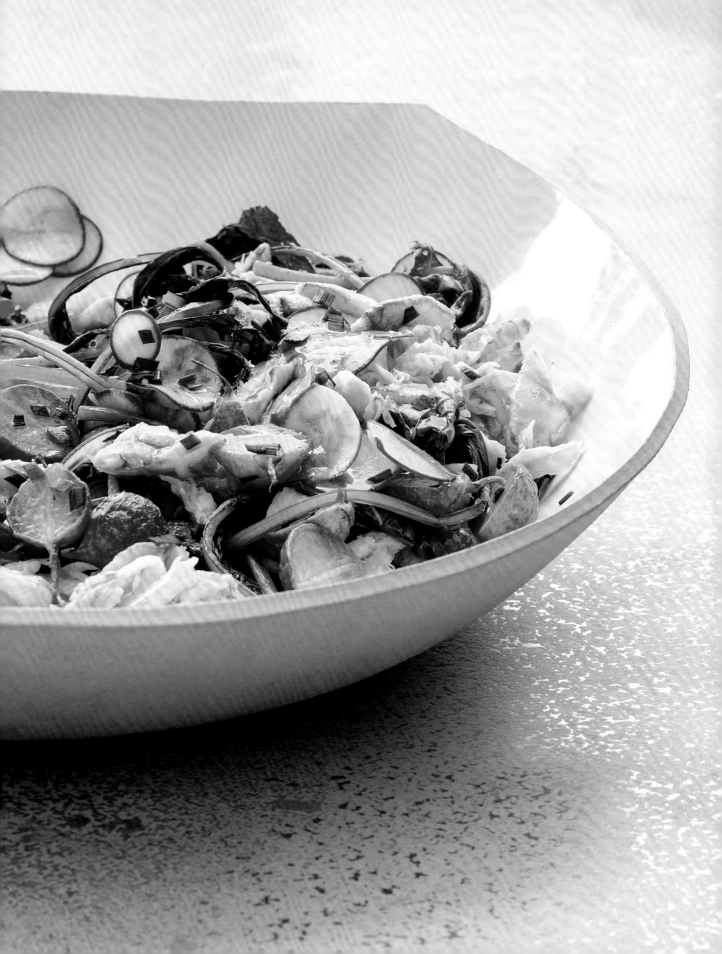

This is an elegant, simple dish that completely transforms two familiar ingredients: Melon and sage. It is best made using a seasonal melon that is not overripe but still juicy, sliced on a mandoline into thin, broad ribbons. If your melon is too ripe, it won't pass over the blade easily and will be too mushy to hold its shape. If you prefer, cut the melon into broad, thin strips using a chef's knife, trying your hardest to keep the thickness of each ribbon consistent. Once cut, use your thumb and forefinger to gently roll the pieces and assemble them on the platter, trying to get as much volume as possible. Arranging the salad is the fun part, your chance to make your dinner sculptural.

If your sage leaves are small and tender, leave them whole on top of the salad. If they are on the large side, you will likely want to break the fried leaves into pieces before scattering on top of the salad (just gently crush them between your fingers). Be sure to use a nice flaky sea salt for this dish; the crystals add much-needed texture and variation from one bite to the next.

Melon Ribbons with Olive Oil, Crispy Sage, and Sea Salt

1. Cut the melon in half and remove the seeds. Cut it into quarters and cut off the skin. Cut the flesh into long, very thin strips on a mandoline. Pile the slices onto a serving platter, curling the melon onto itself, twisting it to achieve volume.

1 (2¼- to 2½-pound/1- to 1.2-kg) melon, such as cantaloupe, muskmelon, or Crenshaw

3 tablespoons high-quality extra-virgin olive oil

20 to 25 fresh sage leaves, stemmed

Flaky sea salt

2. Put the oil in a small skillet over medium heat. When the oil is hot, add the sage and cook for 30 seconds, until it just barely starts to brown around the edges. If the oil begins to smoke, adjust heat to a low flame. Spoon the sage evenly over the melon and drizzle the oil on top.

3. Season generously with salt and serve.

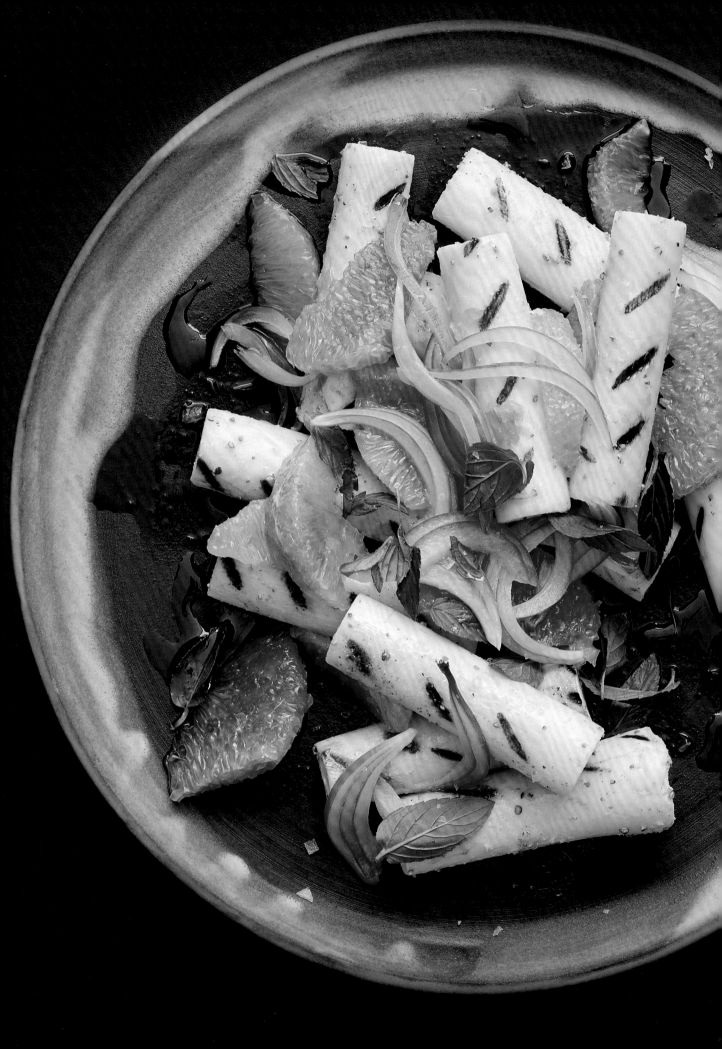

Serves
4 to 6

Prep Time
15 minutes

If you've never grilled hearts of palm before, you're in for a treat. The otherwise soft spears firm up on the grill, changing their texture completely. I much prefer the more expensive hearts of palm in a glass jar ($5 to $6 a pop) raw, but once grilled, even the cheaper canned version ($2 a pop) tastes like a million bucks. Once in a blue moon I have found fresh hearts of palm in the specialty food store, crunchier than the common brined version. This is how they are eaten in South America, and they are worth trying if you happen upon them. Just grill the fresh hearts for 10 minutes (instead of 3 to 5), rotating each spear to achieve dark grill marks all around.

Grilled Hearts of Palm with Mint and Triple Citrus

1. Drain and rinse the hearts of palm, pat them dry, and cut in half lengthwise. Put them in a shallow dish and drizzle with 1 tablespoon of the olive oil. Season with salt and white pepper to taste and turn gently to coat.

2. Prepare a medium-hot charcoal fire or preheat a stovetop grill pan to medium-high. Lightly oil the grill grate or grill pan with the vegetable oil. Working in batches if necessary, drop the hearts of palm on the hot grill and cook, without disturbing them, until distinct grill marks appear, 3 to 5 minutes. Turn and cook the other side until marked, 3 to 5 more minutes. Remove to a serving platter or individual plates.

3 (14-ounce/400-g) jars or cans brined hearts of palm

1 tablespoon plus ¼ cup (60 ml) olive oil

Sea salt and freshly ground white pepper

1 tablespoon vegetable oil

2 Ruby Red grapefruits

1 Cara Cara orange

1 blood orange

About 2 tablespoons drained Pickled Red Onions (page 255)

2 teaspoons small fresh mint leaves

½ teaspoon honey

3. Supreme the citrus fruits, reserving the grapefruit membranes: Cut off each end of a fruit and set the fruit upright on the cutting board. Using a sharp knife, slice off the pith, following the contours of the fruit, moving from top to bottom, cutting as little of the flesh away as possible. Rotate the fruit 90 degrees and cut next to each strip of membrane to cut out the sections. Repeat with the remaining fruit. Arrange the citrus on the platter with the hearts of palm and scatter the pickled onions, and mint.

4. Squeeze 1 tablespoon juice from the grapefruit membrane into a bowl and whisk in the honey and the remaining ¼ cup (60 ml) olive oil until the dressing is emulsified. Drizzle lightly over the salad and season with salt and white pepper.

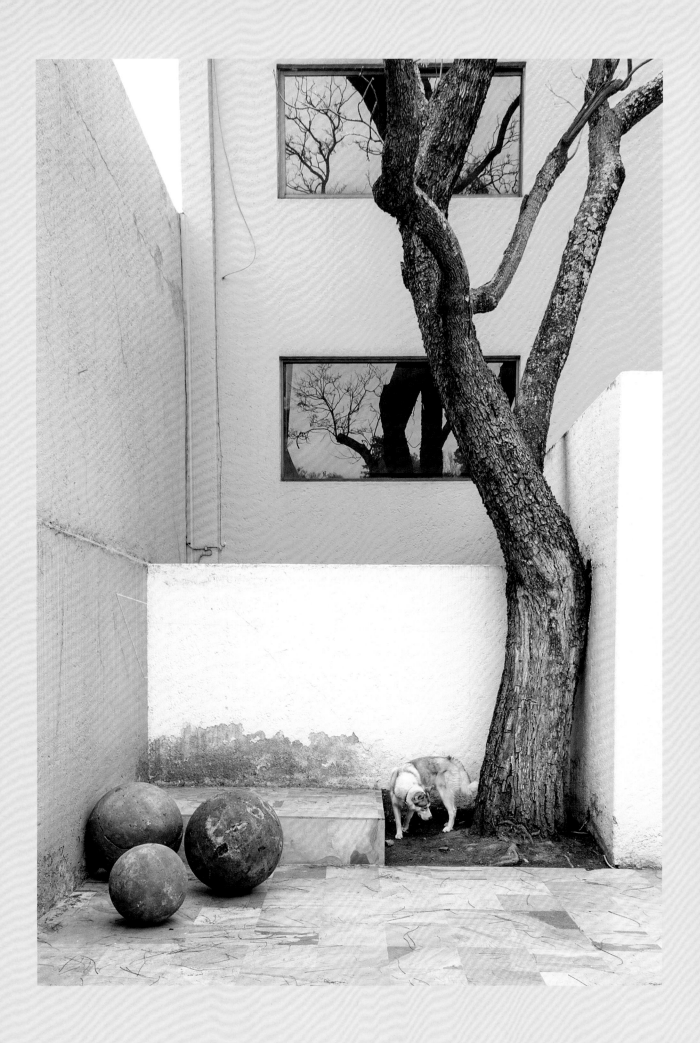

Luis Barragán and the Luque Family

Occupation: Architect, artist
Location: Mexico City
Salad: Sucrine and Avocado Salad with
Passion Fruit Vinaigrette (page 189)

There are historical museums that present works of art from the past, and then there are those museums that present works of art as living, breathing ideas. The Casa Gilardi, in Mexico City, cannot help but be the latter. In 1976, Francisco Gilardi and his business partner, Martín Baltazar Luque Valle, commissioned Mexican modernist architect Luis Barragán to build the bachelor pad of their dreams. This final example of Barragán's oeuvre remains the home of the Luque family to this day. Although Barragán worked as an architect, I consider him an artist, and few would disagree. He worked with large swathes of saturated color, light, wood, concrete, and water. He created metaphysical spaces that newly alter one's perception of them on each encounter. Although he created entirely functional homes, it is hard not to think of Barragán as a sculptor exercising an intuitive, additive, and organic process.

The Luque family—Martín, his wife Arcelia Guadalupe Pérez Peña, and son Martín Jr.—inherited a historic work of architecture, and with this privilege came great responsibility: It is theirs to maintain and preserve, but they were never compelled to keep this shining example of Barragán's work to themselves. Rather than open their home to the public as an institution, they decided to offer it as a pilgrimage site. The house has no nonprofit status or board of directors; it does not even have a website. But, you can pick up the phone and make an appointment to tour the premises with Martín Jr., now twenty-five and an architect himself.

Over the years, many renowned callers have made the pilgrimage to Casa Gilardi, including artists James Turrell, David Hockney, and Robert Rauschenberg, architects Tadao Ando and Zaha Hadid, and fashion designer Issey Miyake. But for every superstar, there is a daily stream of students and tourists to interrupt the domestic routine. I met the Luque family as one such visitor. Next thing I knew, I was making salad with mom, dad, and son, and sharing a meal with them in the transcendent space they call home. Just as we sat down to eat, twenty young architects arrived to delight in the experience of the magical house.

The genius of Barragán's work lies in its balance of the spiritual and the everyday. While the top two floors of Casa Gilardi are minimal, with natural-wood accents and custom-made furniture, the more public ground floor's inundation of light and color is a near-religious experience. The hallway glows with filtered sunlight refracting off marigold walls and tinted windows. Open the doors at the end of the foyer, and you will happen upon what can only be described as a three-dimensional color-field painting: A plane of cobalt blue bisected by a plane of primary red that appears to plunge infinitely into the depths of the earth below. Just when you think you have made sense of it, you step to the right and your brain somersaults. Those planes just morphed into a radiant cubic formation. Take one step closer and the cube reveals itself as the world's most fabulous swimming pool. The reflection of the primary-colored walls in the water has just played the best kind of trick on the mind—the kind that makes you question the very fabric of your world. The hallway is only the beginning.

Barragán may no longer be with us, but his work is as alive as ever and increasingly relevant to the next generation of artists enchanted by his ability to integrate art and life.

Previous page: View of the courtyard and Barragán's beloved jacaranda tree at Casa Gilardi.

Opposite: Martín Baltazar Luque Valle in the kitchen Barragán designed for him and his colleague, Gilardi, in 1976.

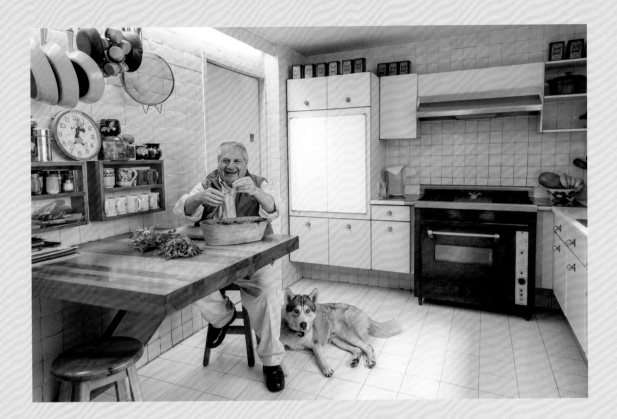

Julia Sherman: How did the house come to be, and what was your relationship with Francisco Gilardi and Luis Barragán?

Martín Baltazar Luque Valle: Gilardi and I were business partners in an advertising agency. I was the creative half, and he was the salesman. Gilardi was friends with Barragán. Barragán had recently retired when we asked him to build us a home. He rejected our project twice, insisting that he was no longer working. But the moment he saw our jacaranda tree, he fell in love. This was on a Thursday. We started demolition the following Monday.

JS: Wait—so when did he have time to design the house?

Martín Jr.: He sketched spontaneously during the construction. He never made architectural plans. My father and Gilardi gave him complete creative control.

JS: That's crazy! If I didn't know he was a genius, I would be very nervous to stand beneath this roof. So, Martín Baltazar, you and your friend Gilardi set out to make this the ultimate bachelor pad?

MBLV: Yes. [Laughs.] At the time, we were both single. We made an agreement that if one of us

were to marry, he would move out. I met my wife and got married, and Gilardi lived in this house for the rest of his life.

JS: Did you always know you would inherit this home and have a responsibility to share it with the public?

MBLV: Of course not! When I moved out of the house I never thought I would return. I had no idea this would become an international destination. Some people come to the house just because it's famous. But this was designed to be a home; it was not an egotistical project, and fame was never a factor for Barragán or for Gilardi.

JS: You can tell by his designs that Barragán was friends with artists.

ML: He spent more time with artists than he did with architects. So often architects make architecture for other architects and forget about the people who will inhabit the space, the senses, light, and water. Barragán never fell into that trap because he surrounded himself with artists.

JS: It is reciprocal then—so many artists nowadays are inspired by his work.

MBLV: Yes, of course, and they all show up at our door! Did you know that David Hockney made

his first swimming pool painting right in this house? I framed the rag he used while he painted our pool. We have it upstairs. And this is actually not the first time we have been photographed eating. [Architect] Tadao Ando filmed us eating at this table. He wanted to videotape the architecture in use.

ML: My brother and I were very little at the time. We thought it was very creepy. I didn't know who Tadao Ando was. I only remember I wanted to punch my brother but couldn't because we were on tape.

JS: [Laughs.] That must have been very strange indeed. But I'm sure this house, and all your exposure to incredible artists, has had an impact on your development and your thinking?

ML: Yes, of course. My brother and I both see the world a little bit differently. We are deeply attuned to how space affects consciousness. As an architect, I try to design for the full range of human emotion, creating room for solitude and communion. My brother, a chef, cooks to match the surroundings in which his food is served. He marries differing flavors with the colors, scale, and vantage points of a particular site.

JS: Why do you think so many artists are inspired by Barragán's work? Have you noticed any common themes over the years?

ML: Barragán worked with forgotten traditions and the human senses to create something meaningful and timeless. The simplicity of his work—his ability to impart feelings of nostalgia and spirituality using such modest materials—is what compels all of these wildly creative artists.

JS: So, why not make this house into a museum?

MBLV: Making this house into a museum would kill its essence. When people visit our home, they feel humbled. They free their minds and distill their purpose as architects or designers. It's only possible to create this kind of experience with honesty and intimacy, and that is the beauty of this place.

Below: Martín Jr. and Martín Baltazar Luque Valle sharing a salad with my mother, Joan Sherman.
Opposite: Martín Jr. sitting next to the indoor pool.

The goop that surrounds the crunchy seeds of a passion fruit is tart and mouth-puckering, and makes for an unusually exciting vinaigrette. There are a few different varieties commonly seen in stores, some with dark-purple and others with yellow-to-orange skin. They are all delicious. For salad dressing, I use the purple passion fruit, which is a little more pungent than the yellow. When ripe, they should have a wrinkly skin and feel a bit heavy in your hand. Sucrine is a French lettuce, a smaller variety of romaine that tastes like a hybrid between Bibb lettuce and Little Gem, with a buttery texture and a compact head. Look for it at farmers' markets in the spring, but if you cannot find it, use Little Gem, Bibb, or any other lettuce with volume, a little crunch, and mild flavor.

The Luque Family's Sucrine and Avocado Salad with Passion Fruit Vinaigrette

1. Make the dressing: In a small bowl, whisk together the passion fruit seeds and pulp, honey, chile, lime juice, orange juice, salt, and cilantro stems until well combined. Add the oil in a slow stream and whisk until emulsified.

2. Make the salad: Put the lettuce in a large salad bowl and toss with about 1 tablespoon of the dressing and a pinch of sea salt. Divide the salad among four plates and add the avocado slices gently to each portion.

3. Spoon the rest of the dressing over the salads, distributing the passion fruit seeds evenly. Garnish with the cilantro leaves, orange zest, pickled onion, if desired, and more sea salt.

For the dressing

3 tablespoons fresh purple passion fruit seeds and pulp (from 2 to 3 small passion fruit)

1 teaspoon honey

1 teaspoon minced fresh Fresno chile, seeds removed

Juice of 1 lime (2 tablespoons)

1 tablespoon fresh orange juice (zest the orange first)

¼ teaspoon kosher salt

1 tablespoon minced fresh cilantro stems

¼ cup (60 ml) high-quality extra-virgin olive oil

For the salad

4 heads sucrine, Little Gem, Bibb, or romaine hearts, leaves separated

Flaky sea salt

1 to 2 ripe Hass avocados, cut into ½-inch (12-mm) slices

1 tablespoon torn fresh cilantro leaves

Grated zest of 1 small orange

Pickled Red Onions (optional, page 255)

Serves
4

Prep Time
15 minutes

Lotus root has a subtle nutty taste and the texture similar to a water chestnut. It can be found at any Asian grocery store worth its salt. Look for lotus root that is heavy and firm, pale brown without soft spots or bruising. It is possible to buy frozen lotus root sliced and packaged, but then you wouldn't get to walk down the street with a giant tuber tucked under your arm (my stand-in for the French baguette). If using frozen lotus root, let it thaw before frying. Asian pear and lotus root will keep for a long time in the fridge; Asian pears for up to three months, and lotus root up to a month if wrapped in a damp cloth and stored in a plastic bag.

If you cannot find fresh yuzu, an aromatic Japanese citrus, substitute bottled organic yuzu juice and Meyer lemon zest. Myoga (fresh ginger flower) is less common, but ask for it at your Japanese market. It's crunchy with delicate ginger notes, and the color is a stunning pale pink. If you can't find it the salad will still be great.

Golden Crispy Lotus Root with Asian Pear and Yuzu Dressing

1. Make the dressing: Whisk together all the ingredients.

2. Make the salad: Peel and core the Asian pears and cut them into 1-inch (2.5-cm) chunks. Put them in a bowl with the yuzu juice and zest and toss to combine.

3. Peel the lotus root and rinse well. Cut it into ¼-inch (6-mm) rounds.

4. Lay out a few layers of newspaper or cut apart an old paper shopping bag to soak up the extra grease of the lotus roots once they are finished cooking.

5. In a large skillet, heat ¼ inch (6 mm) of oil over medium-high heat until sizzling hot and just beginning to smoke. Lower the heat to medium. Working in batches of about six slices

For the dressing

1 tablespoon fresh yuzu juice

1 tablespoon olive oil

¼ teaspoon sugar

1 teaspoon rice wine vinegar

For the salad

2 pounds (910 g) Asian pears

1 tablespoon fresh yuzu juice

¼ teaspoon grated yuzu zest

1 pound 6 ounces (625 g) lotus root

Vegetable oil

¼ teaspoon kosher salt

1 tablespoon thinly sliced myoga flower (optional)

1 teaspoon minced fresh chives (optional)

at a time, add the lotus root to the pan, being sure not to overcrowd. As they start to brown, flip them over and cook until they reach a deep golden brown on both sides, 3 to 5 minutes total. Using a slotted spoon or tongs, transfer the slices to the newspaper and sprinkle with the salt when they are still hot. Repeat with the remaining slices.

6. Plate half the lotus root on a shallow serving dish. Top with the Asian pear, and distribute the remaining lotus root on top of that. Spoon the dressing on top and, if using the myoga, scatter it over the salad along with the chives. Serve immediately.

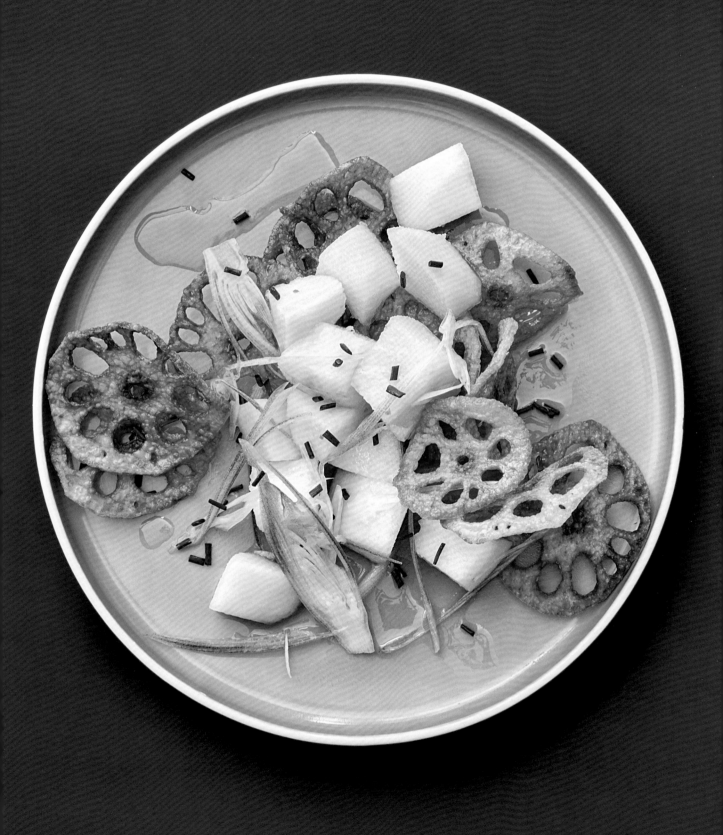

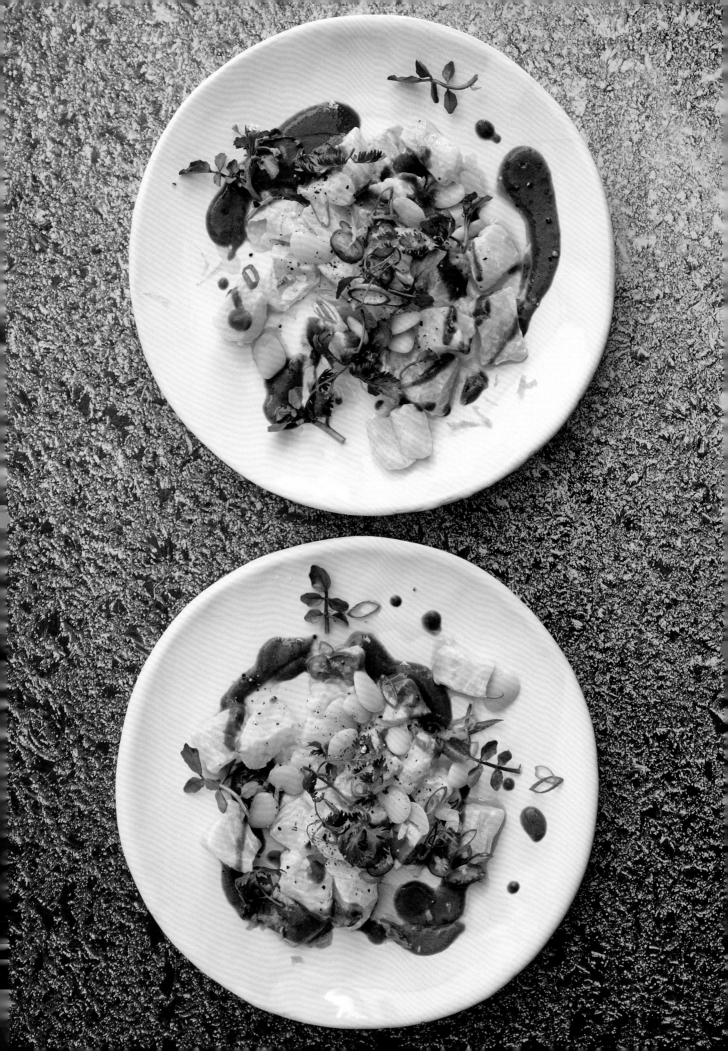

This is a Peruvian-Mexican mash-up ceviche, using the protein-rich runoff of the fish marinade as the base for the bright-green herby sauce, and adding a glug of olive oil like they do in Mexico. It might seem weird, but be sure to use all of the juice that will pool around the marinating fillets for your sauce. This stuff is liquid gold.

Ceviche with Butter Beans and Herb Leche de Tigre

1. Make the ceviche: Rinse the fish fillets and pat them dry. Using a very sharp knife, cut out the fish's bloodline, which is the dark red portion in the center of the fillet. (This will reduce the fishy flavor and prevent a tough texture.) Cut the fillets into ¾-inch (2-cm) chunks and put them in a large bowl. Sprinkle with the salt and lemon juice and toss well to coat. Cover and put in the refrigerator for 10 minutes, or longer if you want a more "cooked" texture. Taste and add more salt if needed.

2. Make the dressing: Put the herbs, watercress, garlic, butter beans, jalapeño, and lemon juice in a high-powered blender. Holding back the fish, add the *leche de tigre* (the cloudy white liquid that is now pooling around the fish) to the blender. Blend until finely pureed, scraping down the sides of the jar as needed, then, with the motor running, add the oil in a thin stream through the hole in the lid, blending until the dressing is thick and creamy.

For the ceviche

2 pounds (910 g) skinless fluke fillets, or any firm, mild white fish

1½ teaspoons sea salt

Juice of 2 lemons (about 7 tablespoons/105 ml)

For the dressing

1 cup (40 g) chopped fresh basil

1 cup (40 g) chopped fresh cilantro, plus extra for serving

½ cup (20 g) fresh parsley leaves

½ cup (20 g) watercress leaves, plus extra for serving

1 small clove garlic

12 ounces (340 g) cooked and drained butter beans (see Note)

1-inch (2.5-cm) piece jalapeño pepper, seeded

½ lemon, zested and juiced (about 2 tablespoons)

6 tablespoons (90 ml) extra-virgin olive oil

For serving

¼ cup (45 g) cooked and drained butter beans

2 green onions, very thinly sliced

2 serrano chiles, seeded and minced

Sea salt and freshly ground black pepper

Fancy extra-virgin olive oil

3. Pile the fish on a platter or individual plates and spoon the dressing over it. (If you're feeling fancy, use a squeeze bottle.) Sprinkle with the whole butter beans, green onions, chiles, cilantro and watercress leaves, lemon zest, more salt, and pepper. Drizzle with oil and serve immediately.

Note: You can use canned butter beans (or baby lima beans), drained and rinsed, or cook your own: Soak dried beans overnight in cold water to cover by at least 2 inches (5 cm), then drain and put them in a saucepan with fresh water to cover generously. Bring to a simmer and cook until tender, 20 to 30 minutes.

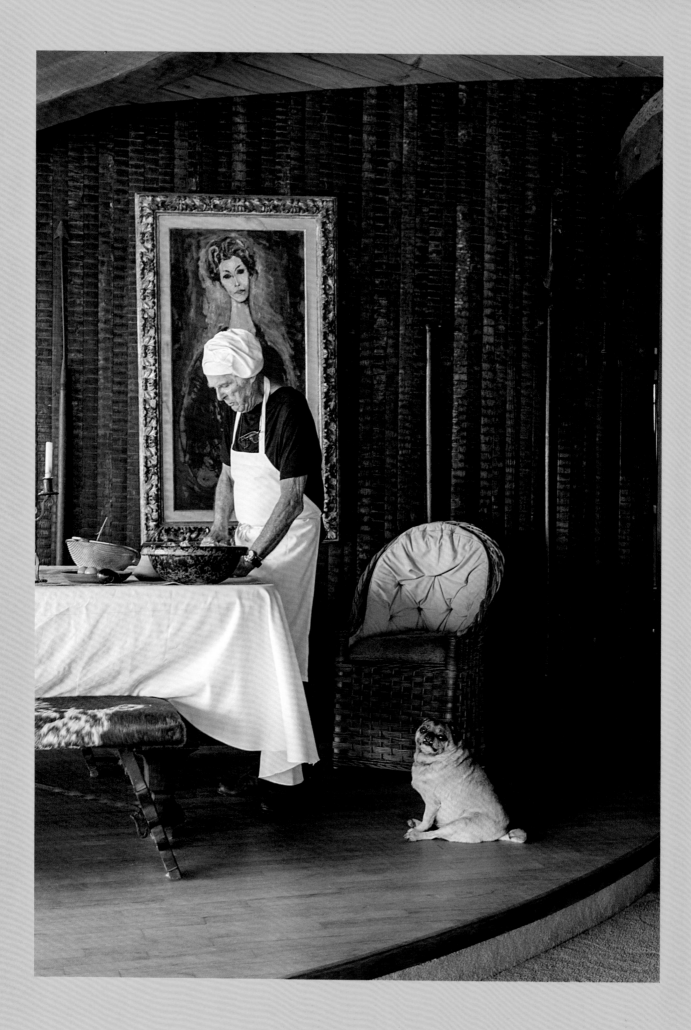

Harry Gesner

Occupation: Architect, inventor, surfer, and war hero
Location: Malibu, California
Salad: Red Fresh Dates, Marcona Almonds, and Upland Cress Salad (page 203)

Harry Gesner's architecture heightens your awareness of the sun, the horizon, the water, the overwhelming improbability of being perched on the edge of a cliff. His work is an homage to the earth itself. He sketched his most famous project, the Wave House, directly on his handmade balsa-wood surfboard, bobbing in the ocean and looking back at the land that was his to adorn. If that doesn't make you swoon, you are reading the wrong book.

I first learned of Harry when I stumbled upon the little-known Scantlin House (referred to now as the Trustee House), which remains hidden behind a grove of trees on the Los Angeles Getty Museum grounds. It was built in 1965 and features a swimming pool that reaches under a rock wall and into the living room, an indoor waterfall and fern garden, two fireplaces, and sweeping views of the city. As soon as I stepped foot in this mysterious building, I accepted my mission to find its creator.

Harry stopped surfing a couple of years ago (in his eighties), but he swims in the Pacific Ocean every morning. He has adventured around the world, befriended the most eccentric of characters, and loves to tell a good story. He also has a James Bond–like trick cane that unfolds into a sword (that was scary). When I finally finagled my way into Harry's Malibu beach house, a cylindrical building anchored by a cavernous central fireplace, he put on his chef's hat (literally) and got to work. He let me boss him around and climb on his furniture while taking pictures, as if this were the normal way to conduct an interview.

Above: The view of the Pacific Ocean as seen from Gesner's deck.

Opposite: Gesner enjoys the view of the ocean, flanked by giant clamshells he found on a trip to Tahiti with former client Marlon Brando.

Harry Gesner: Tell me, am I an exception to the rule, or is this how you conduct every interview? How did you know I would be willing to cook for you?

Julia Sherman: Because you're cool?

HG: Right. But I thought you said you were going to make the salad. What does this have to do with your architectural preservation group, Iconic Houses of Los Angeles?

JS: I'm not sure what you mean.

HG: In your voice message, you said you were calling from the organization Iconic Houses of Los Angeles, right?

JS: Nope. I told you I was an artist doing a project at the Getty Museum and a big fan of your work.

HG: [Laughing.] Oh my God, are you in luck?! I mixed you up with an architectural historian who called the same week you did. She was inquiring about the Scantlin House, too. There is no way I would have agreed to all of this ahead of time. I can't believe I'm doing this!

JS: You know, it's not the first time I've heard that.

HG: And I was wondering why this historian kept talking about salad . . .

JS: Well, aren't you having fun?

HG: Oh yes, this is fabulous. [Harry continues pitting dates one by one.]

JS: Well, the kitchen is the center of your home. You must like to cook?

HG: Oh yes, I do. I also used to smash my own grapes to make wine. I grew grapes up on the hillside here. We still have a couple bottles down in the basement. They've been there for about thirty-five years.

JS: Is there a certain occasion you're waiting for?

HG: When I pass away, I want my kids to go out to sea right here and drink it.

JS: Wow, what a touching idea. How many houses have you made here in Malibu?

HG: A lot.

JS: Is the Wave House [the massive house next door to Gesner's] your favorite?

HG: Every house that I have made is my favorite.

JS: You never lived in the Wave House, did you?

HG: No, but Rod Stewart lived there. I didn't know who he was.

JS: No way! How long did it take you to figure that out?

HG: About ten years. In reality, he was nothing like what you'd expect.

JS: But that hair! You just thought he was a guy named Rod?

HG: Well, he only wears it that way when he performs, and nobody told me! One night, I left the TV on for our Labrador, and Nan, my wife, says, 'Oh there's Rod.' She knew who he was.

JS: [Laughs.] I have only had the chance to go inside two homes that you designed and built, but it seems like you really work with the landscape, not against it.

HG: Why knock down trees just to put up a house? I invented what I called a tripod design, which doesn't require bulldozing or retaining walls. I called these houses "tree houses." They grow on the mountainside without destroying the beauty of the natural terrain.

JS: But you've been innovating green technology for years, right?

HG: Did you know I designed a twenty-million-dollar compost plant that turned all the garbage from the city of Madisonville, Kentucky, into compost in six days?

JS: How did you do that?

HG: The metals, glass, rubbers, and plastics were taken out first, and then everything remaining was made into mulch. We channeled all of the sewage sludge, which is really stinky and impossible stuff to get rid of, and we mixed it with the organic compost: the papers, food waste, trees, leaves, or anything you put out in front of your house to be taken away by a garbage truck.

JS: What did you do with the inorganic or unrecyclable trash?

HG: We sold it back to the industries—the glass, plastics, and steel.

JS: What about Styrofoam?

HG: That was included in the mulch. Styrofoam was one of the best things for mulch. The whole process took six days. After six days, the garbage was black, sweet-smelling humus soil.

Gesner pitting fresh dates.

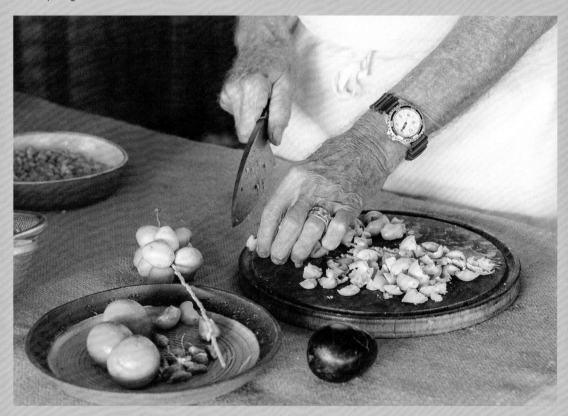

We carted it away and put it over land that had been strip-mined by coal miners. Within six months, that land returned to nature—the trees were beginning to sprout. It was a great breakthrough. The city could get rid of its garbage and create a viable product to go with it. Then the mayor told us we couldn't put the landfill out of business; it was owned and controlled by the Mafia.

JS: From reading about the Scantlin House, I understand that before they drained the pool, you could swim into the living room?

HG: Oh yes, there was an indoor waterfall that created an air lock and disguised the passageway, but you could swim right under that and enter the house.

JS: There's a rumor that once they drained the pool, a homeless man was entering and exiting and squatting there.

HG: Wrong story! The homeless guy was living there when the pool was still a pool. He must have come to take a bath, and realized that the pool actually flowed into the house. So, he swam into the house, walked to the front, and unlocked the door.

JS: We need to find that guy; he has squatter's rights!

HG: That was when [architect] Richard Meier was living there; he was building the Getty Museum. When Meier was out of town, this homeless guy was sleeping in his bed and wearing his suits. He was even smoking Meier's cigars. Poor Meier. I consider him my unknown friend because he refused to tear the Scantlin House down when he was planning the Getty Museum.

JS: It's amazing that people don't know that the house is still there—you can't see it through the trees, but it is smack-dab in the middle of the museum. I was shocked when I happened upon it for the first time.

HG: It's the Getty's own little private hideaway. But the house has changed. They trashed the kitchen. And the toilet. There used to be an indoor fern garden around the pool. I planted tons of ferns to conceal the bathroom.

JS: Ah, so you do love plants! Do you still garden?

HG: No, now I'm inventing electric cars and things like that, and I'm still designing houses. I used to have the most amazing horseradish garden here. Also tomatoes, onions, strawberries, raspberries . . .

JS: What was your favorite plant?

HG: Horseradish. I would love to make prepared horseradish again.

JS: Why?

HG: I almost lost my legs on D-Day. I was sent home from the war on a boat. On the journey back to the States, I got ahold of a book about medicinal plants, and there was a whole chapter on horseradish. I decided I would learn to garden and grow my own. I wore a World War II gas mask when I processed the horseradish, to protect my eyes from the noxious fumes. The whole family had to evacuate the house. Then, I would bottle it up and give it away. There was just so much of it.

JS: Maybe I can grow some horseradish for you at the Getty? We can prepare it together in the Scantlin House?

HG: Yeah! Definitely. It will be fun!

JS: You can bring the gas masks.

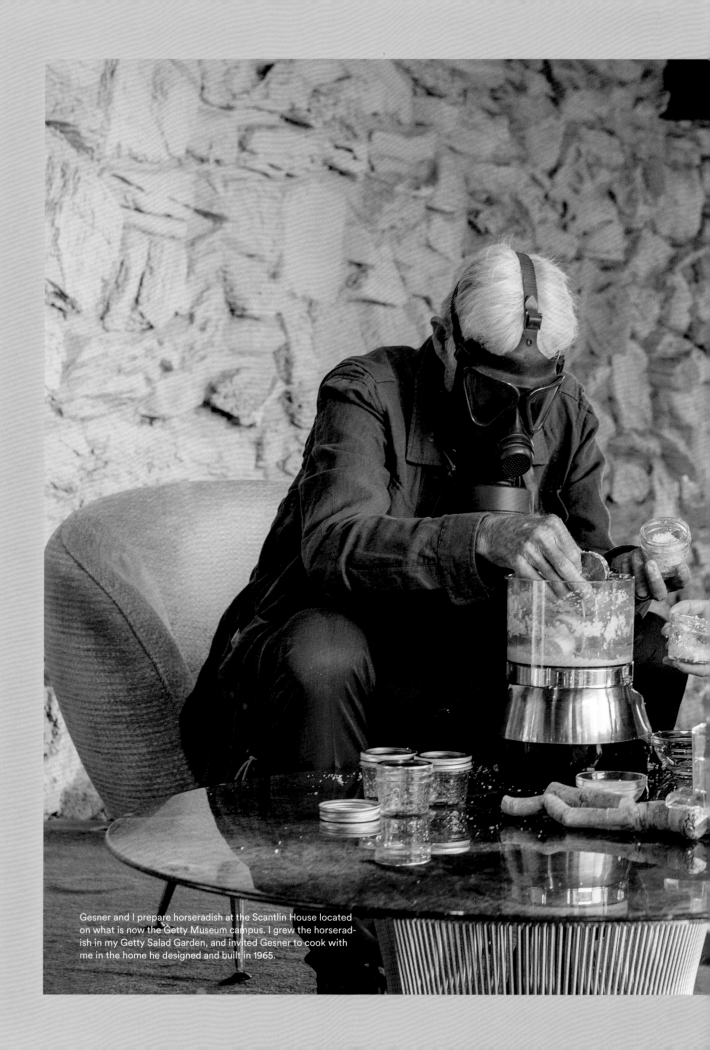

Gesner and I prepare horseradish at the Scantlin House located on what is now the Getty Museum campus. I grew the horseradish in my Getty Salad Garden, and invited Gesner to cook with me in the home he designed and built in 1965.

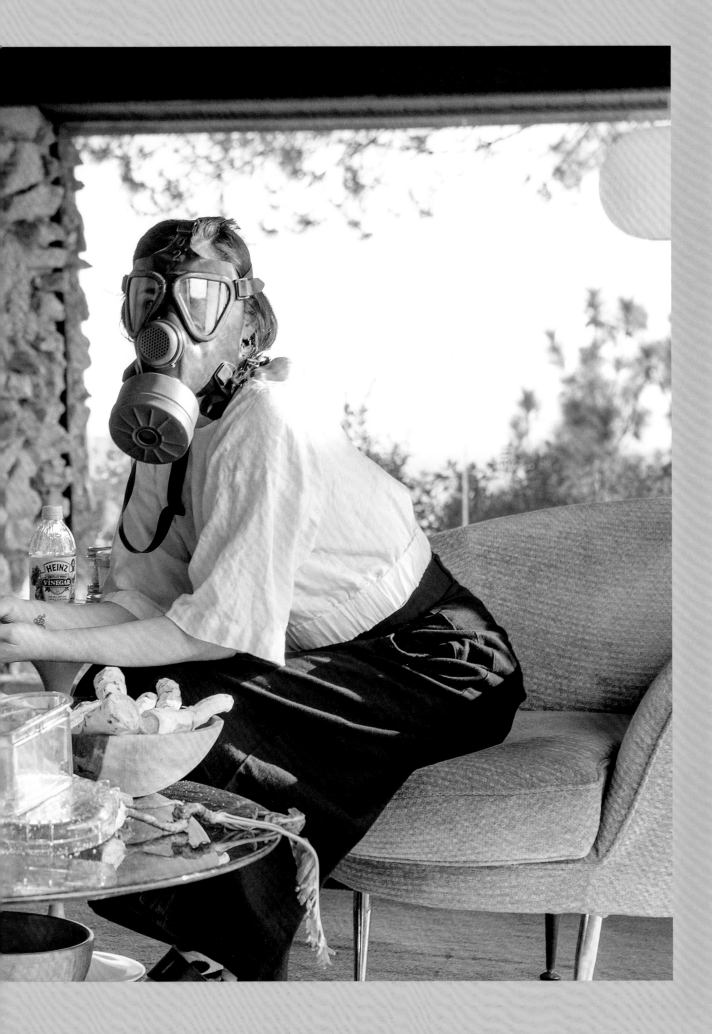

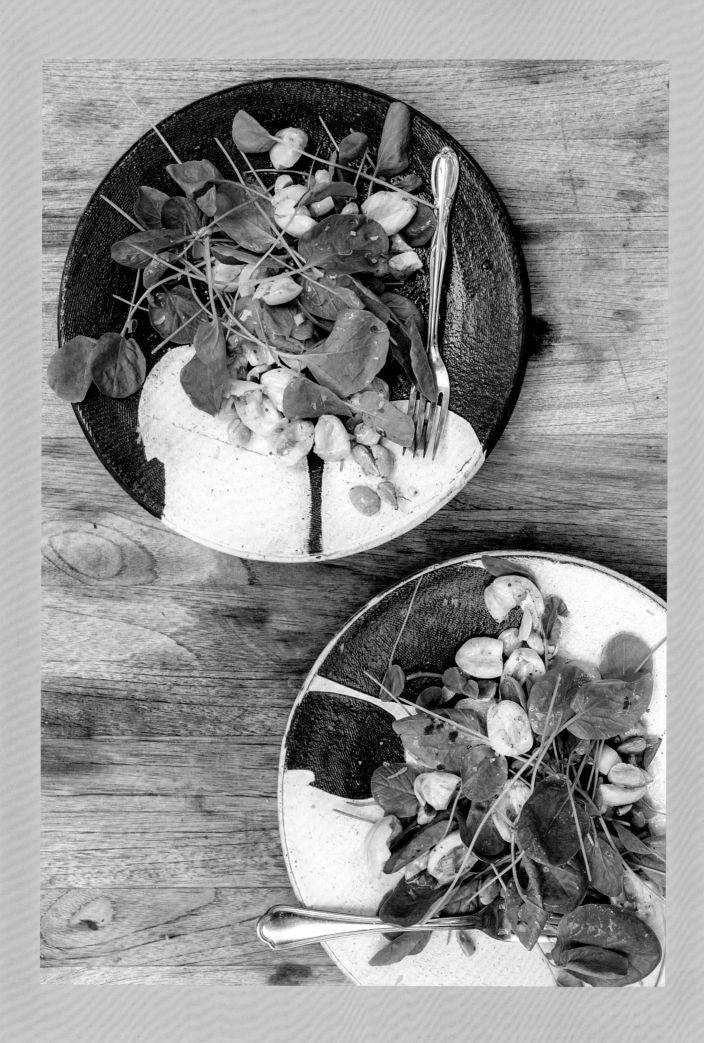

Dates do not acquire their caramel sweetness until they are fully dried and the sugars have had time to develop. Fresh dates are crunchy with a tame sweetness like sugarcane and have the texture of a crispy apple. I have spotted them lately at the greenmarket, the supermarket, and the Middle Eastern grocer, and I have even seen them sold at the fruit cart on the street.

Although this is clearly not an everyday item, fresh dates are increasingly available, but only in season for two to three months, beginning in August. They absorb dressing and retain excellent crunch in a salad. Of course, Marcona almonds from Spain are the champagne of the nut family: oily and toasty in flavor, but somehow light in texture.

Harry Gesner's Red Fresh Dates, Marcona Almonds, and Upland Cress Salad

1. Make the dressing: Dissolve the honey in the vinegar in a large salad bowl. Add the shallot, zest, and mustard and stir to combine. Add the oil to the dressing in a slow stream, whisking to emulsify.

2. Make the salad: Remove the base of the dates' stems. Smash the dates with the broad side of a chef's knife to crack them. Remove and discard the pits and toss the fruit in the bowl with the dressing.

For the dressing

1 teaspoon flavorful honey such as buckwheat

2 tablespoons sherry vinegar

1 teaspoon minced shallot

¾ teaspoon grated tangerine zest

½ teaspoon Dijon mustard

3 tablespoons olive oil

For the salad

2 cups (360 g) fresh whole dates

½ cup (55 g) chopped salted Marcona almonds

1 tablespoon olive oil

1 head Red Ruffles or Red Oak leaf lettuce

Sea salt and freshly ground black pepper

3. Preheat the oven to 350°F (175°C). Toss the almonds with the oil and spread them on a baking sheet. Bake for 10 minutes, until golden brown.

4. Wash and spin the lettuce and tear it into bite-size pieces. Toss it in the salad bowl, season with salt and pepper, and toss to coat with the dressing.

5. Sprinkle the almonds on top of the salad and serve immediately.

Serves
2

Prep Time
15 minutes
active

30 minutes
+ 2 hours
passive

Pressing your cucumbers might not sound like a good idea, but when you squeeze all that liquid out of this waterlogged fruit, it becomes dense, approaching maximum crunchiness. This salad can be made in advance—the longer it sits under the weight of an old can of beans, the better. Piled on top of earthy soba noodles and dotted with unctuous salmon roe, this is a light Japanese-inspired meal.

Pressed Cucumber Salad with Salmon Roe, Sesame, Nori, and Soba Noodles

1. Slice the cucumber into half rounds ⅛ inch (3 mm) thick on a mandoline. Put the slices in a medium skillet or pie plate (or any flat-bottomed vessel with sides to catch the excess water). Toss the cucumber with 1 teaspoon of the salt and spread them out evenly. Top with an additional pie plate or salad plate, adding as many cans or other weights you can find (this is your chance to make a cool found-object sculpture, so don't blow it). Let it sit for at least 1 hour and up to several hours in the fridge. Liquid should start to pool around the edges after 15 minutes.

2. Meanwhile, put the chile in a ramekin and sprinkle it with the sugar and the remaining ⅛ teaspoon salt. Push down on the chile with the back of a spoon and allow it to sit. The salt should encourage the chile to release its spicy juices. After 10 minutes, add the vinegar, stir until the sugar dissolves, and set it aside.

3. Remove the weights on the cucumbers, press the plate down aggressively on the cucumbers, and tilt the cucumbers over a strainer in the sink to release all of the water. Be patient and make sure to really press all of the water out. Put the cucumbers in a serving bowl and pat them dry with a

1 pound (455 g) seedless cucumber, halved lengthwise

1⅛ teaspoons kosher salt

½ Thai bird chile, halved lengthwise and seeded

½ teaspoon sugar

2 tablespoons plus 2 teaspoons seasoned rice wine vinegar

3 teaspoons toasted sesame oil

1 teaspoon toasted sesame seeds

6.5 ounces (184 g) dried soba noodles

2 teaspoons tamari

½ (8 x 7½-inch/20 x 19-cm) sheet toasted nori (Japanese seaweed)

4 teaspoons salmon roe

1 green onion, roots and tops trimmed, thinly sliced on the diagonal

clean kitchen cloth if they still seem very watery.

4. Mince the chile and add it to the dressing if you like extra heat, or remove and save it for another use. Add 1 teaspoon of the sesame oil to the chile and vinegar and whisk quickly to combine. Pour the dressing over the cucumbers and sprinkle them with the sesame seeds.

5. In a saucepan, bring a pot of water to a boil over high heat and add the noodles. Lower the heat to medium-high and cook for 10 minutes. Drain the soba and run them under cold water. Shake out all the excess water and put the noodles in a mixing bowl. Toss them with the remaining 2 teaspoons sesame oil and the tamari. Pile the noodles in two bowls and top them with cucumber salad and all of their dressing.

6. Set your stovetop burner to low. Holding the sheet of nori with tongs, wave it over the burner repeatedly until you start to feel it contract, making sure to keep the seaweed from making direct contact with the flame or burner. Roll the seaweed up and use kitchen scissors to cut strips ⅛ inch (3 mm) wide on top of the salad. Top with the salmon roe and onions and serve immediately.

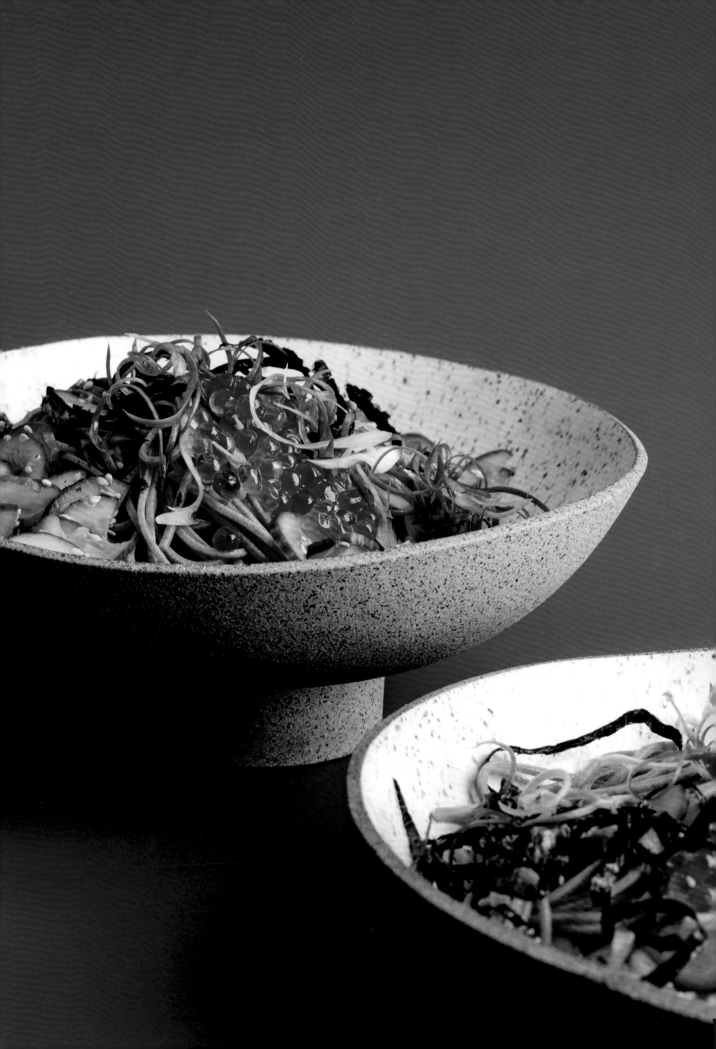

Emerald Fennel Apéritif

Adding chickpea water to a drink might sound like the fastest way to ruin a perfect apéritif, but when the protein-rich stuff is shaken vigorously it transforms into a neutral, creamy foam that rests on the surface of the cocktail. The texture is even more velvety than that of the more traditional cocktail ingredient, egg white, and better yet, it's vegan.

Mauro Vergano is an especially floral white vermouth, a great investment since it's lovely to sip all by itself on the rocks or with a spritz of soda.

Serves
1

Prep Time
10 minutes

For the Cocktail
1 ounce (30 ml) high-quality gin (I prefer Greenhook Ginsmith gin)
1 ounce (30 ml) Mauro Vergano vermouth
1½ ounces (45 ml) fresh fennel juice (see Note)
½ ounce (15 ml) fresh lemon juice
½ ounce (15 ml) chickpea water (from a can of chickpeas)

For the Garnish
Toothpick-skewered shiso leaf–wrapped Mexican sour gherkin

1. Combine all the ingredients in a cocktail shaker and fill it three-quarters full with ice. Shake vigorously for 20 seconds.

2. Strain into a coupe glass.

3. Place the shiso gherkin garnish on the edge of the glass and serve.

Note: Juice enough fresh fennel to accommodate your number of guests (¼ bulb will yield 1 to 2 ounces/30 to 60 ml). Get a bit of the green stalk in there so the juice has a nice color.

The Freshest Bloody Mary

By juicing your own ripe tomatoes and pureeing garden herbs, you can whip up a refreshing version of a classic Bloody Mary that errs on the side of gazpacho. Using the palest yellow tomatoes for the juice will result in a vibrant color when combined with the green herb puree. The addition of red tomato juice will still taste great, but the color of the finished drink will be murky.

Serves
4 to 5

Prep Time
30 minutes

For the Bloody Mary mix
4 to 5 large, ripe pale-yellow-tomatoes
1 unripe green tomato
1 cup (240 ml) fresh lemon juice
1 tablespoon tamari
1 tablespoon apple cider vinegar
½ fresh red Thai chile (more if you like it spicy)
½ cup (55 g) grated fresh horseradish
1 teaspoon kosher salt
2 teaspoons celery seed
1 tablespoon freshly ground black pepper
Grated zest of ⅓ orange
½ cup (20 to 25 g) mixed fresh herbs such as thyme, dill, oregano, and basil

For the Drinks
6 to 7½ ounces (180 to 220 ml) vodka
High-quality extra-virgin olive oil
Kosher salt

For the Garnish
Fresh-cut parsley, dill, or basil
Cherry tomatoes, quartered
Celery curls (see Note)

1. Make the Bloody Mary mix: Juice the yellow and green tomatoes to make about 1 quart (960 ml) juice (use more tomatoes if your tomatoes yield less liquid). Set the juice aside in a large container with room to spare.

2. Add the remaining ingredients to a Vitamix or other high-powered blender and blend until very smooth, then add to the fresh tomato juice, stir well, and set aside.

3. Assemble the drinks: Put 1½ ounces (45 ml) vodka and 4 ounces (120 ml) of the Bloody Mary mix in each Collins glass and add ice to the top. Drizzle oil on top, sprinkle with salt and garnish with a handful of herbs, cherry tomatoes, and celery curls, if desired.

Note: Cut celery stalks in half lengthwise and shave with a Y-shaped vegetable peeler or a mandoline to make broad, paper-thin strips. Plunge them immediately into an ice-water bath and allow to sit for 5 to 10 minutes, until the celery begins to curl into tight tendrils. Top the drinks with the curls just before serving.

Salad Garden Martinis

This cocktail was born in my Salad Garden on the roof of MoMA PS1 in Long Island City. Using the wild array of herbs I had grown, Arley made twenty different infusions for twenty different martinis. Each one had its own distinct, crystal clear character.

After stuffing the vessels with herbs, Arley uses a wine pump to speed up the process and keep the herbs nice and fresh, but if you don't have a pump, don't fret.

This is the basic recipe, but it can be made with any herb of your choice—our favorites are bronze fennel, anise hyssop, and coriander berry. It's always a nice touch to chill martini glasses before serving. Pop them in the freezer for 15 minutes before you plan to serve.

Serves
12 cocktails per bottle

Prep Time
5 minutes, plus infusing time

For the Infusion
½ cup (20 to 25 g) fresh herbs of your choice
1 (750-ml) bottle high-quality vodka or gin (we prefer Material vodka or Greenhook Ginsmiths gin)

For each Martini
1 ounce (30 ml) Dolin dry white vermouth

For the Garnish
Wide lemon twist (see Note)

1. Wash and dry the herbs, removing all tough stems.

2. Remove about 2 ounces (60 ml) of vodka or gin from the bottle and stuff the herb leaves and blossoms inside. Put a Vacu Vin stopper in the bottle and pump until the pressure is high and all the air has been removed (at this point, it will make a clicking sound or will be difficult to pump). Set aside in a dark place for at least half a day and up to 3 days.

3. Assemble the martini: Put 2 ounces (60 ml) of the infused alcohol, 1 ounce (30 ml) vermouth, and a large scoop of ice in a cocktail shaker and stir for 20 seconds. Strain the drink into a chilled martini glass.

4. Twist the lemon zest over your martini to release the aromatic oils, then place it in the cocktail and serve.

Note: Use a vegetable peeler to cut a 2-inch (5-cm) oval strip of lemon zest, trying your best to avoid removing any pith.

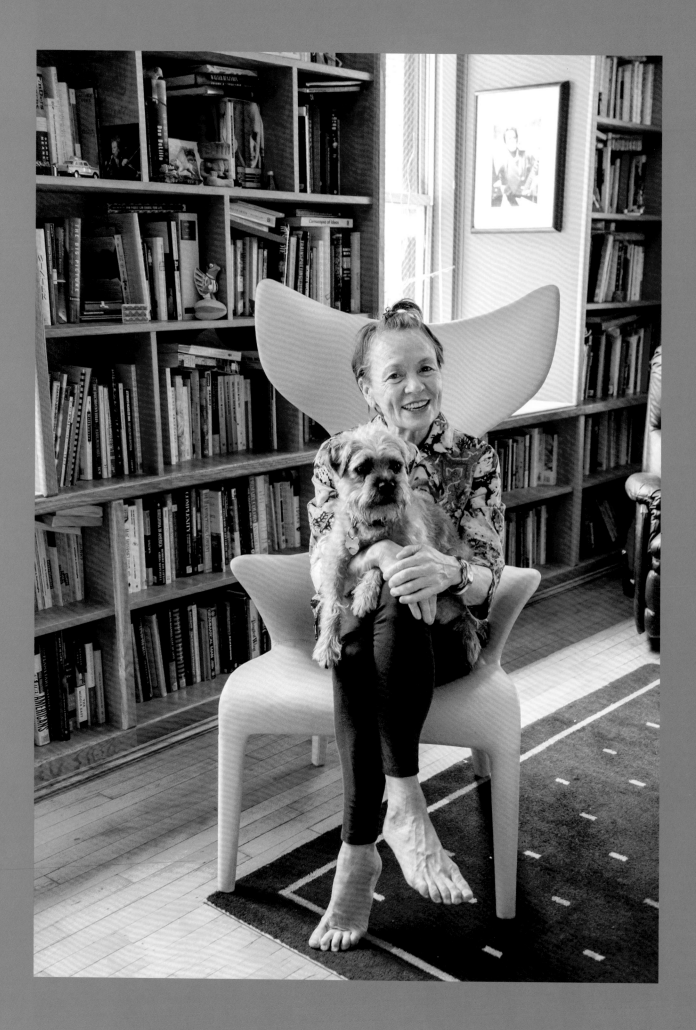

Laurie Anderson

Occupation: Artist, musician, director
Location: New York City
Salad: Roasted Eggplant Dip and Pile of Herbs (page 221)

Laurie Anderson and I exchanged sixty-two emails before we managed to meet in person. By that point, my anxious anticipation had outgrown the humble act of salad-making itself. Laurie is the artist who has achieved everything to which I have ever aspired. She has experimented with every medium from music to film, painting to performance. Her one-woman shows weave together deeply personal narratives, political commentary, and fantasy in one brave package that floors me every time. She lays bare the inner workings of an artist's mind without pretense, and the result is as entertaining as it is challenging. Her career is proof that artists are essential to our society, not superfluous (exemplified by her stint as NASA's first and only artist-in-residence).

Now in her sixties, Laurie's professional life is accelerating at a mind-bending pace. Over the course of our six-month salad courtship, Laurie had been to Greece, North Carolina, England, Italy, and France. In addition to performances and installations, she was busy directing the Brighton Festival, playing concerts for dogs in opera houses, and exhibiting what she describes as "big, terrible paintings." Despite her success, Laurie doesn't aspire to run an empire, and she "won't be opening the London office" or expanding anytime soon. The afternoon I showed up in her Canal Street studio was atypical because there were twelve Taiwanese engineers experimenting with virtual reality. Laurie was figuring out how to fly using new technology, because somehow she hasn't figured out how to do that in real life yet.

Laurie Anderson: I loved all the unusual herbs we used in our salad. Maybe you can advise me on what to grow?

Julia Sherman: I can, but I insist that I am not expert.

LA: Maybe you will become an expert?

JS: People always want you to be an expert, but I prefer to be a professional amateur. I love to garden because every day still feels like the first time for me.

LA: Well maybe you can be an authority on "the new"?

JS: Yeah! I like that. You mentioned that, like me, you had once worked with Benedictine nuns. I have never met another artist who had this specific interest. I was wondering, what initially attracted you to that community?

LA: Like me, the nuns were interested in "the voice." The Benedictines are gruff farmer girls; they aren't angelic, delicate singing nuns. So their fascination with language is part of their desire to figure out how the farmer girl can ask something of god? Do they have to be [in a

baby girl voice] sweet singing women, or can they pray and talk to god in their own authentic voice? You know? We talked about how to not become little girls when we want something. I know people who use a baby girl voice and I just wonder who they are being cute for. It drives me crazy.

JS: The Benedictine nuns are certainly anything but cute. They completely defied my own expectations: They are self-sufficient farmers, artists, and politically savvy feminists, though they would never describe themselves that way. It's impossible to put them in a box.

LA: There are huge barriers between institutions in the United States, but the Benedictines blur the boundaries between an art, a religious, and a meditation community in a way that I find really compelling.

JS: It's exciting to identify with people who are seemingly your polar opposite, culturally speaking.

LA: I just love it when artists try to push those barriers down and try to move their work into another arena. For example, when my friend Brian Eno created something called the Quiet

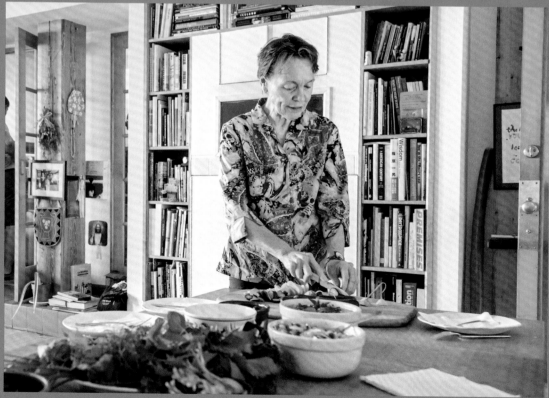
Anderson cuts cucumbers for the studio lunch.

A moment of dedication to Anderson's late husband, Lou Reed.

Club. He made a room for people in Brighton, England, to come and listen to extremely quiet, well-produced music. It was intended to be an artwork, but then a surgeon discovered it and said, "we need this room at our hospital." Hospitals are really violent, loud, and boring. Within two weeks, the Quiet Club was installed in this hospital. Brian could have showed those Quiet Club things in galleries or at music festivals forever, but they have a whole different meaning and function in a hospital.

JS: How does the work change when it is in this non-art context?

LA: The Quiet Club still has the meditative quality that Brian meant for it to have, but now it has an additional function—it is therapeutic. A lot of artists find it problematic if their work is considered therapeutic. Like if art helps people there has got to be something wrong with it, it's not pure. I don't feel that way at all.

JS: Do you make art to help people?

LA: I personally can't say that art should make the world a better place. That just really sticks in my throat. Better for whom? For you and your friends? It's very presumptuous. But if you make something that you really enjoy, other people will feel the same way. That's always been the underlying premise of my work: I find something interesting, something I want to learn about, and it's only natural to express it. If you make art to help people, it might be too specific and less effective than if you make something that's really beautiful and hope that people use it in a way that's good for them.

JS: What does failure mean to you?

LA: I think failure is the engine that propels you to continue questioning: "Why doesn't this work? Is something too oblique? Or, why doesn't it feel exactly right?" The moment when something is exactly right can be hard to pin down—it has to have the right combination of inner and outer, under and over, political and not, beautiful and ugly, relevant and timeless. If a work is missing some of those ingredients, I try and shift my focus. If a piece is just beautiful I won't be motivated to continue working on it. I don't question someone else making something purely beautiful, because I love to see purely beautiful things. But for my own sense of meaning it has to have a few more elements.

JS: It occurs to me, your work is kind of like a salad.

LA: A salad is a composition. I am perfectly happy to see cars or clouds or salads as artworks. We live in a universe that's aesthetic. You can use anything to call attention to the structure and meaning and beauty of things. It's what you do with them and how you contextualize them that matters. I'm totally on the same page with you on that one.

Serves
4

Prep Time
45 minutes

This roasted eggplant salad can be served as a dip with endive spears or crackers, but it's also a prime excuse to make exploding herby salad wraps, slathered with tahini-laden eggplant, stuffed with mint, parsley, basil, fennel, and maybe even a sprinkling of olive oil–marinated feta.

Eggplant dip can be made in advance and refrigerated, as long as you bring it back up to room temp about twenty minutes before serving. I cheat on the bread and stop by the falafel shop near my house to grab wood-fired pita warm from the oven.

Laurie Anderson's Roasted Eggplant Dip and Pile of Herbs

1. Preheat the oven to 375°F (190°C).

2. Cut the eggplant in half lengthwise and brush the flesh generously with some of the oil. Place the eggplant halves on a baking sheet cut side down and bake for 30 to 40 minutes; to test for doneness, poke the eggplant with your finger—it should be squishy and soft. Remove from the oven and let cool.

3. Scoop the flesh from one eggplant half into a food processor and add the garlic, tahini, lemon juice, za'atar, and salt. Puree until smooth. (If you don't want to break out the food processor, just whip the mixture manually in a bowl using a fork until it is as smooth as possible.)

4. Transfer the puree to a small serving bowl and scoop and add the flesh from the remaining eggplant half to the bowl. Mix to combine, breaking up large chunks of eggplant, but allowing the spread to have texture. Taste and add more salt if needed.

For the dip

1 Italian globe eggplant

¼ cup (60 ml) extra-virgin olive oil, plus more for roasting and finishing

½ clove garlic, grated or Microplaned

1 tablespoon tahini, preferably Soom brand

1 tablespoon freshly squeezed lemon juice

1 teaspoon za'atar or sumac

½ teaspoon kosher salt, or more to taste

1 teaspoon thinly sliced fresh mint

1 tablespoon pomegranate arils (see Note)

Cracked black pepper

For the herbs

Any mix of the following herbs, gently washed, patted dry and left on their stems:

Mint, Thai/Genovese basil, Lovage, Fennel fronds, Marjoram

For serving

Pita or lavash bread

Feta cheese (optional)

5. Scatter the mint and pomegranate seeds on top, drizzle generously with oil, and season with cracked black pepper and za'atar and/or sumac. Serve alongside a large platter of mixed herbs on the stem. Encourage guests to pick their own combo of herbs and use their bread/lavash to make little eggplant/herb wraps with feta if they choose.

Note: To remove the arils from a whole pomegranate, cut the top and bottom off the fruit. With a sharp knife, score the peel from top to bottom in five or six places around the fruit, trying to score along the raised ridges. Put the fruit in a deep bowl of water and use your hands to pull it into sections, then pick out the arils (these are the juicy little seeds). The separated peels and membranes will float to the surface of the water, and the seed-heavy arils will sink; skim or pour off the detritus, then drain the arils in a sieve.

This soup is ideally made with sweet summer corn, but it's also uplifting in the winter made with frozen corn (beyond corn season, always use frozen kernels, not canned). For a smooth soup, blend all the corn from the get-go, skipping the part where you reserve the ½ cup (70 g) corn for the end. If you like lots of texture like I do, add 1 (15-ounce/430-g) can of drained hominy to the soup at the end. Hominy is crazy corn, with larger, chewier kernels. To make this into a filling main course, poach eggs directly in the simmering pot of soup one at a time, ladling them into each bowl as soon as the whites have congealed.

Tomatillo and Corn Chowder
with Hominy and Avocado

1. Make the chowder: Bring a medium pot of water to a boil. Add the tomatillos, jalapeños, and garlic and cook until the tomatillos turn from bright green to muted green, 10 to 15 minutes. The skin should start to crack but the fruit remain intact. Turn the veggies over if they seem to only be cooking on one side. Remove all the veggies from the water with a slotted spoon.

2. Trim the stems from the jalapeños and the tomatillos. Transfer one whole jalapeño and the tomatillos to a blender with the garlic, onion, 4 cups (580 g) of the corn, 1 cup (240 ml) of the cooking water, and the kosher salt. Blend until completely smooth. Taste. If the puree is spicy, deseed the second jalapeño and add just the flesh. If the soup is not spicy enough, add the second jalapeño with its seeds (remember, you have not yet added the chicken stock, so that will dilute the soup a bit).

For the chowder

5 to 8 clementine-size tomatillos (about 1 pound 3 ounces/540 g total), husks removed, washed

2 jalapeños

3 cloves garlic

½ small white onion, roughly chopped

4½ cups (650 g) yellow sweet corn kernels, fresh or frozen

1¾ teaspoons kosher salt

1 tablespoon grapeseed oil or schmaltz

1 (15-ounce/430-g) can drained hominy (optional)

2 cups (480 ml) Chicken Stock (page 253) or vegetable stock

1 teaspoon coriander seeds, toasted

½ teaspoon sea salt

For the optional accompaniments

Eggs

¼ cup (60 ml) full-fat plain yogurt

Chopped fresh chives

Chopped fresh cilantro

Avocado slices (highly recommended)

Tostadas

3. Dump the remaining water from the pot and in it heat the oil over medium heat until hot. Swirl it in the bottom of the pot to evenly coat the surface. Pour the corn and tomatillo puree into the pot, and bring it to a boil. Reduce the heat to low and simmer for 10 minutes, stirring occasionally.

4. Add the remaining ½ cup (70 g) corn, hominy, if using, and the chicken stock and simmer for an additional 10 to 15 minutes.

5. Coarsely crush the coriander and sea salt in a mortar and pestle.

6. If you'd like, crack eggs into the soup, cover, and cook until the whites are solid but the yolks are still runny, about 5 minutes. Ladle the soup (and eggs) into individual serving bowls and garnish with the coriander salt and any additional toppings. Serve with tostadas on the side, if you'd like.

Why would you make a white soup when it can be bright green?

This soup is a Hail Mary for the East Coast garden, blending bushels of the last remaining fresh herbs of the season to make vichyssoise, traditionally a basic potato and leek soup. The straining is a bit labor intensive, and a little bit messy, so I do suggest reserving this for smaller parties on your first go-round. If you manage to keep the kitchen in better shape than I did, go ahead and cater your next banquet with this bright green crowd-pleaser.

Fall Garden Herb Vichyssoise

3 cups (120 g) stemmed fresh parsley

1½ cups (55 g) coarsely chopped fresh chives

1½ ounces (40 g) watercress

3 medium Yukon gold potatoes (1 pound 6 ounces/625 g)

2 tablespoons ghee

1 small shallot, sliced

2 small cloves garlic, minced

1 quart (960 ml) Chicken Stock (page 253), plus more if needed

Sea Salt

Grated lemon zest

A drizzle of high-quality extra-virgin olive oil

¼ cup (60 ml) crème fraîche (optional)

1. If using herbs from the garden, be sure to submerge them in cold water to rinse as well as possible. Bring a medium pot of water to a boil and prepare an ice bath by filling a large bowl with ice cubes and water. When the water comes to a boil, dunk the parsley, chives, and watercress in the water for 5 seconds, then immediately transfer them to the ice bath and swirl around to stop the cooking process. Drain them in a sieve and squeeze excess water from the greens with your hands. Transfer them to a cutting board and coarsely chop the greens, being sure to break up the long stringy stems.

2. Peel the potatoes and cut them into 1-inch (2.5-cm) cubes. Put the ghee and shallot in a large saucepan over medium heat. Cook, stirring with a wooden spoon, until tender, 2 to 3 minutes. Add the garlic and cook for 1 minute, then add the potatoes and stir to coat with the ghee and to prevent them from sticking to the bottom of the pot. Cook for 5 minutes, stirring frequently.

3. Add the stock and bring it to a boil, then lower the heat and simmer until the potatoes are tender, about 10 minutes. Add the blanched greens and remove from the heat.

4. Using a high-powered blender, puree the soup in batches, blending on high speed until completely smooth. Be sure to remove the plastic cap in the center of the blender's top and cover it with a hand towel as you work. This allows some of the steam to release without splattering soup all over the kitchen.

5. Pass the soup through a fine-mesh sieve set over a large bowl, stirring with a wooden spoon, leaving the fibrous strings of the greens alone in the sieve. Taste and season with salt if needed.

6. Serve either warm or lightly chilled (if the chilled soup is too thick, stir in a little more stock to thin it), each bowl garnished with a light zesting of lemon, a drizzle of olive oil, and a dollop of crème fraîche, if desired.

Serves
4 to 6

Prep Time
15 minutes
active

30 minutes
passive

Gazpacho marks the peak of the summer season, the only time you have such a glut of tomatoes that you are willing to blend them all up and drink them (it's all downhill from here, people). Don't be seduced by the full spectrum of heirlooms out there right now; for this recipe, you want to use the reddest tomatoes you can find. Tossing a green or yellow one in there will muck it up (like mixing all the pretty colors together to make brown). Straining the soup adds time to this recipe, and while it certainly refines the texture, it is not the end of the world if you skip this step. Naturally, you are working with only the best tomatoes and the highest-quality olive oil right now (I am giving you the benefit of the doubt), so thick or smooth, you can't go wrong.

No-Fail Summer Gazpacho

1. Put the cucumber, tomatoes, jalapeño, and onion in a large bowl. Sprinkle with the salt and toss to combine. Let sit for 30 minutes so the juices start to flow. (This will make for a much tastier soup in the end.) Alternatively, toss the veggies on a baking sheet and pop them in the freezer for 30 minutes or longer. Freezing and defrosting will break down the cells of the vegetables and enhance the flavor.

2. In a high-powered blender, and working in batches if necessary, combine the vegetables with their juices, the roasted red pepper, vegetable juice, vinegar, and paprika. Blend on medium speed, adding the oil in a slow stream through the hole in the lid.

6 inches (15 cm) English cucumber, peeled and chopped, plus more finely diced cucumber, if desired, for garnish

3 pounds (1.4 kg) red heirloom tomatoes, chopped

1 small jalapeño pepper, chopped

1 small vidalia onion, chopped

1½ teaspoons kosher salt

¼ cup (25 g) diced marinated roasted red pepper

¾ cup (180 ml) tomato-based vegetable juice (organic is best)

1 tablespoon plus 2 teaspoons sherry vinegar

⅛ teaspoon sweet paprika

¾ cup (180 ml) extra-virgin olive oil

Fresh corn kernels for garnish (optional)

3. Pass the soup through a fine-mesh sieve into a large bowl, using a wooden spoon to coax it through, leaving only the seeds and bits of peel behind. Taste and add salt if needed.

4. Ladle the soup into shallow bowls and garnish with corn or finely diced cucumber. Serve at room temperature or cold.

Yoshua Okón and Mariana Vargas

Occupations: Mixed-media artist, educator, and fashion designer
Location: Mexico City
Salad: Purslane and Tomatillo Stew with Seared Squash (page 235)

In one of Yoshua's videos, he documents himself breaking car windows and stealing stereos. In another video, he coerces uniformed policemen to dance like creepy strippers on camera, a disturbingly funny snapshot of the perversity of institutional power. In another, he manages to convince the management of a McDonald's to let him videotape an obese customer splayed out nude on one of their dining tables. Furthermore, he is the co-founder of one of the most important artist-run spaces in Mexico City, the former Panaderia, and he later went on to establish a completely independent, non-accredited art school called SOMA. There, artists come from all over the world to do everything but make art—they talk, collaborate, and incubate, but material production is not encouraged.

Familiar with this work before we met in person, I assumed Yoshua would be brash, intense, maybe a little intimidating. To the contrary, the home he shares with his fashion designer wife, Mariana Vargas, is serene but lively, with a litter of newborn puppies, a sweet hairless dog, and two parrots living in harmony. Their kitchen is hot pink, they love to cook, and Yoshua cares deeply about the politics of food and farming.

Yoshua and Mariana were so welcoming that they honored our salad date in the wake of Mariana's bout with the flu (hence her surgical mask while cooking). She was eager to share her mother's most traditional recipe, purslane in tomatillo sauce, a massive salad masquerading as a healthful stew that she grew up eating on a weekly basis.

Previous page: Okón in his colorful kitchen.

Above: Okón's hairless dog poses in his Mexico City home.

Opposite: Okón and Vargas prep purslane for their dish.

Julia Sherman: You were born and raised in Mexico City, and you have shaped the art world here. Now you are leaving the city and moving to a ranch. What's the idea?

Yoshua Okón: We are moving to our ranch part-time. We will have studios there, but we will still be dependent on the city, which is okay—the city is great. But I don't need to be in my studio here every day of the week, and we want to have the best of both worlds. The air at our ranch is amazing, and we are making a really nice kitchen. Our plan is to be cooking a lot.

JS: Ah, that sounds like a dream. And will you have a garden?

modified corn and soil from the United States. The traditional farmers can't compete with Monsanto; a lot of their traditions are getting lost, which has adversely affected the way people eat.

JS: Is your interest in food largely a political one?

YO: Any sensible person with a minimum level of education, and who is somewhat health conscious, can understand the negative impact of agribusiness on our health and on our culture. It's especially tangible in a place like Mexico, where processed food is a relatively new phenomenon, and the majority of the population still relies on fresh produce. I believe that we are what we eat.

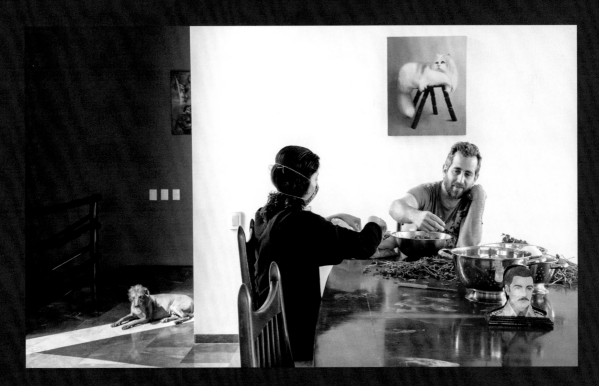

YO: The rivers were diverted into separate streams called an apantle. This is a pre-Hispanic system that rations the water on a schedule, sending it to different properties at different times of the week. The river water comes to our land twice a week, so it would be ridiculous not to grow our own food. Everyone around us is also farming, which means we can all trade produce.

JS: Wow, so there is already an active farming community for you to plug into?

YO: Yes, there are small farmers, but it's really hard for them right now. The farming economy was massively destabilized by the recent NAFTA trade agreement and by the influx of genetically

If we are passive about that, we might as well be dead.

JS: You grew up in the city—how do you know how to farm?

Mariana Vargas: I come from Xochimilco, where historically all of Mexico City's food was grown. My great-grandparents were farmers. My grandmother taught me the region's cooking traditions firsthand.

JS: Is this your grandmother's recipe?

MV: Yes, my grandmother and mother made this every week. For her, the spirituality of food is in

the preparation, from beginning to end. If you want to cook with purslane, you have to know how it grows, what parts to eat, how to pick the leaves from the stalk, and so on.

JS: Growing up in Mexico City in the 1970s, did you have many role models or mentors, people whose practices you emulated?

YO: I didn't have specific artists in mind when I chose this life path. I was more committed to the idea of being an artist. When I was an adolescent, I figured out that what I cared about most was agency. That is the most important thing for a human being. I had a romantic notion of the art world as a place where I could make a living and enact my philosophical perspective every day.

JS: Has that changed?

YO: Yes—following the rapid growth of the art industry since 2000 or so, artists increasingly work within the framework of a corporate structure, rather than the framework of cultural institutions. Most contemporary artists cater to an industry that is run with business logic; they do not operate as free agents. The commercial gallery system is limited. I don't want to demonize it, but I worry about it being the only option. What happened to the do-it-yourself mentality?

JS: I felt the same way, but have found some of that agency again by creating a work that doesn't entirely belong to one "world," be it art or food. Did something similar happen for you when you started your own art school, SOMA?

YO: Yes. By founding our own cultural institutions, we can define the role of art in society for ourselves. This is one way we might reclaim agency. For me, art is a way to engage. Artists operate in a political arena; our language and approach is just different than those of activists or politicians. And, even if art's impact on society is difficult to qualify and quantify, I believe that, as artists, we can shape the world around us.

Okón and Vargas enjoy their meal on the terrace in the Condessa neighborhood of Mexico City.

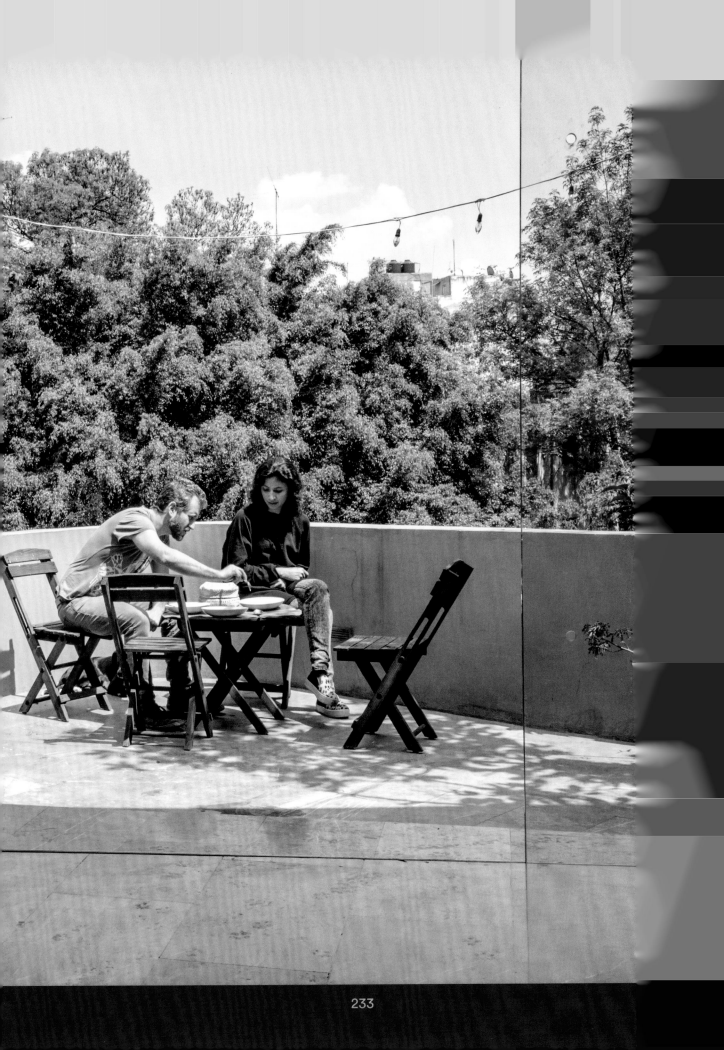

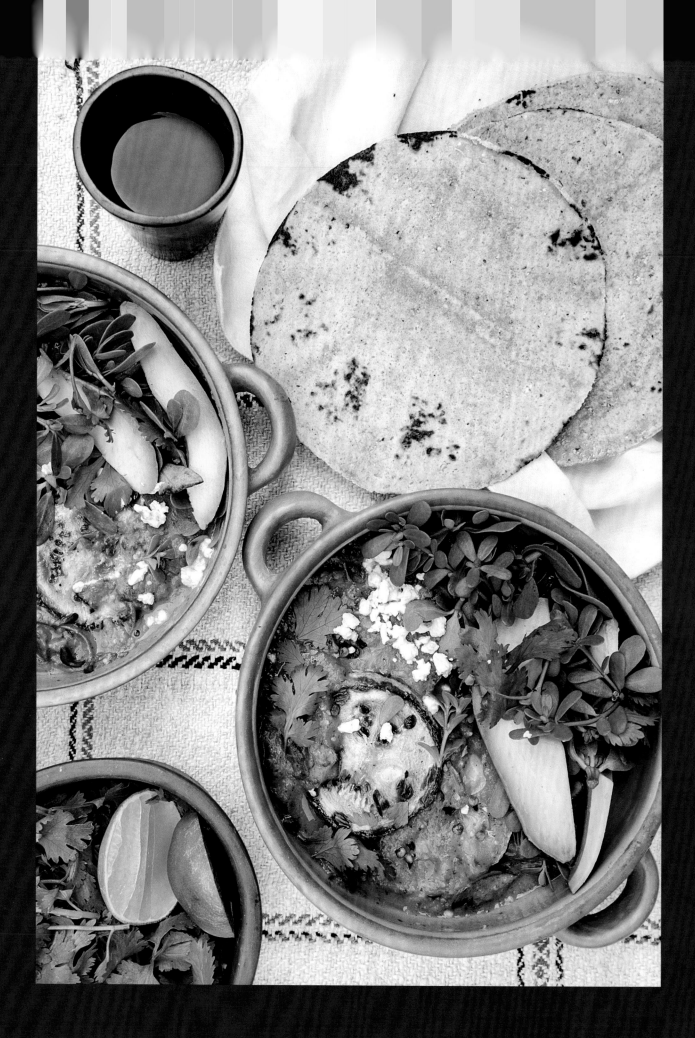

Makes
1 pint (480 ml)

Prep Time
2 hours,
including
inactive time

I often end up with lots of small green tomatoes at the end of the season that just refused to ripen on the vine. This recipe is an effort to use that stubborn fruit, and I liked it so much I started to pick the tomatoes before they even had a chance to turn red—now look who's boss.

I choose the ones that are about to change color, not the tiniest on the vine. I also prefer cherry tomatoes to larger tomatoes for this, since I am doing a quick pickle and using them a couple of hours after they are bathed in the brine. Serve these alongside grilled chicken or fish or in a salad with grilled corn.

Pickled Green Tomatoes

1. In a nonreactive saucepan, bring the vinegars, peppercorns, mustard seeds, salt, sugar, and ½ cup (120 ml) water to a boil, then lower the heat and simmer, stirring to dissolve the sugar and salt completely.

¼ cup (60 ml) distilled white vinegar

¼ cup (60 ml) cider vinegar

1 teaspoon whole Tellicherry peppercorns

1 teaspoon yellow mustard seeds

2 teaspoons kosher salt

2 teaspoons sugar

2 cups (300 g) green cherry tomatoes, halved

5 to 10 sprigs fresh dill

¼ habanero pepper, seeded

2 cloves garlic, smashed

2. Put the tomatoes, dill, habanero, and smashed garlic in a sterilized pint- or quart-size (480-ml or 1-L) canning jar and pour the hot liquid over them to cover. The tomatoes should be completely submerged; if not, push them down into the jar with a spoon. Secure the lid on the jar and refrigerate for at least 2 hours. These should be good in the fridge for up to 3 weeks.

Serves
8 to 10

Prep Time
5 minutes

Sometimes it takes an old friend to remind me of my own simple recipes from the past—the ones I made before "salad" was work, before I ever considered taking photos of the food I served to friends. I recently bumped into writer Nikki Darling, whom I hadn't seen in nearly a decade. It was November in Los Angeles, the time of year, Nikki said, that I am always on her mind. Why? Apparently, many persimmon seasons ago, I improvised a salad that she has been making and sharing since.

Nikki described the simplicity of this salad, its unwavering appeal, the rave reviews that make her feel like a seasoned hostess (she is actually a far more prolific writer than cook). The funny thing was, I had no recollection of this particular dish. I pressed Nikki for the play-by-play and ran home to follow her instructions. I was dubious that something so simple—no salt, no oil—could pass muster now that I am a salad-slinging professional. But Nikki was right; this salad is tart, sweet, takes minutes to prepare, and will leave you with a deep appreciation of the look, taste, and full potential of the fruit itself.

Fuyu Persimmon with Ginger, Honey, and Lime

1. In a small bowl, combine the honey and lime juice and stir to dissolve the honey completely. Stir in the ginger.

2. Remove the stems from the persimmons and cut the fruit horizontally into slices ⅛ inch (3 mm) thick. Arrange the persimmons on a serving platter, overlapping them in a scalloped, fish scale arrangement. Spoon the dressing over the persimmons and garnish with edible flowers.

1 teaspoon honey

¼ cup (60 ml) fresh Key lime juice

1 teaspoon grated peeled ginger

5 to 6 Fuyu persimmons (see Note)

Edible flowers, preferably purple pansies

Note: Be sure to use Fuyu, not Hachiya persimmons. The Fuyu are meant to be crunchy, whereas the Hachiya are inedible until they are so ripe they have turned to mush.

This is a readymade kind of dessert, with practically no preparation needed. Medjool are the most common variety of dates; they are large, sweet, and sticky, and when they are good quality, they should have a papery thin skin on their wrinkled surface (dates are not the cover girls of the dried fruit world, but they make up for it with their shocking amount of naturally occurring sugar). I personally prefer Medjool for this recipe, but if you have a real sweet tooth, try Halawi, with their deep caramel notes.

A flaky sea salt will work for this, but to take the presentation up a notch, experiment with different colors, like the ruby red Merlot-stained salt, or the naturally occurring pink Himalayan salt in a medium grind.

Tahini-Dipped Dates with Merlot Salt

1. Pour the tahini into a small serving dish or ramekin. Thin it with 1 teaspoon water at a time, stirring to incorporate. Continue adding water (if you're using Soom brand, you needn't add water; you can skip this step) until the tahini is just thick enough to heavily coat the back of the spoon.

½ cup (120 ml) tahini, preferably Soom brand

8 to 10 fresh Medjool or Halawi dates

1 tablespoon Merlot or Himalayan sea salt

2. Arrange the dates on a small plate with a pile of salt on the side. Encourage guests to dip the dates individually into the tahini and season with salt if desired.

Serves
2

Prep Time
10 minutes
active

1 hour or
overnight
inactive

In my experience, peak season strawberries are usually eaten straight from the paper carton on my way home from the market. But if you have enough self-control to wait until you get home, there's nothing better than strawberries and cream. Well, maybe there is: Strawberries and coconut cream.

Whipped, canned coconut milk has all the same fatty goodness as the real McCoy, with the added bonus of being dairy-free and made from a shelf-stable pantry item. The cream will separate from the water in the freezer or fridge, allowing you to hone in on the thick coconut goodness that wants to form stiff peaks when whipped. You might want to start storing your canned coconut milk in the fridge from now on so it is always ready to go.

To make the whipped coconut topping, use high-quality coconut milk; the cheaper stuff won't separate into cream and water, and if you skip that step, it won't achieve the fluffy consistency when whipped. If you don't have the time to whip your own coconut cream, look for store-bought Anita's coconut yogurt, made from coconut cream with added active cultures—indulgent and good for you, too.

If dairy is your vice, go for it—whip up about ½ cup (120 ml) heavy cream, use a schmear of mascarpone, or even a scoop of fancy vanilla ice cream.

Strawberries and Coconut Yogurt with Cacao and Halva Crumble

1. Do ahead: Place the can of coconut milk in the freezer for 1 hour, or refrigerate overnight.

2. Hull and quarter the strawberries.

3. Remove the coconut milk from the freezer (be sure not to leave it in there for more than an hour or it will freeze) and open the can. The cream should now be consolidated at the top of the can, with a few inches of milky liquid below. Using a spoon, transfer the cream to a medium bowl, reserving the liquid in the can.

1 (13½-ounce/400-ml) can high-quality unsweetened coconut milk (full-fat)

1 cup (145 g) ripe organic strawberries, rinsed and patted dry

½ teaspoon pure vanilla extract (never use imitation vanilla)

1 teaspoon maple syrup

1 (2-inch/5-cm) square plain halvah

2 teaspoons cacao nibs

¼ teaspoon white chia seeds (black are fine too, but white are prettier)

4. Add the vanilla and syrup to the cream, along with 1 tablespoon of the coconut liquid. Whip using a hand blender or standing mixer on high speed, until soft peaks form and it has the nice, thick consistency of whipped cream (about 1 minute).

5. Scoop the cream into a shallow serving bowl or onto a plate and spread it out. Pile the strawberries on top. Using a vegetable peeler, shave the halvah over the top. Sprinkle with the cacao nibs and chia seeds and serve.

This dessert doubles as a nightcap. Nocino is a traditional Italian liqueur—dark, sticky, and made from unripe green walnuts. To me, it is the classy alternative to Kahlúa (though it tastes a bit more of spices and vanilla bean than of coffee).

I was skeptical when Arley tossed lovage, a leafy herb with the flavor of celery, on top of my ice cream. While lovage is an acquired taste, it marries seamlessly well with the nocino, nuts, and smooth ice cream. This is as salad-y as an ice cream sundae gets.

Ice Cream with Lovage and Nocino Liqueur

1. Scoop the ice cream into a small dessert bowl and pour the nocino over it.

1 large scoop high-quality vanilla ice cream or dairy-free coconut ice cream

1 tablespoon Nocino della christina

2 tablespoons chopped walnuts, toasted

½ teaspoon thinly sliced lovage leaves (about 2)

2. Top with the walnuts and lovage and serve immediately.

The Presidential Cabinet: Pantry Staples

Let us eliminate the first obstacle to becoming a daily home cook and loving it: your scantily clad pantry. Granted, if you looked in my pantry, you would find mystery powders, sauces, and brews from all over the world. Most of them unlabeled or in another language, used once in a blue moon but bought with a sense of urgency. But hiding among the more adventurous items is my periodic table, the foundation of my simple, healthy food. Armed with these essential salad staples, all you need is some stellar produce and you've got dinner.

FATS

Olive Oil

I keep a high-end and a mid-range cooking olive oil on deck at all times, plus a top-shelf oil for finishing dishes. If you are looking to save money on cooking oil, you are better off frying and sautéing with an organic grapeseed or vegetable oil than cheap olive oil. There's a lot of shady dealing when it comes to bottom shelf olive oil, so all olive oil you purchase should be labeled extra-virgin and cold-extracted. Any decent oil will display the harvest date and best by date on the label. The harvest should be within the last year, and the best by date should be at least a year into the future. Don't judge an oil by its color; yellow olive oil can be just as fragrant as one that is dark green. In general, oils from Spain tend to be more mild and fruity, and those from Italy more peppery and bitter. That peppery tinge of bitterness is not a bad thing! Quite the contrary, the back-of-the-throat sensation is what defines a newly pressed oil with low acidity and a high degree of antioxidants. As with all oils, store olive oil in a cool, dark place, away from hot cabinet lights or the oven.

Grapeseed Oil

It is important to keep a flavorless oil on hand that has a high smoke point, for frying or searing. Olive oil is actually unhealthy when used beyond its smoke point, so always opt for grapeseed or vegetable oil when cooking with high heat. When buying oil, always pay attention to how it was processed—cheap vegetable oil can be made with harmful chemicals, so go for the higher-end brands like Spectrum, whose oils are expeller pressed or cold extracted.

Coconut Oil

I don't proselytize the infinite health benefits of coconut oil; I don't gargle with it or add it to my smoothies. But I do endorse this oil for its deep nutty flavor, and I use it the same way I use most oils—sparingly. Coconut oil can withstand high heat, so use it for searing and pan-frying. It does wonders as a moisturizer for your hair and skin, too.

Untoasted Sesame Oil

Untoasted sesame oil works well for light Asian dressing, for pan frying or sautéing. It has a much lighter taste than toasted sesame oil, and should be stored in the fridge.

Toasted Sesame Oil

Toasted sesame oil is nutty and fragrant, and it is used more for its flavor than as a cooking fat. Its color should be a rich, dark brown. Because the seeds are baked before they are pressed, toasted sesame oil is more shelf stable than plain sesame oil, which should be refrigerated after opening.

Ghee

Ghee is an oil extracted from butter, with tons of benefits: it has an amplified butter flavor, a high smoke point, and it is lactose- and casein-free, making it much easier to digest than pure butter. The most flavorful and nutritious ghee is derived from cultured butter (meaning it has healthy, active bacteria). If buying ghee, go for the best. It is shelf stable, so perishability is not a concern.

ACIDS

Sherry Vinegar

This is my preferred acid for vinaigrette, far more complex and aromatic than red wine vinegar. Sherry vinegar is protected by Denominación de Origen, which includes nine sherry-producing municipalities in the Spanish province of Cádiz, so the authentic vinegar will be labeled from the Spanish region of "Jerez." I love Gran Gusto from Bodegas Paez Morilla. It's oaky and nutty and great for everyday use. If you want something on the sweeter and more complex side, try Montegrato's Pedro Ximenez vinegar, aged for 16 years, and it shows.

Red Wine Vinegar

I don't bother buying the expensive brands of red wine vinegar. I use affordable red wine vinegar for pickled onions, and cooking, and the occasional dressing, and my go-to for those purposes is Laurent du Clos Red Wine Vinegar.

Japanese Rice Wine Vinegar

A very mild, low-acid vinegar, rice wine vinegar is great for light pickling, seasoning grains, and making Thai- or Vietnamese-style dressings that do not use oil. Not to be confused with seasoned rice wine vinegar, which has added sugar.

Seasoned Rice Wine Vinegar

Just like rice wine vinegar, but with added sweetness, this is the key to good sushi rice, but also a bunch of great salad dressings. It's okay; sometimes a little sugar goes a long way.

White Wine Vinegar

A nice white wine vinegar can be the perfect addition to a citrus vinaigrette, and it is handy to have in the pantry when you don't want the color of red wine vinegar but you need a bump of acidity.

Balsamic Vinegar

Most balsamic on the supermarket shelf is crap, made with artificial caramel coloring and sugar. Real balsamic should come from the Italian regions of Modena or Reggio Emilia, and it should be pricey. Grape must, *mosto d'Uva*, should be the only ingredient listed. Like wine, the longer the vinegar is aged, the more expensive and complex. If you love balsamic, I suggest stocking one younger variety for marinades and dressing, in addition to a goopy, thick, pricier option for finishing drizzles (I love it on strawberries) or dipping bread.

Lemon

Organic lemons should always be on hand for use in dressings and zest, but also to squeeze on avocados, apples, and other fruit with a tendency to turn brown when cut. Once zested, if you are not squeezing the lemon right away, just wrap it in plastic wrap and store in the fridge.

Lime

I love limes for cocktails, dressings, and marinades. Whenever I can find them, I opt for Key limes over the more common Persian limes. These small, ovular limes are sweeter and juicier and have a delicate thin skin. Don't worry if they appear yellow; commercial Key limes are harvested when they are green, but when they are fully ripe their skin turns from green to yellow.

SWEET

Honey

For use in cooking, I look for something mild and light in color, like a clover, alfalfa, or a wildflower honey. When I am looking to add the distinct taste of honey to a dish or dressing, I use Manuka honey (pricey but prized for its medicinal use), or other raw, local honey with a more intense flavor, like dark buckwheat honey.

Grade A Dark Amber Maple Syrup

I prefer a syrup with color—the darker the syrup, the more it will taste of maple. Don't be fooled; "fancy" grade syrup isn't actually fancy, it's just lighter with less distinct maple flavor.

SAVORY

Tahini

This Middle Eastern sesame paste is a great thickener and a healthy, rich alternative to dairy. My preferred brand is Soom, made from white sesame seeds. This tahini never separates and has no chalky aftertaste. It's a little pricier than the mid-range tahini but totally worth it. Buy it online or at your upscale grocer.

Oil-Packed Anchovies

Anchovies add saltiness and umami to a dish in an instant, and when well-incorporated, they shouldn't leave a trace of fishiness. If your goal is for them to dissolve in a sauce or dressing, soak the fillets in warm water for 5 minutes and pat them dry before using. For cooking, I use Roland brand in a glass jar; they're affordable and mild in flavor. If the anchovy is the star of a dish or destined for a piece of toast, I go for Ortiz brand, also in a glass jar (tin cans impart a metallic taste to the fish, never a nice effect).

Maille Dijon Mustard

This French Dijon has just the right bite for classic vinaigrette.

White Miso

Also known as shiro miso, white miso paste is lighter, sweeter, and less salty than yellow or red miso. Shiro miso is made from fermented soybeans and rice that are aged in wooden barrels to create a concentrated umami paste (the fifth taste after sweet, sour, bitter, and salt). As always, read the label; your miso should only contain four or so ingredients: soybeans, water, salt, and a grain (rice), with no additives like MSG. These misos have been aged naturally and will have a deeper flavor as a result. Once opened, miso can be kept in a tightly sealed container in the fridge for 9 months.

Fish Sauce

Free your mind and consider fish sauce as a seasoning for all kinds of dishes, not just Asian cuisine. It is made from Vietnamese fermented anchovies, adding subtle saltiness and savoriness when used in moderation. I like Red Boat brand; it has no MSG or additives, and I rarely ever make a soup or a Thai-style dressing without a dash of this stuff.

Whole Black Peppercorns

Please, for the love of god, grind your pepper in a pepper mill, don't use pre-ground pepper. Keep Indian Tellicherry peppercorns on hand, as you should be refilling that pepper mill often.

Flaky Sea Salt

Flaky sea salt is almost always my finishing touch on a salad. I use Maldon brand, because I like the large, flat crystals that you can easily crush with your fingertips to control the size of the flake. Reserve this pricey salt for finishing salads or dipping veggies, but use it often.

Kosher Salt

The standard salt for cooking and seasoning, kosher salt is easy to measure, easy to distribute, and sticks to the surface of meat and veggies.

LARDER

Shallots

Sweeter and milder than onion, shallots are the key to my vinaigrettes. I always have 4 or 5 on hand, though I try to buy only as many as I will use in one week since they are more perishable than onions.

Onions

I keep a combo of red and white onions in the pantry at all times. Duh.

Organic Eggs

Egg yolks are a great way to thicken and add richness to a salad dressing, and a soft-boiled or fried egg is the perfect quick protein supplement. Sometimes I soft-boil a bunch of eggs, then peel and store them submerged in cold water in a tightly sealed Mason jar. The yolks will stay runny. Just bring the eggs to room temperature before slicing and serving.

Nuts and Seeds

Which nuts and seeds you like to have around is a matter of taste, but I like to keep a variety of raw nuts (we want to toast and salt ourselves) in the freezer at all times, including hazelnuts, almonds, walnuts, pepitas and sunflower seeds. That's right; you want to freeze nuts to prevent their perishable oils from becoming rancid. Of course, you will want to let them come to room temperature or toast them lightly before using.

Pantry Staples to Make Yourself

My husband's credo in life is, "It's not worth doing something unless you do it right." While I find this to be an incredibly attractive perspective, I personally tend to rush, cheat, and cut corners with pretty much everything *except cooking*. The evidence is just too clear to ignore—a great dish is really just the sum of its handcrafted parts.

The following items require a little preparation on your part, but they will take your food from "meh" to "how the hell did you do that?"

Making Stock

I am a firm believer in the healing effects of chicken soup, but I am most interested in how to make use of all my kitchen scraps and how to maximize flavor in my cooked food. When I make stock, I store it entirely unsalted so I can season beans and grains cooked in the liquid on a case-by-case basis.

Making stock for me is more of a practice than a recipe. I am making use of what would have otherwise been thrown out: herb stems, mushroom stems, carrot ends, onion peels, garlic skins, and any leftover chicken or beef bones from previous meals. All these valuable bits go into a freezer bag, and when the Ziploc is full, I get out the stockpot. You want to avoid brassicas (kale, broccoli, cauliflower) and potatoes or starchy vegetables, but everything else is gold. I even toss in eggshells, whose calcium is leached over time, lending even more nutritional value to my witch's brew.

I will occasionally make vegetable stock, but chicken stock is where it's at. If you don't want to cook a whole chicken—as I do in by bone broth recipe—ask the butcher for carcasses and chicken feet. They are as cheap as can be, and the bones and collagen from the feet are all you need; the meat in the Chicken Bone Broth is just an added bonus to save for later: It's a great way to poach a chicken and kill two birds with one stone. Below are my two methods for making stock; choose between the two according to what you have on hand.

Chicken Stock

Makes
4 quarts (3.8 L)

Prep Time
4 to 10 hours

1 whole chicken carcass (hearts and gizzards included)
6 chicken feet (optional but encouraged)
1 gallon (3.8 L) vegetable scraps
1 small white onion, cut in half
Extra celery and carrot if needed, chopped into 2-inch (5-cm) pieces
1 tablespoon olive oil
10 sprigs flat-leaf parsley
2 bay leaves
1 tablespoon whole black peppercorns
1 head garlic, pulled apart but cloves left whole with skins
2 tablespoons white vinegar

1. Preheat the oven to 400°F (205°C). Toss the chicken bones, feet, veggie scraps, onion, celery, and carrot (if using) on a baking sheet, drizzle generously with the oil, and roast for 10 minutes.

2. Transfer the veggies and bones to a stockpot with the parsley, bay leaves, peppercorns, garlic, and vinegar. Cover with 4 to 5 quarts (3.8 to 4.7 L) cold water. Bring to

a boil. Reduce to a simmer, partially covered, for 4 hours or as long as 10 hours. If foam appears on the surface of the stock, skim with a slotted spoon and discard. If simmering for more than 4 hours, add 2 cups (480 ml) water every few hours. The stock should reduce to about 2 inches (5 cm) below where it began.

3. Strain the stock and allow it to cool. Skim the excess fat and set it aside for future use. Transfer the cooled stock to Mason jars or quart containers and store in the fridge for a week or in the freezer.

Chicken Bone Broth

Makes
4 quarts (3.8 L)

Prep Time
4 to 10 Hours

One 3-pound (1.4-kg) chicken, broken down in parts
6 chicken feet (optional but encouraged)
2 bay leaves
1 tablespoon whole black peppercorns
1 head garlic, pulled apart but cloves left whole with skins
1 gallon (3.8 L) roasted vegetable scraps
1 small white onion, cut in half
Extra parsley, celery, and carrot if needed, chopped into 2-inch (5-cm) pieces
2 tablespoons white vinegar

1. Add the chicken pieces and feet to a stockpot with the bay leaves, peppercorns, and garlic. Cover with 2 inches (5 cm) cold water. Bring to a boil. Reduce to a simmer, partially covered, for 15 minutes, or until the meat is just cooked through. Remove the chicken and set it on a cutting board to cool.

2. Add roasted veggie scraps, onion, parsley, celery, and carrot (if using) to the water. Bring the water back up to a boil and reduce to a simmer.

3. When the chicken is cool enough to handle, remove all the flesh from the bones and set it aside for future use in quart containers (I like to shred this with a fork, to have the consistency of pulled meat). Return the bones and the skin to the pot with the vinegar and simmer for 4 hours or as long as 24 hours. If simmering for more than 4 hours, add 2 cups (480 ml) water every few hours. The stock should reduce to about 2 inches (5 cm) below where it began.

4. Strain the stock and allow it to cool. To keep the chicken meat nice and moist, pour stock into those containers with the chicken meat, submerging them in liquid. Transfer the remaining stock to quart (960-ml) containers and store in the fridge for a week or in the freezer.

Note: Fat will solidify on the top of the cooled finished stock, but don't throw that away! Skim some of it and

save it in a small container for cooking (this is schmaltz, the foundation of Jewish cooking), but leave some of it in your stock too; it will dissolve when reheated and add invaluable flavor.

Vegetable Broth

Over the course of the week, collect all the unused bits and bobs from carrots, celery, herbs, and aromatics, everything except starchy veggies and brassicas, in a one gallon re-sealable plastic bag. When the bag is at least half full you are ready to make stock. Depending on what I have collected in the bag that week, I will add extra celery, onion, and carrot if there is not enough in there. The more the merrier.

Makes
3 quarts (2.8 L)

PREP TIME
2½ hours

1 4-inch (10-cm) square piece of dried kombu seaweed
1 gallon (3.8 L) vegetable scraps (carrots, celery, mushroom stems, onion trimmings, herbs stems)
1 head garlic, pulled apart but cloves left whole with skins
2 tablespoons olive oil
2 bay leaves
1 tablespoons whole black peppercorns
10 sprigs flat leaf parsley
1 extra onion, carrot or celery stalk if not present in your veggie scraps, chopped into 3 inch (7.5 cm) pieces

1. Add the kombu to a stockpot and cover with water. Bring to a simmer over low heat.

2. Preheat the oven to 400°F (205°C). Toss the veggie scraps and garlic on a sheet pan, drizzle with the olive oil, and roast for 10 minutes.

3. Transfer roasted veggies to the stockpot and cover with 4 to 5 quarts of cold water. Add bay leaves, peppercorns, and parsley. Bring to a boil and simmer partially covered for 2 hours.

4. Transfer to ball jars or quart containers and allow to cool on the countertop. Once the stock comes to room temperature, seal and store in the fridge or the freezer (see Note).

Note: When storing glass containers in the freezer, be sure to only fill the jar ⅔ of the way to the top. The broth will need space to expand as it freezes.

Pulled Poached Chicken

This is a basic recipe for simple poached chicken, pulled into shredded pieces, and a great addition to most salads. The by-product is a clear, light broth that I drink warm in a mug with herbs and minced chile.

Makes
2¼ cups (340 g)

Prep time
1 hour 15 minutes

2 chicken leg quarters (thighs with drumsticks attached), with skin
2 chicken breasts (about 1 pound/455 g), with skin
¼ cup (60 ml) olive oil
½ white onion, peeled
½ head garlic, cut in half
2 ribs celery
1 large carrot
3 sprigs fresh parsley
4 or 5 sprigs fresh thyme
2 bay leaves
2 tablespoons kosher salt
1 tablespoon whole black peppercorns

Optional Asian Additions
2 fresh or dried lemongrass stalks, tops removed
4 makrut lime leaves
1-inch (2.5-cm) piece fresh galangal
2 Thai bird chiles

1. Put the chicken legs and breasts in a large stockpot and cover with 2 inches (5 cm) cold water. Add the rest of the ingredients and bring the liquid up to a boil over high heat. As soon as you reach a boil, reduce the heat to maintain a brisk simmer and cook for 10 minutes, uncovered. Remove from the heat, cover, and set aside for 1 hour. The chicken will not be fully cooked at the 10-minute mark, but it will continue to gently poach in the hot broth, cooking to completion in the next hour while covered.

2. After 1 hour, remove the chicken pieces from the liquid and transfer them to a large cutting board. Remove and discard the skin. Using a large fork, pull the meat off the bones and transfer to a quart (960-ml) container. To make a richer broth, add the bones back to the broth, add another 3 cups (720 ml) water, and continue to simmer partially covered for another hour or more. Strain the broth through a fine-mesh sieve into a bowl and discard the solids.

3. Refrigerate the meat submerged in the cooled broth for up to one week. The liquid will keep it moist and flavorful. You can also freeze the meat in pint (480-ml) containers this way, defrosting as needed.

Whole Roasted Garlic

This is a great habit to get into, as roasted garlic is less sharp than raw and is great in salad dressings, sauces, and marinades. Slice off the top of a bulb, drizzle with olive oil, wrap it in foil, and pop it in the oven whenever you are cooking something else at 350°F to 400°F (175°C to 205°C). The garlic will be soft and cooked after 30 minutes. Store the peeled cloves submerged in olive oil in the fridge for up to a month or just keep the whole roasted bulb wrapped in tinfoil in your fridge for a week and squeeze each roasted clove out of its papery skin as needed.

Pickled Mustard Seeds

Pickled mustard seeds have a texture similar to caviar but are so much cheaper! I like to keep them on hand for garnish and as an addition to grains or vinaigrettes.

Makes
¼ cup (45 g)

Prep time
15 minutes

¼ cup (45 g) yellow or brown mustard seeds
½ cup (120 ml) cider vinegar or distilled white
 vinegar
4 teaspoons sugar
1 bay leaf (optional)
¼ teaspoon kosher salt

1. Put the mustard seeds in a small heatproof bowl or Mason jar and set aside.

2. In a small saucepan, combine the vinegar, sugar, bay leaf, if using, and salt. Place over medium heat and bring to a boil, stirring to dissolve the sugar and salt.

3. Pour the hot liquid over the mustard seeds. Stir and set aside at room temperature for 4 hours. Store in a tightly sealed container in the fridge for up to 1 month.

Pickled Red Onions

Who doesn't love pickled onions? Plunging thinly sliced red onion into pickling liquid turns them bright magenta, tames their sharpness, and transforms them into a versatile pop of acidity for everything from tacos to salads.

Makes
1 quart (960 ml)

Prep time
35 minutes

2 small red onions (about 1 pound/455 g total),
 peeled and thinly sliced
1½ cups (360 ml) red wine or white wine vinegar
1½ teaspoons sugar
1½ teaspoons kosher salt

Put the onions in a large bowl, pour the vinegar over them, and sprinkle with the sugar and salt. Press the onions down with your fingertips to submerge them in the liquid. Let stand for 10 minutes, then use or transfer to a nonreactive container (a quart/liter jar or two pint/half-liter jars, for example), cover, and refrigerate for up to two weeks.

Preserved Lemons

Preserved lemons are incredibly forgiving as far as fermentation projects go, and they are a quick way to brighten a cheese plate, a stew, a salad dressing, or a smoked fish platter. I am going to share my recipe with you, but I don't usually measure for this, and it's a little bit different every time. The flavor will change the longer they ferment—saltier and more lemony after a month; intensely floral after a couple more. The key is to be liberal with the salt. Start with a clean, dry vessel, and make sure the lemons are always submerged in their own juice (if not submerged in the acid, they may rot). Preserved lemons are one of the great wonders of the kitchen—easy to make, and they literally last forever.

8 organic lemons, plus 4 or 5 more for juicing
 (to yield 2 cups/480 ml juice)
2 cups (540 g) kosher salt
¼ teaspoon whole cloves
5 or 6 pieces star anise
1 teaspoon pink peppercorns
3 bay leaves

1. Spray the organic lemons with veggie wash (if you have it) and scrub them clean. Using a paring knife, slice each lemon into quarters from the bottom, leaving them attached at one end. Place them in a large, nonreactive bowl and slowly add 1 cup (270 g) of the salt, covering the lemons inside and out, making sure to coat the entire surface.

2. Cover the bottom of a very clean, dry Mason jar or preserving pot with a ½-inch (12-mm) layer of salt. Stuff the cut lemons in, packing them tightly. Sprinkle more salt, the cloves, star anise, bay leaves, and peppercorns on each layer as you fill the jar.

3. Using your hands or a potato masher, press the lemons down to release their juices, and squeeze the juice of the additional lemons into the jar until the whole lemons are entirely submerged. (You can toss those juiced lemon rinds in too, as long as you sprinkle salt on their surface and as long as everything is covered in juice once the rinds are added to the jar.)

4. Close the jar and let the lemons ferment in a cool, dark place, shaking the jar occasionally, for 1 month. Once the peels are soft and easy to eat, you can store them in the refrigerator or keep them in your pantry, as long as the lemons remain submerged; take care not to introduce any water to the jar, which can encourage spoilage. The brine can be reused for your next batch.

The Presidential Aides:
Salad Tools

Citrus Reamer

A citrus reamer is a great tool for juicing limes, especially when you want to avoid the bitter peel oils that are released with a citrus squeezer.

Citrus Squeezer

This is a levered hand tool used to extract the juice from citrus while capturing the pulp and seeds. These come in multiple sizes, but the larger orange juicer works perfectly well for lemons and limes (there, I saved you $10). Look for the unpainted steel juicer; while the brightly colored versions are far cuter, the paint will chip with repeated exposure to citric acid, and I suggest you leave the paint chips out of your guacamole.

Japanese Vegetable Scrubber

This attractive tool is a multi-purpose brush for cleaning root vegetables and thin-skinned veggies. In the case of root veggies, this tool sloughs off all the dirt and unwanted texture without stripping the nutritional skin entirely. These brushes are more useful than you might imagine, and they are beautifully designed Japanese objects worth owning.

Mandoline Slicer

When vegetables are cut uniformly, a salad is ushered into the big leagues. A mandoline slicer is a tabletop cutting tool that controls the precision of your cuts, while allowing you to slice veggies so thin they are translucent. I use the heavy-duty OXO brand for maximum safety (I'm known for being careless with my fingertips), though most people will do just fine with the more compact, cheaper Benriner Japanese mandoline.

Microplane

I use this very sharp, fine grater to zest the thin outer layer of citrus, but it is also useful for finely grating hard cheeses, ginger, and garlic. Microplaned garlic is the way to go when you want to distribute the garlic evenly in a dressing or a broth.

Mortar and Pestle

I love my mortar and pestle and use it daily. This is an essential tool for blending herbs, making marinades, and combining ingredients. I prefer stone to wood, as the material absorbs and retains less of the smell of whatever it is you are smashing. If you don't already have one, choose wisely—this is a tool that will outlive the chef.

Pour Spout and Glass Bottle

The best thing you can do is to keep your olive oil in a dark glass bottle, to avoid exposure to light that causes spoilage, fast. I add a pour spout to my fancy olive oil bottles for greater control. Pour spouts can be purchased at any culinary shop or online for a few dollars.

Salad Spinner

If there is one mantra to take away from this book, let it be this: A wet salad is a bad salad. A salad spinner is the best tool to remove excess water from salad greens. I believe it is a must-have in any kitchen. I prefer the OXO brand or any of the designs with a large center button instead of a retractable cord. But whichever style you choose, spinning your greens after washing will ensure you are nowhere near a soggy salad.

Thin Cotton Dish Rags and Paper Towels

I store leafy herbs and veggies wrapped in breathable cotton cloth, or layered in a sealed container with a paper towel. Always have these on hand to get longevity out of herbs and greens.

Vegetable Peeler

The Zena Swiss is my favorite vegetable peeler, with a minimal Y-shaped design and great manual control; they even come with a lifetime guarantee. The flat, broad blade across the top allows you to peel veggies, but also to shave cheese into delicate ribbons.

Victory Garden: Growing Your Own

When I choose what plants to grow in my home salad garden, I gravitate toward the ones that are nearly impossible to find in the market. It's easier to grow shiso than it is to purchase it in my neighborhood. Many of these herbs, edible flowers, and greens are too delicate to sell, and they are really best eaten the moment after harvest. These are no doubt VIP salad ingredients, but that doesn't mean they are difficult to cultivate. Many of my favorites are considered weeds.

The market offers a brief snapshot into the life cycle of your favorite greens and vegetables. These plants have other parts that are useful and delightful: flowers, seeds, early stage shoots, and late-flowering buds. This is part of the experience of growing salad, specifically. Ninety percent of the population loves cilantro, but how many of them have tasted the green coriander berries that appear when that plant goes to seed? I pickle them, steep them in simple syrup, and toss them on everything that I can, and yet I have never seen them for sale. There are wonders you have yet to discover.

Contrary to popular assumption, you don't need an empty lot or south-facing light to grow your own food. Like lots of urban home gardens, my garden gets partial sun. Stubborn as I am, I have spent too many years pampering tomato plants and berry bushes only to come to the realization that, convenient to my line of work, greens are far more forgiving to the amateur gardener than fruiting plants. They flourish in partial sun; in fact, tender greens prefer not to expose their fragile leaves to the scorch of UV rays (plants after my own heart). So don't be discouraged by limited real estate or sunlight; you can make it work.

This isn't a gardening manual. But if you are looking to dip your toe into the world of homegrown salad, these are a few of my favorite varietals to consider. I buy my seeds from Baker Creek Seed Company. They have the most extensive collection of rare, heirloom seeds available.

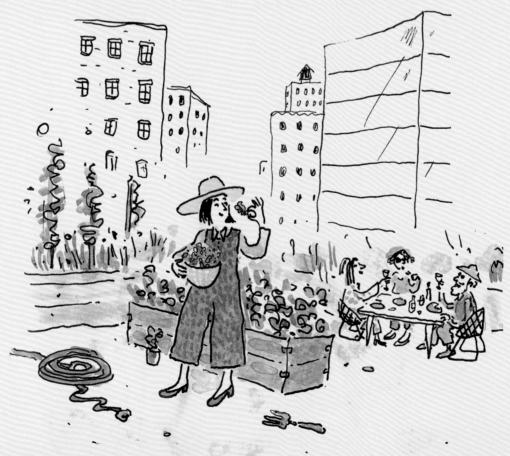

Agretti

Agretti is the coolest thing to grow. It has a succulent texture and looks and feels more like something you would have in your fish tank than in your raised bed. It's salty and crunchy, and sells for upwards of $20/lb in the market, so much better to grow it yourself!

Arugula and Arugula Flowers

You can buy arugula easily, but have you tasted their delicate white flowers? When arugula bolts, the leaves will get tough and, eventually, be too spicy to enjoy raw (still great if wilted in pasta or chopped as garnish). When arugula goes to seed, the white flowers that appear have all the spicy arugula-ness in one tiny bud. Look for more exotic varietals as well: "Wasabi" arugula or "Runway" arugula. Arugula will reseed itself year after year—it's the gift that keeps on giving.

Borage Flowers

The tiny, star-shaped, sky blue flowers have a hint of cucumber flavor and are a favorite of fancy chefs. This is a decorative plant, and will grow quite large if given the chance, so give it space in the garden. The edible blooms are a magnet for pollinators, which is good for the garden, and good for the world too.

Bronze Fennel

If you like the anise taste of fennel, bronze fennel is for you. It has a noticeable sweetness, like the plant has been grown in sugar water. Unlike green fennel, there is no bulb to be had; you will only use the lacy fronds.

Calendula

Bright orange or yellow, I scatter the individual petals on salads. They don't have much flavor, but it is decoration with health benefits. Some calendula is a natural digestive, but you would have to eat a lot of flowers to reap those benefits.

Chervil and Chervil Flowers

Chervil is by far my favorite herb, with its delicate anise flavor and the softest lacy leaves. I toss the stuff anywhere you might consider parsley, tarragon, or even mint. This one loves the cool shade. Be sure to make use of the ladylike white blossoms when the plant goes to seed.

Chives and Chive Flowers

Chives are a type of onion grass usually grown for its greens, but chive blossoms are where it's at. So much more than garnish, the lilac globe blossoms are not solely decorative, they have a bright, concentrated onion taste. Try long, flat, blade-like Chinese garlic chives for something new. The greens are robust and easy to grow, and at the end of the season they produce white blossoms pretty enough to adorn the table and the plate.

Coriander Leaves (Cilantro), Berries, and Buds

As previously mentioned, I grow cilantro everywhere I can. I use the leaves all summer and I am wild for the coriander berries and flowers that appear when the plants bolt. The flavor of the berries and flowers tends to be more citrusy than the leaves, and the berries will keep well in the freezer.

Fava Shoots and Flowers

Fava beans are a favorite vegetable of mine, but they are a real pain to prepare. The tender green leaves of fava shoots, on the other hand, are easy to pick and enjoy—they have the same nutty flavor of the fava bean. Eat them raw or do a quick sauté with great olive oil and a squeeze of lemon.

Flashy Butter Gem Lettuce

More tender than its more common cousin, the "Flashy" varietal has delicate leaves with a freckled coloring that adds variation to your salad mix (I am sold on the name alone).

Gem Lettuce

This tight, small head of crunchy lettuce has great structure. When pulled apart, the leaves make for a worthy finger food served with dip or dressing on the side. The firm boat-like shape of each leaf adds volume to salads and conveniently catches dressing in its tight wrinkles. Gem grows well in colder temperatures, or as an early crop to start the season.

Lovage

Lovage tastes like celery on steroids. I use the leaves anywhere I might use celery: soup stocks or a mirepoix (a roughly chopped combo of onions, carrots, and celery, used as a flavor/aromatic base for stocks, sauces, soups, etc.), or as a robust herbal note on salads.

Mâche

Sometimes called Corn Salad or Lamb's Lettuce, the small heads are delicate with a mild, nutty flavor. A French culinary go-to, it does not hold up very long past harvest, making mâche expensive and difficult to find . . . unless you grow your own.

Miner's Lettuce

A wild-growing green often foraged, Miner's Lettuce is easy to grow, loves shade, and it packs more vitamin C than almost any other green. Chances are, you have Miner's Lettuce growing in your yard, on your street, and in the closest park. But I like to grow it myself so I know it's organic.

Minutina

Aka *Erba Stella*, minutina is an Italian heirloom green that grows as a small bush. It has a crunchy texture, a bizarre saltiness, and an unusual grass-like shape that will add nice texture to your mix. It is hardy and will even survive through the winter.

Mitsuba

This is Japanese parsley—a little funkier than your everyday parsley. It is another shade-loving plant that would be easy to grow in a kitchen planter box.

Mizuna

Mizuna is a Japanese mustard green with purple or green leaves. My favorite variety is called "Red Streaked," and has a frilly leaf and deep color. Snip them when they are small, before they get too spicy. Later in the season when they are mature, char or sauté the leaves to mellow out the mustard flavor. This plant has a long growing season and is tolerant of shade.

Mustard Greens and Flowers

Hearty ruffled or speckled leaves with a sinus-clearing effect like mild wasabi, these are lovely to eat raw when young or wilted/cooked once they are mature. You have probably seen the delicate yellow flowers growing en masse in the wild; don't be afraid to pick them and toss them in a salad.

Nasturtium Leaves and Flowers

Yellow, orange, and red nasturtium flowers are a favorite of the edible flower camp. They add a particular green kind of peppery zing; the perfectly round, lilypad shape of young nasturtium leaves make for a great garnish; and the mature leaves work well in salads and in sauces.

Pineapple Sage

Some people cook with the leaves of the pineapple sage plant, but I find them to be kinda blah. Better to wait and make use of the fuchsia flowers that that will appear when the plant blooms. They are sweet and light, and look great as a cocktail or dessert garnish.

Pistou Basil

This basil plant is adorable. It is characterized by its uniformity and mini leaves that clump together to make a little basil pom-pom. The flavor is similar to Genovese basil, but the micro form makes it lovely for garnishing and tossing evenly throughout a dish.

Purslane

Mostly despised by American farmers, purslane grows like gangbusters in pretty much every garden and every farm. It has the structure and form of a succulent plant, with pillowy leaves. It has a lovely tang, with stalks that might as well be pumped full of lemon juice. I don't actually plant this in my garden, since it prefers poor soil to the compost-rich stuff I have in my boxes. I just let it do its thing and look for it lurking in unattended nooks in the yard.

Red-Veined Sorrel

Unlike its cousin, green sorrel, red-veined sorrel must be eaten when teeny-tiny before it gets tough and chalky in texture. In my opinion, the main reason to grow this plant is as an eye-catching garnish, so a little goes a long way.

Shungiku Leaves and Flowers

Also known as Asian chrysanthemum greens, the leaves have an herbal, green taste that is delicious raw in salads and wilted in brothy soups. The plant produces a bright yellow, edible flower, whose wispy petals can be pulled apart and used as garnish.

Salad Burnet

Difficult to find in the market, the small scalloped leaves of salad burnet taste vaguely like melon or cucumber. Remove the leaves from the central stalk and use as garnish or toss in your salad mix.

Sorrel

Beloved by the French and increasingly popular in the United States, sorrel is a survivor. Once it establishes itself, it will continue to proliferate. It has a bright, citrus flavor, concentrated in the stalk. I use the leaves for salads, pesto, and garnish, and I add the minced stalks to dressings for extra citrus tang without adding liquid.

Tarragon

Tarragon is easy to grow and also has a mild anise taste, stronger than that of chervil. It's great with chicken and fish and will come back year after year.

Thai Basil

Thai basil has similarities to Italian basil, with additional notes of anise or licorice. The narrow leaves are edible, as are the pretty purple flowers. Thai basil is a great addition to Asian salad and brothy soups.

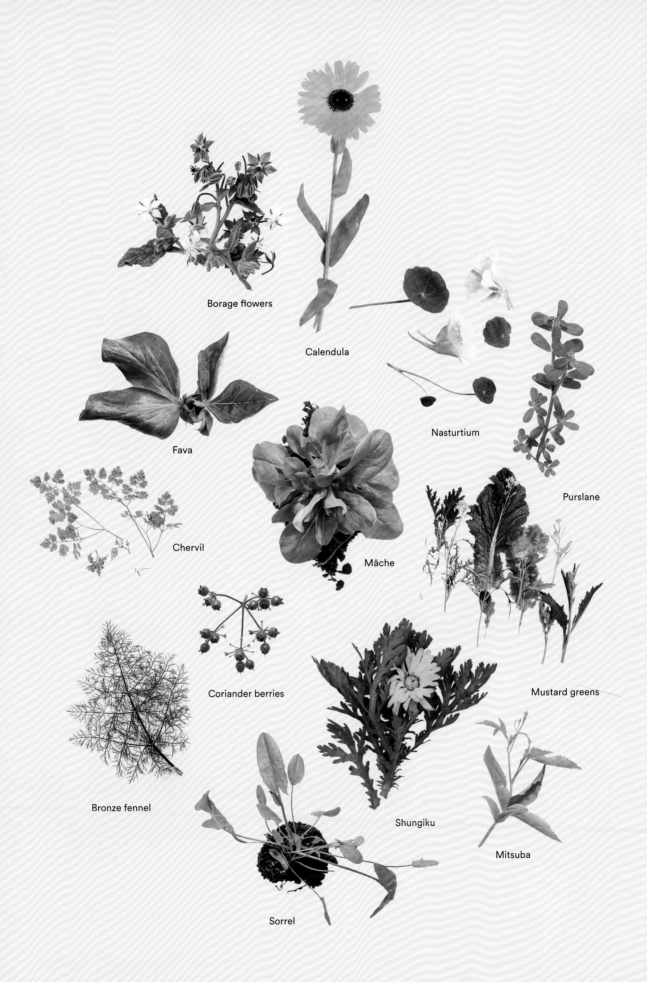

Borage flowers

Calendula

Nasturtium

Fava

Purslane

Chervil

Mâche

Coriander berries

Mustard greens

Bronze fennel

Shungiku

Mitsuba

Sorrel

A Note on Seasonality

When you begin to write a cookbook, the first question is, "How will it be organized?" The organizing principle is the conceptual framework that sets the work in motion. When I decide what to cook for dinner, I first consider my guests and the particular occasion. Are they close friends, new friends, or strangers? Am I preparing a packed lunch or cooking for a potluck? When that's all sorted, I turn to the market or my garden to drastically limit my options.

Seasonal produce is the reason for every good salad I've ever made. Tomatoes don't exist until July, and I abandon my shopping list when something that is too-ripe-to-ignore calls my name. While I've divided the chapters in this book according to occasion, I have included an additional index that organizes the recipes according to season. In this case, the U.S. Northeast is where I dropped anchor. I know that the produce we eat in January in Los Angeles is not the same as what we eat in New York, not to mention what we eat internationally (yes, my ambitions are global), so I leave it to you to pay attention to what's going on in your market, as this book refers to mine.

Recipes by Season

Recipes by Season

Index of Dressings

Index of Artisans

Recipe Index

Recipe Index

Ingredient Index

Ingredient Index

Acknowledgments

Special thanks to my father, mother, and brother for taking every one of my creative pursuits seriously (there have been more than I care to admit). You even believed in me when I told you I would make a career out of salad. Now that's faith.

Thank you to my husband, Adam, to whom this book is dedicated. It was Adam who first created saladforpresident.com, confident that the meals we ate at home were worth sharing. And it is he who continues to encourage, critique, and challenge me every single day.

Thank you to Chopt Creative Salad Company for giving me a "real" job, sending me around the world, and trusting me to work my butt off while I rarely make an appearance in the office. I could not have made this book without Chopt's cofounder, Tony Shure, who gifted me every expensive salad accoutrement he encountered over the last two years. He even let a crew of six people take over his home (and every inch of refrigerator space) so I could shoot this book. His support was a windfall, and I can't wait to see what we come up with next.

Thank you to Holly Dolce, my patient editor, who endured all my brilliant words of encouragement, like that time when I advised, "just don't make me sound stupid." That wasn't nice. Holly, thank you for making me sound smart. Creating this book was crazy fun because of you, and the ladies of Abrams: Deb Wood for holding my hand through our photoshoot (over the weekend no less), Danielle Young for her endless hours working on the layout, True Sims for production direction, and Mary Hern (who probably checked the spelling of vinaigrette more than 1,500 times). Thank you, Liana Krissoff, for testing my recipes and spending six months feeding your family *exactly* the same things I was eating everyday.

Thank you to Omar Sosa, my designer, and Juan Ariezaga, whose talent makes me appear a whole lot cooler than I am. I am so happy to have found a true collaborator in you. That Spanish accent and Latin conviction made me laugh in even the most stressful of times, and I am grateful for that. It was you who introduced me to Olivia Sammons, not only a brilliant stylist, but a confidante and wellspring of moral support. And thank you to Rebecca Jurkevich, the master food stylist who made my recipes come to life. With your talent alone and the help of Lauren Schaeffer, the one thing I *didn't* have to worry about was what was cooking in the kitchen.

Thank you to Kim Witherspoon and Monika Woods for making this happen for me.

Thanks and endless love to all my lady friends who critiqued every single cover option proposed for this book (there were hundreds), and taste-tested every single salad at every single stage of development. You gals always do the dishes when I tear apart the kitchen in the name of dinner, and you always show up with more than one bottle of wine. I am constantly amazed by my coven of brilliant women, in particular Emily Wren, who travels at the drop of a hat to photograph my parties or lend moral support with little more than a sleepover as compensation. And, of course, Madame Joana Avillez, whose witty illustrations capture my personhood better than any photo ever could. You're a genius and I would marry you if I could.

Thank you to all the artists who have given their time to *Salad for President*, and to my mentors and teachers, especially my former professors and friends, Dike Blair and Jon Kessler. These great artists helped me define who I am, and showed me that life is only worth living if you do it your way.

Last but never, ever least, a big, grabby, Jewish Grandma hug to Nana. I am a better person because of our love. You are tough as balls, and so I am, too. *Kein ayin hora*.

Editor: Holly Dolce
Designer: Studio Omar Sosa
Production Manager: True Sims and
Denise LaCongo

Library of Congress Control Number:
2016943557

ISBN: 978-1-4197-2411-4

Printed and bound in China
10 9 8 7 6 5 4 3 2 1

ABRAMS The Art of Books
115 West 18th Street, New York, NY 10011
abramsbooks.com